Journey through

RHINELAND-PALATINATE

Photos by
Brigitte Merz and Erich Spiegelhalter

Text by
Maja Ueberle-Pfaff

Stürtz

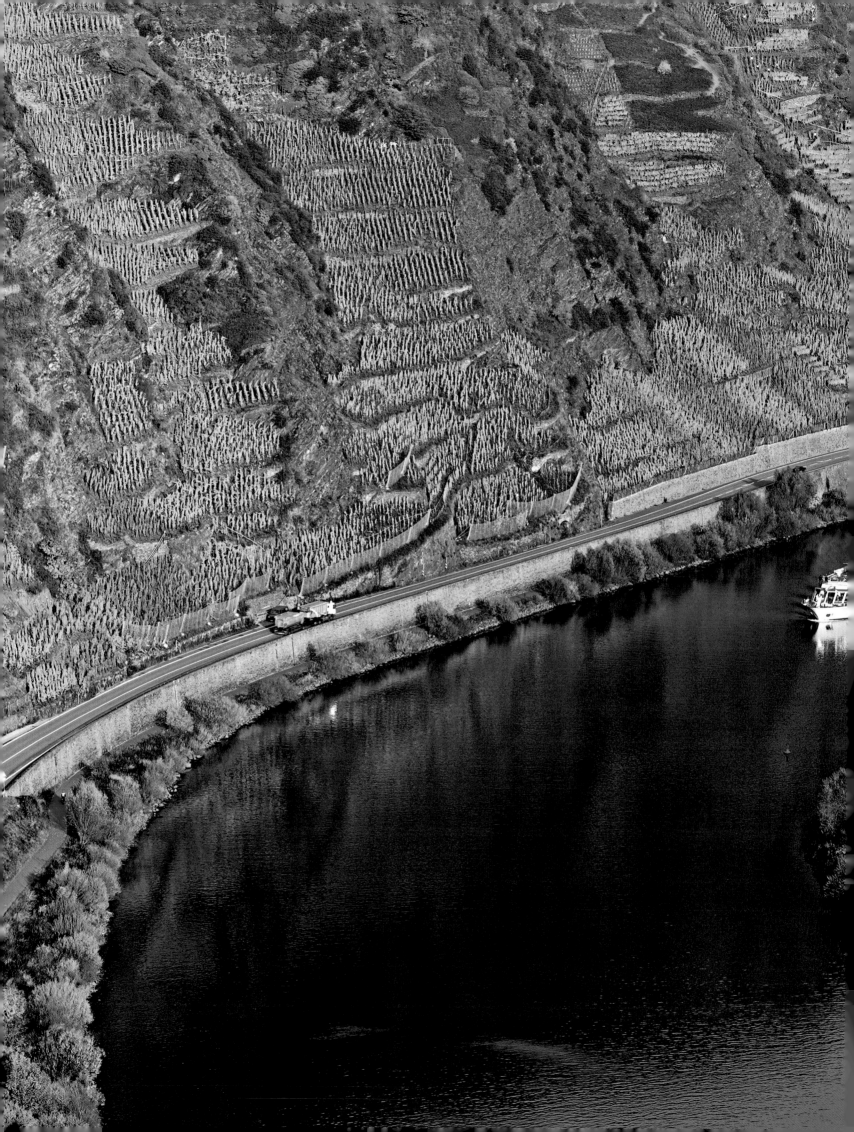

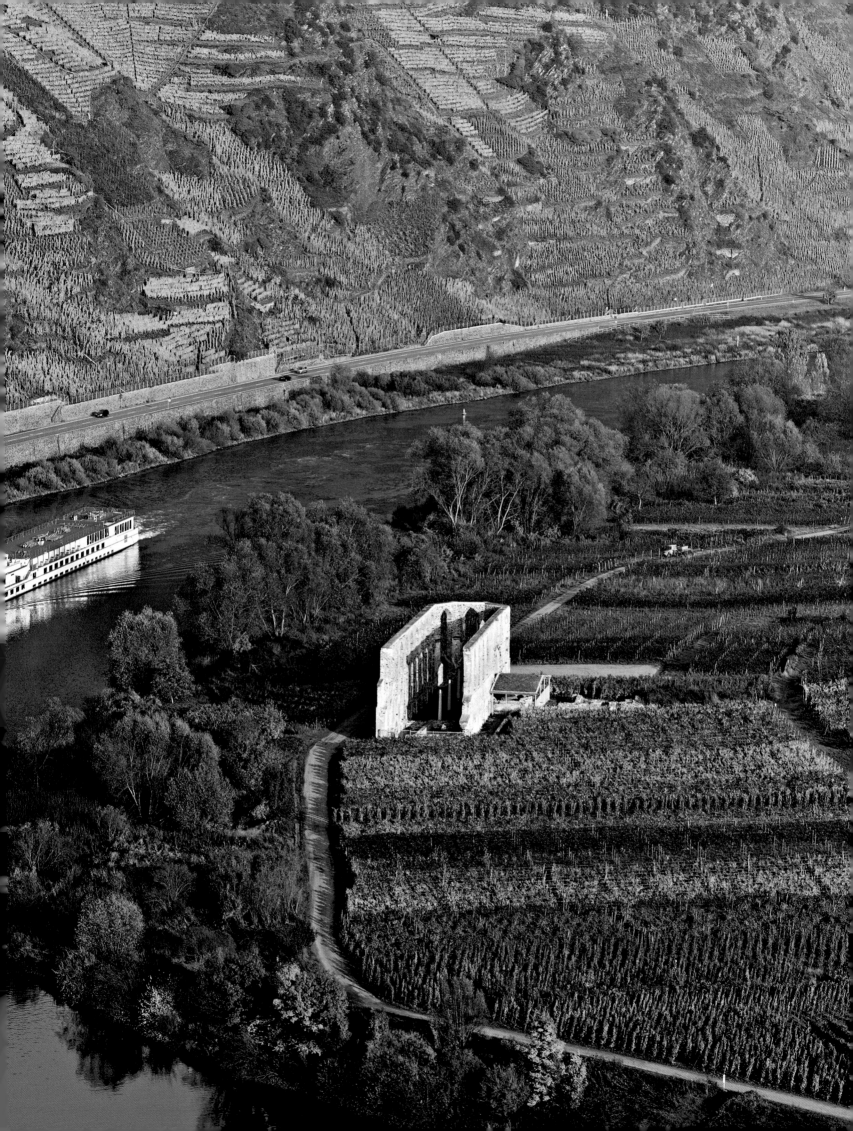

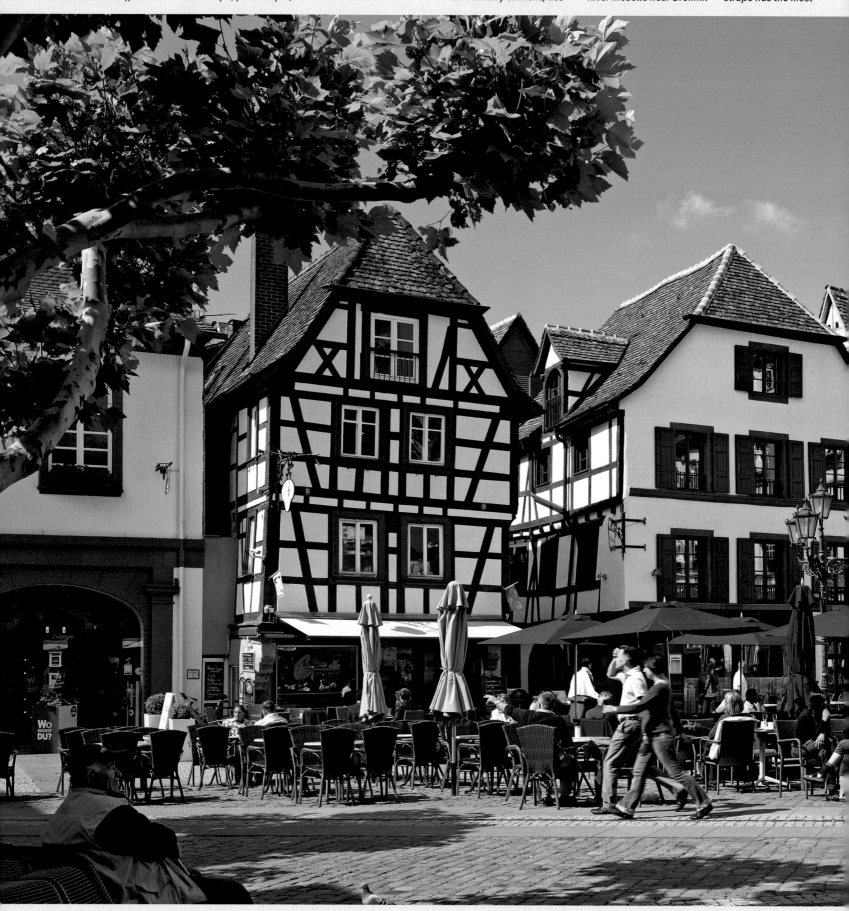

half-timbered buildings in the Palatinate, some of which adorn its pretty market place.

Page 10/11:
The ruined castles of Altdahn, Grafendahn and Tanstein in the hilly forest of the Palatinate. Tanstein is the oldest of the three, *with Altdahn, the ancestral seat of the knights of Dahn, dating back to the 12th century and Grafendahn to 1287.*

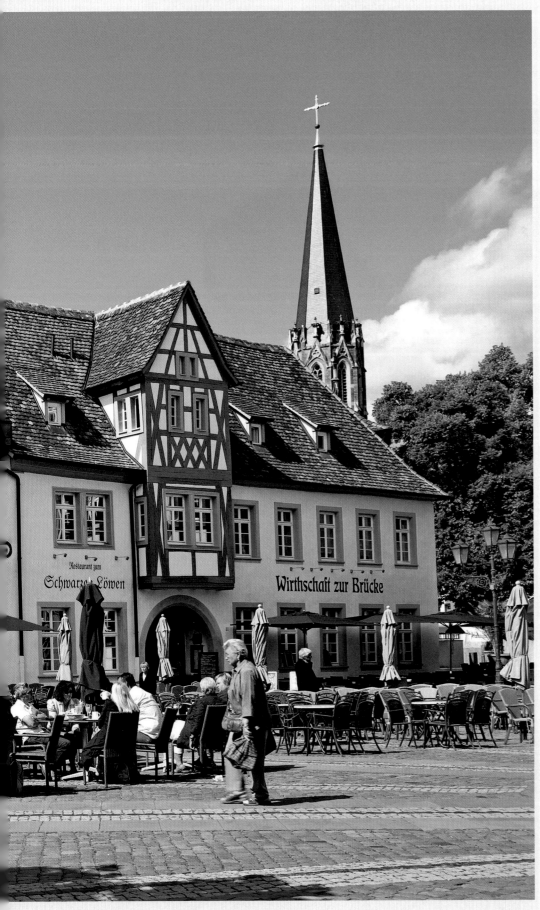

Contents

A rich cultural landscape – Rhineland-Palatinate

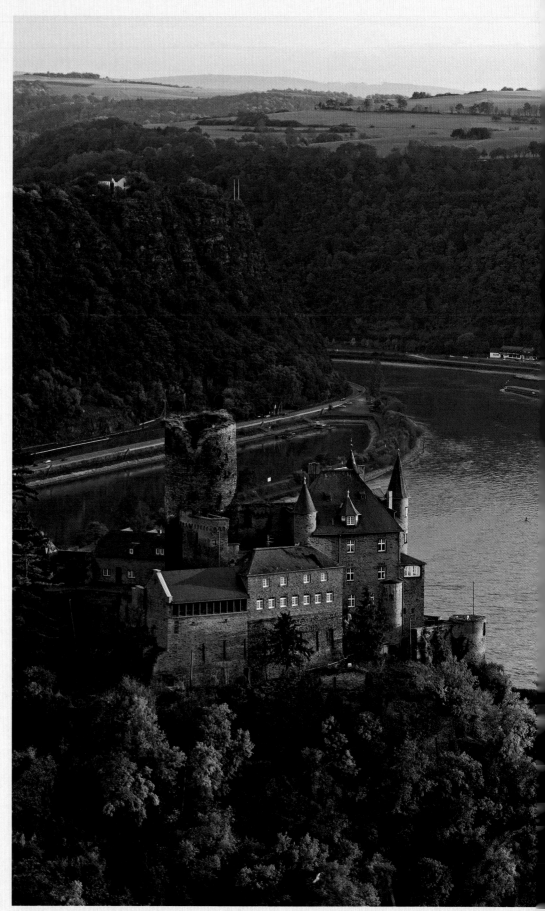

Burg Neukatzenelnbogen up above St Goarshausen on the River Rhine was designed first and foremost as a defence and only sporadically inhabited. From its rocky outcrop each ship that turned the corner from the Loreley could be carefully scrutinised. The locals found the word "Neukatzenelnbogen" too long and so it was shortened to Burg Katz (cat castle), a name it has kept to this very day.

From a certain bank on the side of a road not far from the Palatine town of Landau, to the northeast you can see the towers of Speyer Cathedral, where eight German emperors and kings and one empress lie buried, to the northwest the Hambacher Schloss, the cradle of the civil revolution in Germany, and to the southwest the imperial fortress of Trifels, where during the Staufer period the imperial regalia were kept. Heiner Geißler, ex-minister of Rhineland-Palatinate and owner of a wine estate in Gleisweiler in the Palatinate, once stood here too and smugly remarked: "Each of these historical monuments has a hundred times more to do with German history than Berlin's Victory Column."

This may be a matter of personal opinion but one thing is clear: Rhineland-Palatinate is not short of stone witnesses to Germany's – and often also Europe's – past. Embedded in the Rhenish Massif there lies an ancient European cultural landscape, the settlement of which has been proved to go back as far as the Ice Age. The federal state in the west of Germany is, however, a fairly recent political entity. It wasn't until after the Second World War, on 30 August 1946, that parts of the Bavarian Palatinate, terrain belonging to the free state of Hesse-Darmstadt on the left bank of the Rhine, bits of the Prussian province of Hesse-Nassau and the Prussian Rhine Province were combined to make a whole. "This shall create a region which incorporates the Palatinate and the current administrative districts of Trier, Koblenz, Mainz and Montabaur": with these words the French military government ordered the creation of a new federal state, with which regions formerly linked both historically and economically were driven apart.

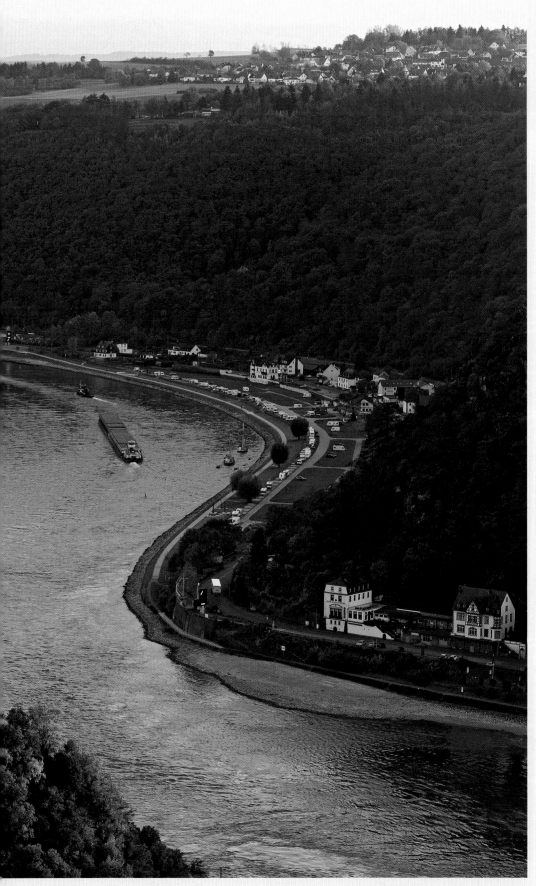

It's thus no surprise that to begin with the territories that had been forced into marriage to create a "land conceived in a test tube" were not optimistic. Not even the first minister of the state, Peter Altmeier, thought it would last very long. On celebrating its diamond jubilee 60 years later, one cabaret artist attempted to define this "triple-gendered phenomenon"; the question of whether the union was male or female, he expounded, was not quite clear, as Rhineland-Palatinate or Rheinland-Pfalz, to give its German designation, consisted of "der Rhein" (the River Rhine, masculine), "das Land" (the state, neutral) and "die Pfalz" (the Palatinate, feminine).

"Weck, Worscht und Woi"

The first seat of government was Koblenz in 1946, the old capital of the Prussian Rhine Province, as Mainz was still too badly damaged after the war. Four years later Mainz was reinstated and the first lord mayor of the city welcomed his civil servant members of staff with a traditional Mainz Carnival feast of "Weck, Worscht und Woi" (rolls, sausage and wine).

The situation has drastically changed since then. In a survey the question "Do you like living in Rhineland-Palatinate?" was answered in the affirmative by 96%. The hyphenated state has found acceptance and can look back on a remarkable history. With almost 20,000 square kilometres/over 7,700 square miles and over four million inhabitants, it has now come together and found its unmistakable independence. What was once a geographical patchwork has turned into an economically strong unit. Its marked determination to succeed and founding spirit have stood the populace in good stead. Its energetic reconstruction work has paid off and a common identity has been formed by the turbulent past all have shared, underlined by the state's wealth of wonderful buildings from different periods, the great significance of its viniculture and its many areas of beautiful scenery.

The people here relate to their particular region, however, and not to the state as a whole. When asked where they come from, not many will answer "I'm from Rhineland-Palatinate". Instead, they see themselves as Rhinelanders, as locals of the Moselle, Rhine-Hesse, Palatinate, Westerwald, Hunsrück or, in a display of even greater local patriotism, as *Kowelenzer* (from Koblenz) or *Meenzer* (from Mainz). These various regional individuals exist perfectly well side by side but can't risk the odd joke at the expense of their neighbours. There are of course plenty of local dialects that help colour each individual area, referred to as *Mainzerisch*,

Pfälzisch, Ripuarisch, Moselfränkisch, Hunsrücker Platt, et cetera. When they talk to one of their distant cousins in their respective broad slang, comprehension is not necessarily guaranteed. Three quarters of all inhabitants in Rhineland-Palatinate can speak their own dialect and even Asterix and Obelix have joined the merry throng. They may have resisted the Romans in Gaul but they have not managed to prevent their adventures being translated into Palatine German and Moselle Franconian. Ancient Palatine patois has even spread as far as Pennsylvania, with emigrants from the Electoral Palatinate in the 17th and 18th centuries not only taking their religion and culinary traditions with them but also their language, continuing to uphold it in their new country of residence.

From a linguistic point of view, in the borderlands with France in the south and Luxembourg and Belgium in the west the transition is fluid; we could even speak of a threshold existing between the Germanic and Romance language area. Latin came with the Romans and mingled with the lingo of the Celtic tribes already living here and that of the Teutons who arrived in late Antiquity. In an attempt to stop them invading, small forts were erected along the Roman Limes that defended and controlled the entrance to the Rhine Valley in the northeast of what is now Rhineland-Palatinate. These fortifications were part of the vast Roman line of defence that stretched from the Rhine via the River Main to the Danube. Its remains, of which 131 watch posts and 18 forts are on Rhineland-Palatine soil, make up what is now the longest and best-known archaeological ground monument in Germany and are a UNESCO World Heritage Site.

No other federal state has longer borders with its European neighbours. Brussels, Amsterdam, Luxembourg and Paris are practically next-door. This has been seized as an opportunity and instead of becoming an outpost on the edge of Germany active dialogue with its neighbours has placed Rhineland-Palatinate in the heart of Europe. Borders have become bridges and cross-border projects are all the rage, with countries collaborating on issues of education, economic development and (un)employment. One pioneering example in the field of protection of the environment is the Franco-German biosphere reserve of Pfälzerwald-Vosges du Nord which UNESCO recognised as the first transfrontier biosphere reserve in 1998.

Diverse range of scenery

In the past few years, with its diverse range of scenery Rhineland-Palatinate has proved increasingly attractive to nature-lovers, hikers

and cyclists. There's hardly another federal state that can boast such an assortment of landscapes and touring routes through rocky river valleys, along wooded ridges and across sun-kissed plateaux. Some of Germany's best forests and medium-range mountains stretch from the Westerwald in the north to the Palatinate in the south. Parts of the Mainz Basin and the hills of Rhine-Hesse are also counted among its green and pleasant lands. The holiday region of the Pfälzer Wald or Palatinate Forest rises steeply up from the Rhine Plateau, its expanses forested since the 17th century and once popular hunting ground for the region's nobles. Beech, oak and alder, pine, spruce, larch and maple thrive in the acidic red sandstone soil, with sweet chestnuts growing near the vineyards.

The Eifel, the medium-range mountains tucked in between the cities of Aachen, Cologne, Koblenz and Trier, is an area distinguished by the volcanoes of the Cenozoic Era, with blue crater lakes or *Maare* filling some of the extinct smoke holes. The Westerwald was also volcanic and it is to here that the conurbations of the Rhine/Main and Cologne/Bonn are increasingly escaping for some respite from city life. Since the opening of the Westerwaldsteig hiking trail in 2008 you can walk across the undulating highland plateau in 16 stages. The basalt mined here (earning the people of the Westerwald the nickname "rock head") was used in part to straighten the Rhine river bed and build up the foundations for Cologne Cathedral. The Hunsrück is shaped like a dog's back ("Hunderücken" in German, hence the name); one of the smaller mountain ranges of the Rhenish Massif, its distinct ridges and hollows form a rolling pattern of fields and forest. The Rhine Valley, the state's main thoroughfare, runs from the southeast to the northwest. It has always been relatively densely populated and is geared entirely towards tourism. Its multifarious landscape can be explored on foot atop the Rhine Plateau, past well-tended vineyards and wild hedgerows, with the glittering river far down below.

The habitat of Rhineland-Palatinate has always been shaped by its four great rivers: the Rhine, Moselle, Saar and Lahn. The Rhine, Germany's biggest waterway, has linked the Mediterranean with the north of Europe for 2,000 years. The territories along the river banks became meeting places for various cultures where humans and other forms of life intermingled. The diversity and mix of peoples that resulted are absolutely typical of Rhineland-Palatinate today.

Of Celts and Romans

Cultural import didn't start with the Romans, however. Before them the Celts introduced their progressive technology to the land, erecting stone circles, settlements and places of sacrifice, some of which have been excavated and reconstructed and now give us an impression of what life BC was like. The past is something Rhineland-Palatinate can make the most of, as a wander through the Römisch-Germanisches Zentralmuseum or the Rheinisches Landesmuseum in Trier excellently illustrates. With the Romans came the more extensive development of the region, with road systems installed and towns built – no less than 45 of them, including the line along the Rhine, or a good 42% of all towns and cities in the state. This systematic town-building policy sparked off the cultural evolution of Central and Western Europe, one that continued far beyond the fall of the Roman Empire.

There are many relicts of the Roman Period dotted about the countryside but nowhere as densely as in Trier, the oldest city in Germany founded about 2,000 years ago by Emperor Augustus. Situated in the north of the giant empire, Augusta Treverorum soon became an important centre of trade and administration thanks to its strategic location. The Porta Nigra, amphitheatre, Constantine's basilica and the imperial Roman baths bear witness to 500 years of Roman rule, at the end of which Trier, with Rome and Constantinople, was one of the capitals of the Roman Empire. Legend even has it that Trier Cathedral was erected on the site of the Roman palace owned by the emperor's mother Helena.

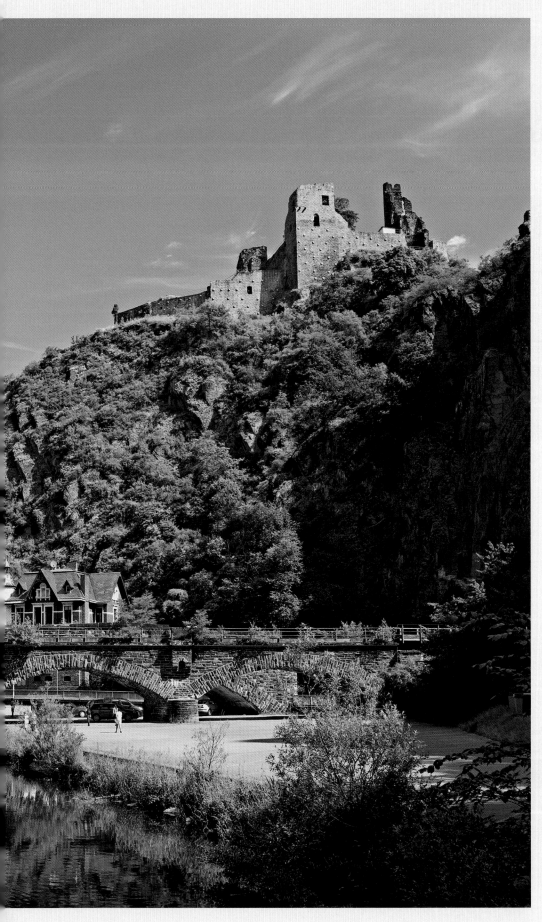

In the middle of the 5th century AD the Roman legions finally retreated from Germania Superior and the Ripuarian Franks seized power. The importance of the region to its Frankish, Salian and Staufer potentates is manifested for instance in the imperial cathedral of Speyer and in the imperial palaces and royal courts in Kaiserslautern, Oppenheim, Worms, Bingen, Bad Kreuznach, Oberwesel, Boppard, Koblenz, Andernach, Remagen and Sinzig. The imperial palace in Ingelheim deserves a special mention, built by Emperor Charlemagne in the 8th century. Here he held court, passed laws and inspected his lands and estates. He was obviously also preoccupied with wine, as almost one tenth of the laws entered in his book of administration relate to viniculture.

Siegfried, Kriemhild and co.

The rule of the Burgundians in the area around Worms was a brief interlude that began in 420 and ended in 436 with a devastating defeat at the hands of a Roman army general and the Huns. These sixteen years nevertheless made their mark on intellectual history and literature in the form of the *Nibelungenlied* or Song of the Nibelungs. The heroic medieval epic tells of the adventurous events at the royal court of the Burgundians and every year at the Rheinland-Pfälzer Kultursommer festival you can watch the antics of Siegfried, Kriemhild and co. on an open-air stage set up outside Worms Cathedral. In the Middle Ages the area that is now Rhineland-Palatinate underwent a political and cultural boom. The areas on the Rhine made up the heartland of the Kingdom of Germany in the Holy Roman Empire. Three of the seven electoral princes lived in the towns and territories of today's federal state: the Electoral Palatinate and the episcopal sees of Mainz and Trier, whose heraldic symbols – the lion, a six-spoked wheel and the cross of St George – now appear on the Rhineland-Palatine coat of arms. With the archbishoprics of Cologne, Trier and particularly Mainz three of the biggest representatives of both sacred and secular power in the empire were concentrated here. The famous Romanesque cathedrals of Speyer, Worms and Mainz are testaments to religious servitude and worldly greatness, as are the many castles and monasteries in the region. Monasticism and spirituality received major impetus from outstanding figures such as Boniface, the 'apostle of the Germans', bishop of Mainz Rhabanus Maurus, Hildegard of Bingen and Nicholas of Kues. Large Jewish communities placed under the protection of the area's spiritual leaders contributed greatly to flourishing city life in Speyer, Worms and Mainz. Although there were several

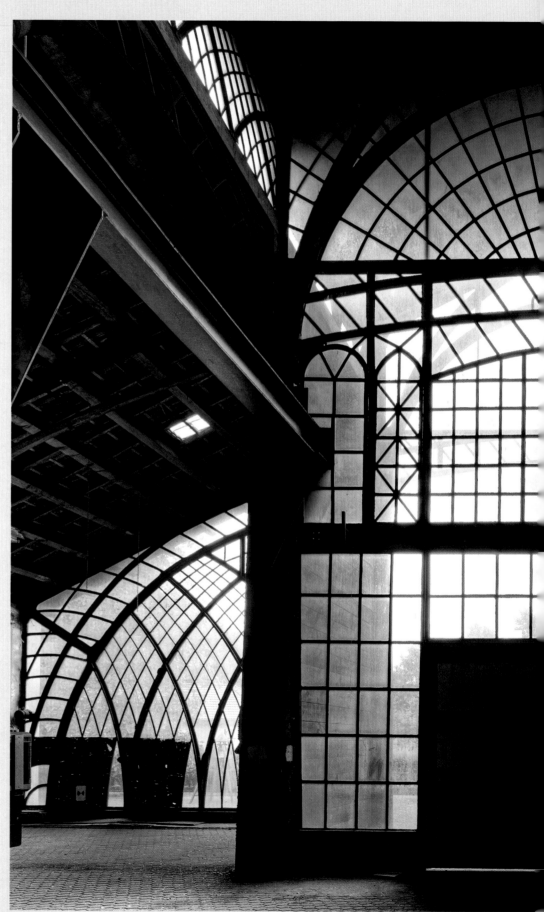

pogroms, the communities always managed to re-establish themselves and down the centuries they helped these cities to culturally develop and diversify. Not far from the old town in Worms is the oldest surviving Jewish cemetery in Europe which bears the name of Heiliger Sand or holy sand.

The cities in Rhineland-Palatinate aren't very big but that makes them all the more confident – and rightly so. In 1254 Mainz, Worms, Oppenheim and Bingen formed a league which many other towns soon joined. It opposed feuding and laid down rules for cases of conflict. A Rhine navy was set up to protect Rhenish shipping. Speyer, which had evolved from a Roman camp, was the first place in Germany to be made a free city by Heinrich V, granting its citizens various personal liberties.

Master printer

In the late Middle Ages the spirits of the Renaissance and Humanism dominated religious life in the region. Early on people recognised the importance of an all-round education, prompting the founding of the first universities in Trier in 1473 and Mainz in 1477. The invention of the art of printing by Johannes Gutenberg in Mainz lead to a veritable revolution in the dissemination of knowledge from 1455 onwards. In a survey carried out a few years ago by the local radio station Südwestfunk, master printer Gutenberg came top of a list of 100 famous people. His pioneering achievement also helped to spread the ideas of the Reformation. As the Palatine electors converted to the Lutheran belief, great swathes of the south of Rhineland-Palatinate are now Protestant.

The strategically exposed locations of the Rhine, Moselle and Palatinate have also caused the people here to suffer many wars and vast areas of countryside to become desolate. The Thirty Years' War (1618–1648), Nine Years' War (1688–1697), War of the Spanish Succession

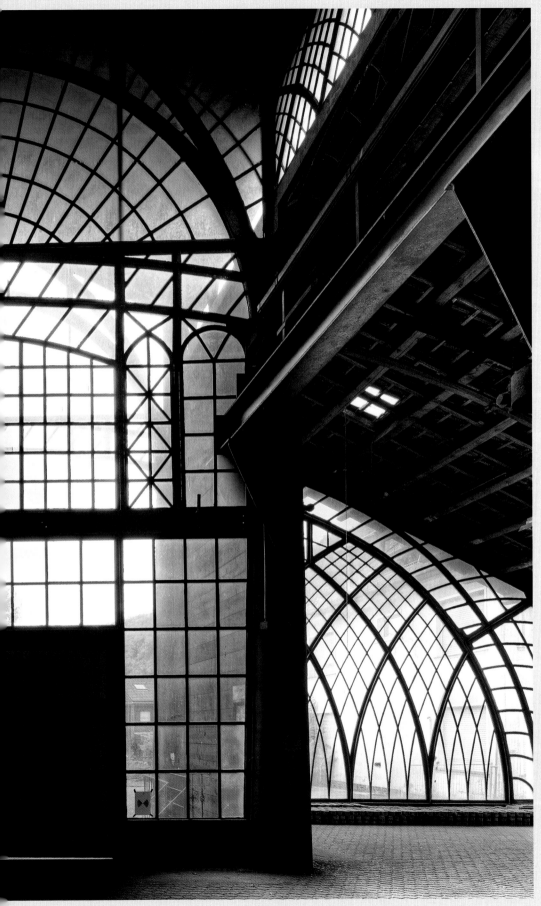

(1701–1714), Seven Years' War (1756–1763) – time and again boundaries were shifted and new rulers demanded their dues. Faced with destitution or hounded by religious persecution, those who could raise the necessary capital emigrated. In the 17th and 18th centuries hoards of Palatines left for North America and especially New York and Pennsylvania, in the 19th century travelling as far as Brazil. It's thus not exactly astounding to learn that the English word for *Pfälzer*, "Palatine", was long used as a synonym for all immigrants from Germany countries.

At the dawn of our modern age the ideas and after-effects of the French Revolution inseminated Germany. With the advance of French Revolutionary armies the first republic on German soil was founded in Mainz in 1793. A coalition force of imperial counts managed to seize the city back but in 1801 the territories left of the Rhine fell to France. This led to the achievements of the French Republic arriving with Napoleon: special privileges for the estates were abolished, the legal system was standardised and reordered. The *Code civil* introduced in 1804 remained in effect in the Palatinate until the German Civil Code superseded it in 1900.

The Hambacher Fest

In 1814/15 the then French territories in the Rhineland fell to Prussia and the areas around Mainz to the grand duchy of Hesse, known from that point forward as Rheinhessen or Rhine-Hesse. The Palatinate was promised to Bavaria. Yet the attempts to introduce a democracy simply didn't cease. France's July Revolution in 1830 also made waves in Germany. In the Palatinate (then Bavarian) about 30,000 people congregated at the Hambacher Schloss on 27 May 1832 to stage the biggest protest yet seen in Germany, vehemently demanding freedom of the press, national German unity and liberty. The Hambacher Fest, as it came to be known, was thus a harbinger of the revolution of 1848/49 which in Mainz had one of its first democratic centres.

In the mid 19th century the areas on the Rhine and in the Palatinate began slipping into the shadows, both economically and politically. In 1870/71, 1914–18 and 1939/40 the inhabitants were forced to watch as the military marched its troops through their homelands on their way to war with France. Even today world politics doesn't stop at Rhineland-Palatinate. Up until the 1980s a strong military presence earned it the epithet of "aircraft carrier of the nation"; with the advent of a more relaxed form of international politics large areas were suddenly freed up. One of the consequences borne of this political conversion is the re-use of

former American airbase Hahn, now the fifth-biggest cargo airport in Germany and just half an hour's drive away from the Middle Rhine. Despite all these innovations there's still plenty of time for fun and some good old German *Gemütlichkeit*. If you wish, you can spend March to October trawling from one cultural and social event to another. Culinary weeks, castle plays, crime festivals, open-air concerts – the arts have the federal state firmly in their creative clasp. Castle festivals complete with knights in shining armour whizz you back to the Middle Ages; a two-day medieval market at the Hambacher Schloss demonstrates ancient crafts, with jousting, travelling entertainers, medieval minstrels and fare from the days of yore. And for several weeks the Rhine is even in flames – or at least it looks like it when between May and September its loveliest shores are lit up by multitudes of fireworks.

Festival marathon

Ancient traditions have also survived here. The start of the festival marathon begins in February with Mardi Gras in Mainz – or Meenzer Fassenacht, to give it its local form of address. Here you can rub shoulders with marching bands, *Schwellköpp* (people masked with giant heads), standard bearers and mini-skirted, dancing girl guards, turning the night into day as Fassenacht in Mainz carries on regardless of any kind of (economic) crisis. Thus claimed the motto for 2010, at least. The Backfischfest in Worms is also crisis-proof and with up to 700,000 visitors the largest public fair and wine festival on the Rhine. For nine days the city is under the symbolic rule of the "mayor of the fishermen's meadow", the one-time master of the Rhenish guild of fishermen founded in 1106. At the Brezelfest in Speyer over 20,000 bread pretzels are flung into the crowds from the floats of the grand parade. Bad Dürkheim's Wurstfest is not particularly famous for its sausage, as the title might suggest, but more

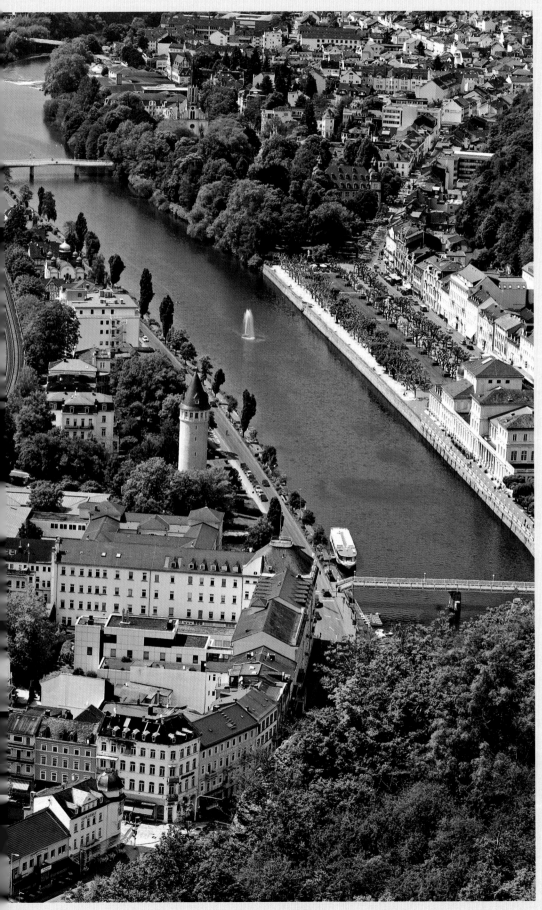

for its wine which is served and imbibed in all its permutations – from white to rosé to red to sparkling – in cosy marquees erected for the occasion.

The harvest month of September is given over to wine festivals in the wine-growing regions of Rhineland-Palatinate. Introduced to the Moselle by the Romans, in the Middle Ages the art of wine-making gradually spread south. Whether enjoying a glass of the local vintage at a *Kerwe* in the Palatinate or *Kirmes* on the River Ahr, at an *Eierkrone* on the Middle Rhine or a *Hammeltanz* in the Hunsrück, guests are always invited to join the locals at their table. And if you're lucky, you might even meet one of the pretty wine queens …

www. in Rhineland-Palatinate doesn't stand for a virtual network but for the tourist concept of walking, wellness and wine. The three go well together and can be combined at will. As far as the latter is concerned, the ultimate glass need not necessarily be your last for just as you're about to toddle off somebody's bound to shout "Let's have one for the road" and a giant half-litre glass of wine will be passed round the table and the party only broken up when everyone's had a final nip …

Page 22/23:
The Marksburg is the only medieval hilltop castle on the Middle Rhine to have never been destroyed. Much of it dates back to the 13th to 15th centuries. Its tower and turrets, bailey and bastions cling to a rocky spur up above the romantic little town of Braubach. The Marksburg is a good example of how castle building evolved from the high medieval residential keep to the impenetrable fortress of later centuries.

Page 24/25:
The Altes Haus in Bacharach is one of the most famous medieval buildings on the River Rhine. Its gables, oriel and Rococo doors have all the ornate character of Rhenish half-timbering.

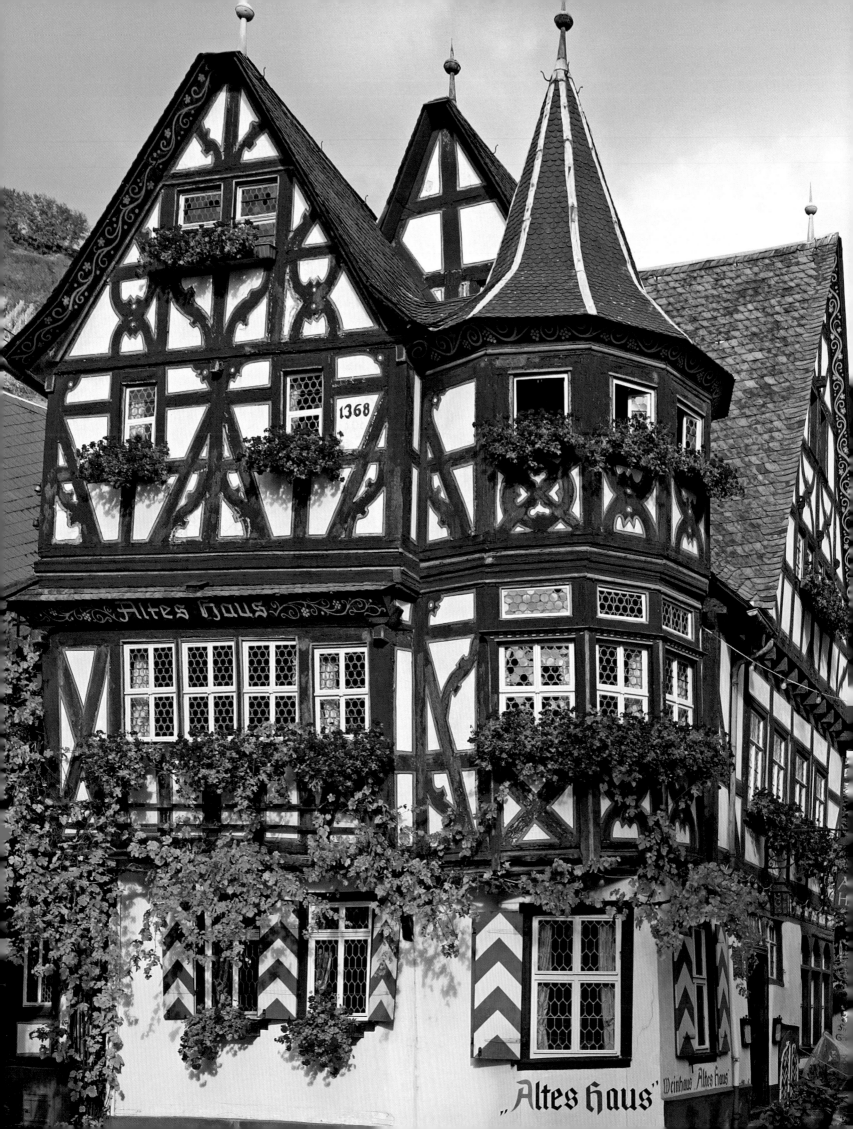

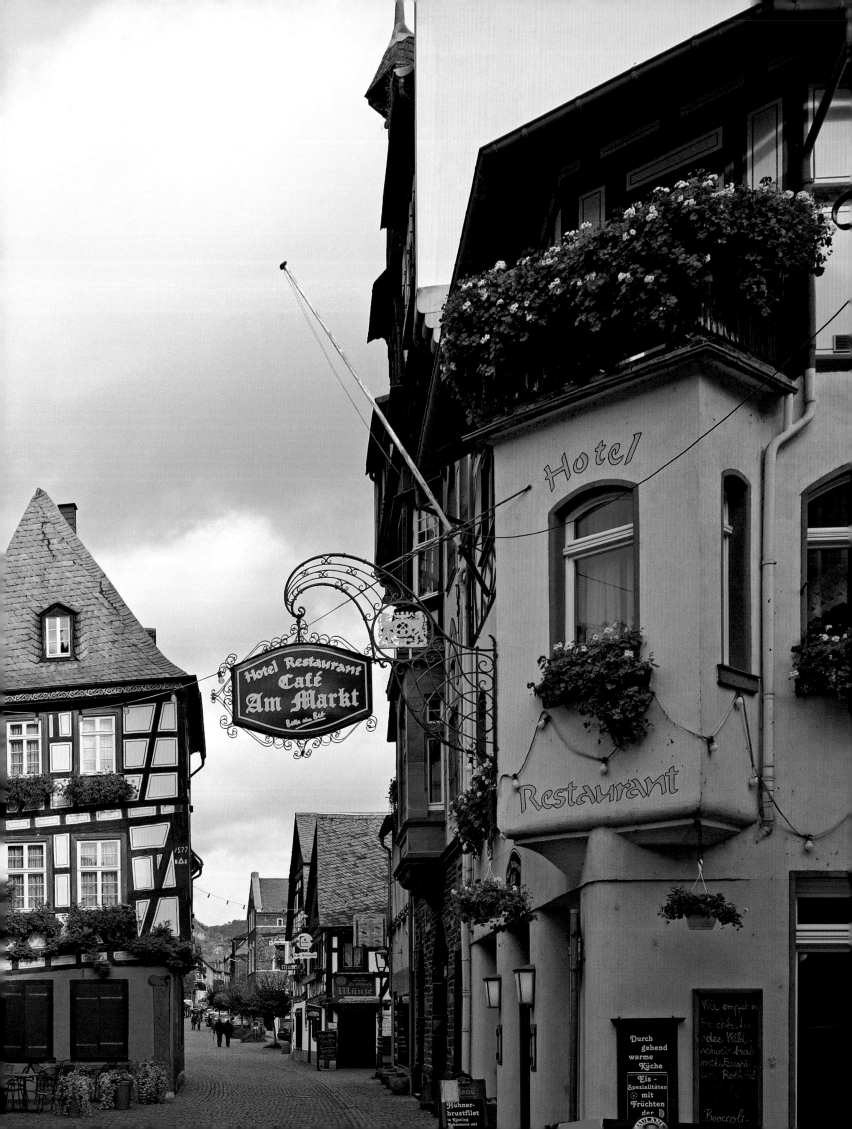

Wine, fruit and culture – the Palatinate

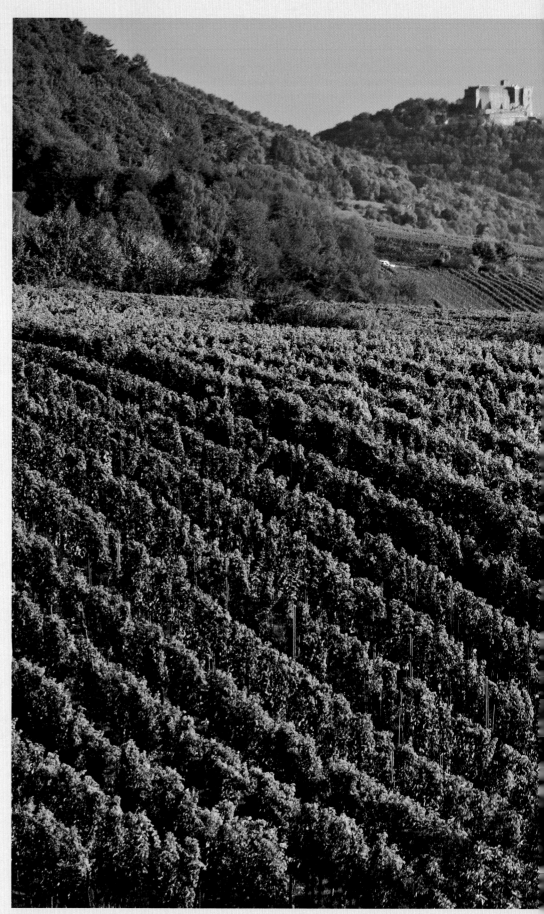

In Bad Dürkheim the Palatines have built the biggest wine barrel in the world and opened a pub in it. This says a lot about the sociable and inventive people who inhabit the Pfalz half of Rhineland-Palatinate. Wine has always been an elixir of life here in the south and is the sturdiest pillar of the economy in the second-largest wine-growing region in Germany, where many of the estates are still family-run. The hilly south of the Palatinate, often described as Mediterranean, is a real garden of Eden; with an average mean temperature of around 10°C a year and over 1,700 hours of sunshine per annum the area is predestined for the cultivation of fruit.

The Palatinate today is the rest of the vast territorial state of the Electoral Palatinate on the left bank of the Rhine. It's divided up into the West Palatinate (Westpfalz) around Kaiserslautern, Pirmasens and Zweibrücken, the undulating North Palatinate (Nordpfalz) with Donnersberg Mountain, the highest massif in the Palatinate with impressive views in all directions, and the more densely populated Anterior and South Palatinate (Vorderpfalz and Südpfalz) between the Upper Rhein River and the Haardt Range, famous for the Deutsche Weinstraße or German Wine Route, 80 kilometres/ 50 miles long.

In this historically significant region on the border with neighbouring France, in the 12th and 13th centuries the might of the Staufer dynasty was visibly manifested in the imperial castle of Trifels near Annweiler and the imperial palace of Lautern. Fashioned in sandstone, Burg Trifels clings to a rocky clifftop, whose rugged, precipitous summit rises tall above the trees on Sonnenberg Hill, almost 500 metres/1,600 feet above sea level.

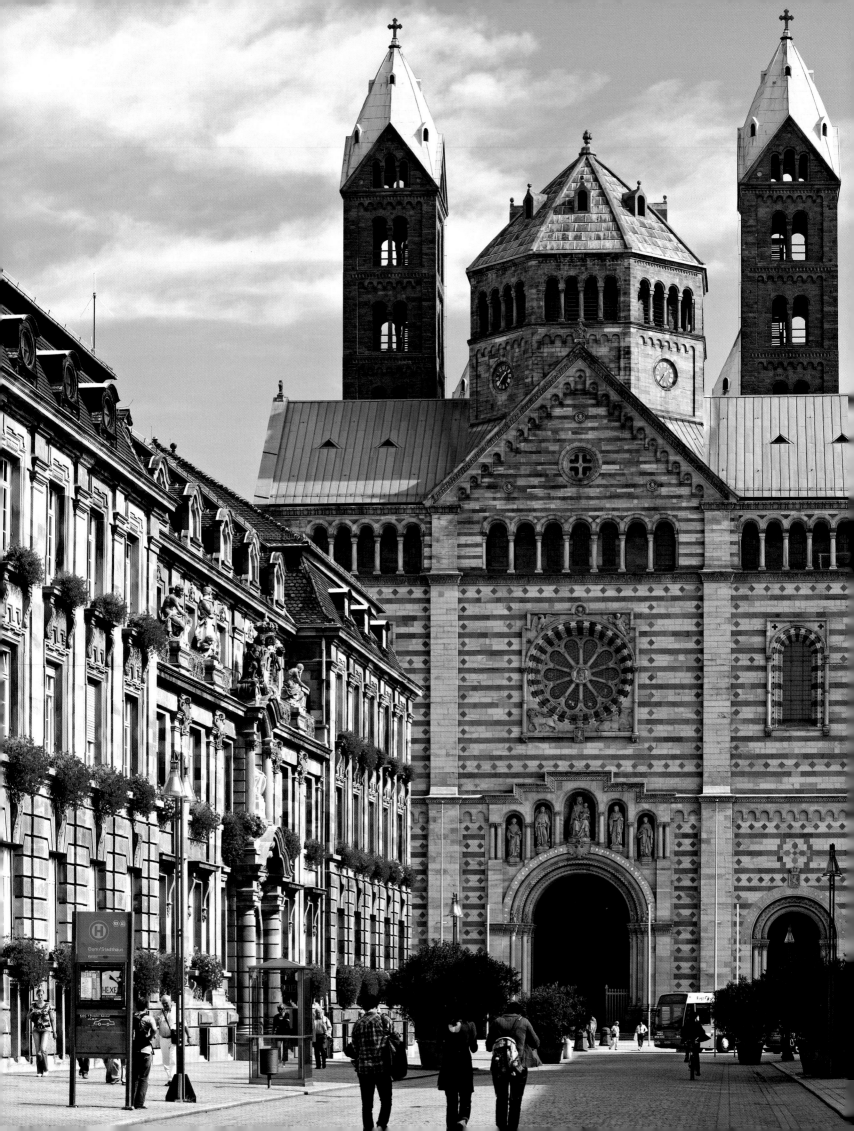

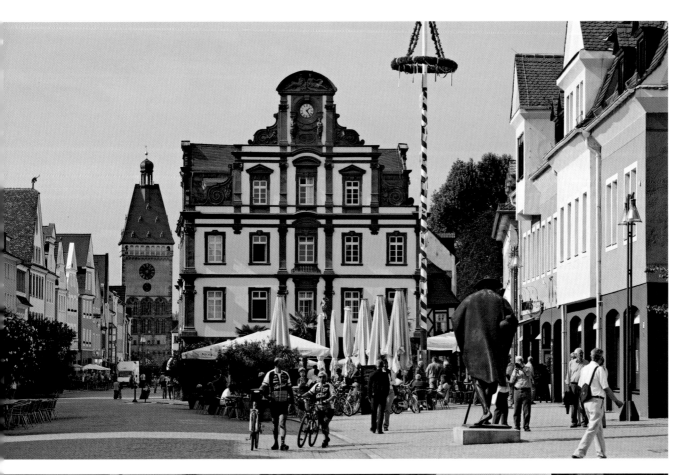

Left page:
In the cathedral in Speyer the Salier dynasty from the Speyer and Worms region created the greatest Christian monument of their day and age. The unique significance of this Romanesque edifice was honoured in 1981 when it was included on UNESCO's list of World Heritage Sites.

The Altpörtel on Maximilianstraße in Speyer is one of the tallest and most important town gates in Germany. First mentioned in 1176, the old west gate was once part of the medieval town walls. Following its conversion the interior is now given over to a permanent exhibition on the history of the city defences.

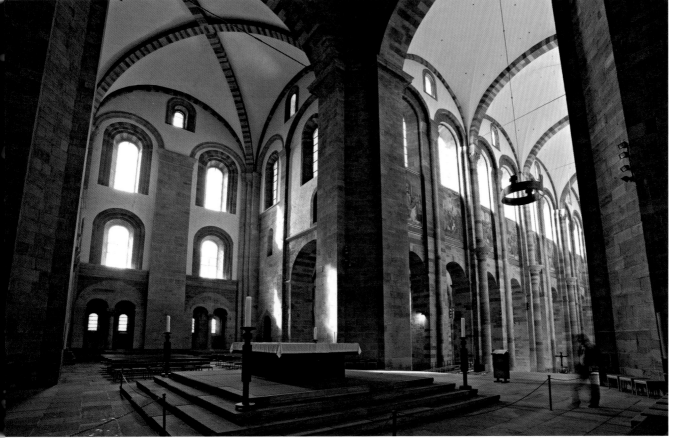

The nave of Speyer Cathedral is characterised by the round arches of the High Romanesque period. The enormous weight of the stone ceiling is equally borne and distributed by the groin vault and a number of mighty pillars.

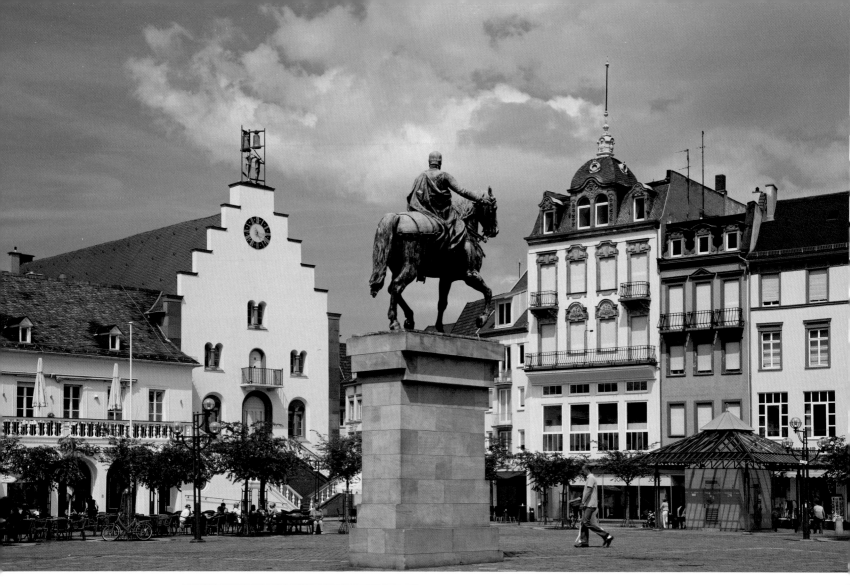

Above:
Landau is a university town, a garden city – and one of the largest wine-growing municipalities in Germany. It also enjoys an idyllic setting tucked in between the Rhine and the Pfälzerwald or Palatinate Forest. This statue of Prince Regent Luitpold on Rathausplatz (formerly a parade ground) reminds us of Landau's Bavarian past.

Right:
The late Gothic cloisters of Landau's Augustinian monastery are an oasis of peace and quiet, perfumed with roses. The monastic order's original church was replaced at the beginning of the 15th century by the Heilig Kreuz parish church.

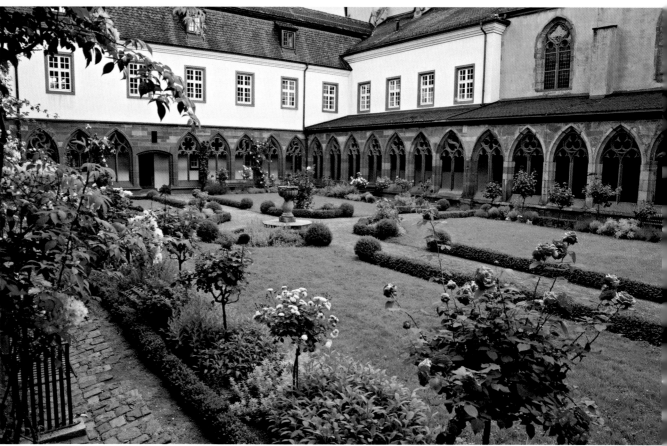

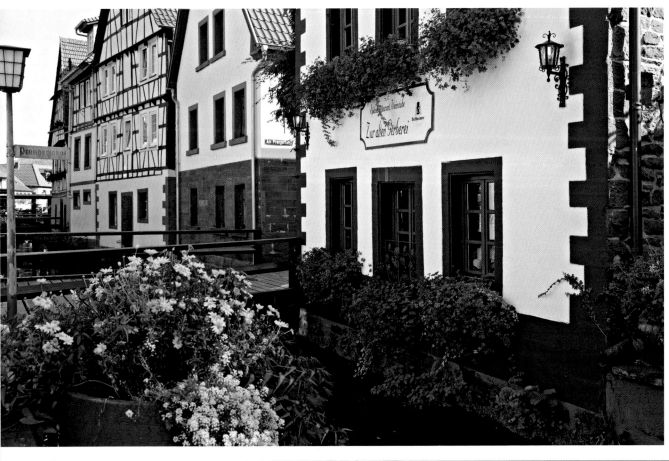

Left:
Annweiler was largely shaped by its community of tanners who plied their trade on the banks of the Queich. Their lovingly restored houses can still be admired on Gerbergasse and Wassergasse.

Below:
Some of the half-timbered houses in Annweiler are more than just a pretty façade. By converting an old mill, three tanner's cottages and a tannery a spacious exhibition hall has been created, in which visitors can learn more about the history of the imperial town and nearby Burg Trifels.

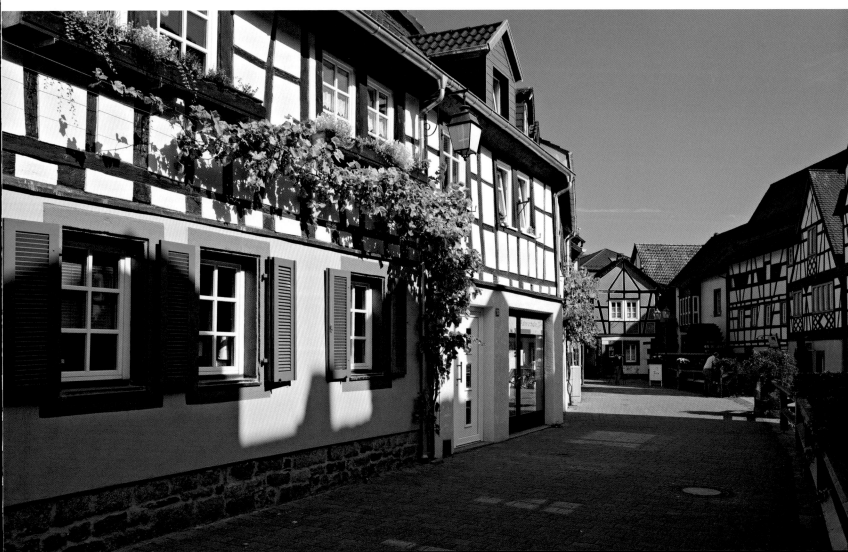

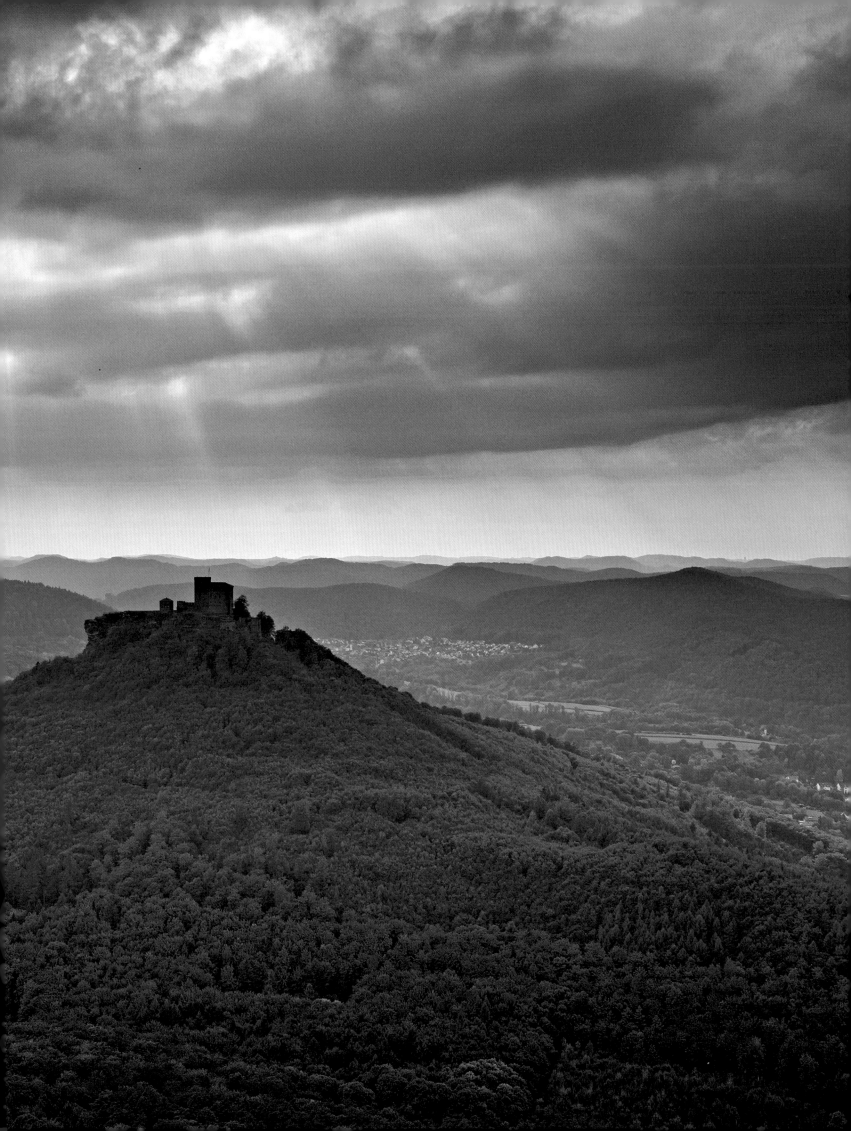

Page 32/33:
High up above Annweiler on the steep sandstone ridge of the Sonnenberg is the imperial castle of Trifels, the most upmarket of the several royal residences maintained by the Staufer dynasty. It took on its present guise between 1938 and 1966.

The Middle Ages comes alive during the summer festival held at the truly vast ruined fortress of Hardenburg near Bad Dürkheim. Throughout the year visitors can explore practically all of this fascinating complex where, according to a local legend, a secret passageway links the red sandstone walls to the nearby monastery of Limburg ...

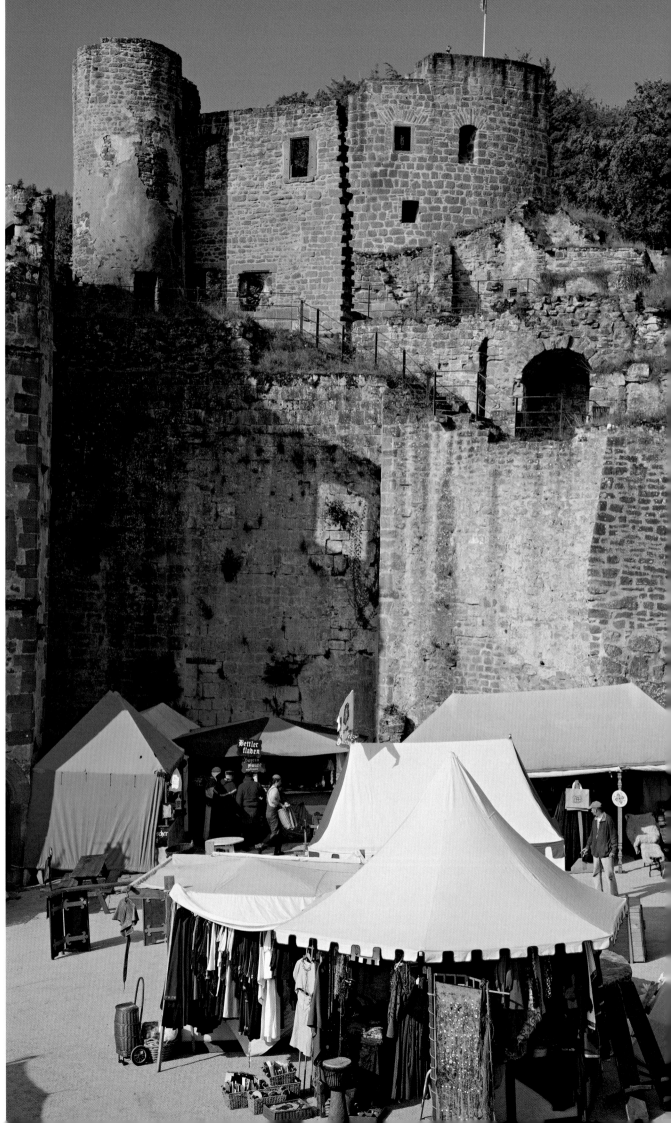

Once a year entertainers, craftsmen and peasants in medieval dress flock to the popular festival held in the ruined castle of Hardenburg. Market traders tout for custom beneath mighty walls while knights in shining armour show off their skill on the terraces and gardens; equally adept artisans demonstrate various medieval trades while wandering minstrels serenade the crowds.

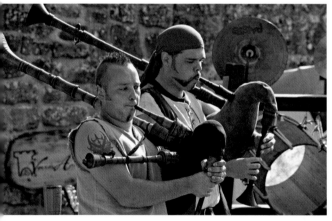

MIGHTY WALLS – CASTLES AND FORTRESSES

„Hoch auf dem alten Turme steht
Des Helden edler Geist..."

Thus begins Goethe's poem Geistesgruß (Ghostly Greeting), to which the 25-year-old poet was inspired on espying the castle of Lahneck whilst on a trip along the River Lahn – an early example of the idealised return to the German Middle Ages by the writers, painters and musicians of the day. There's no doubt that castles and palaces fire our imagination, turning crumbling walls into proud ramparts, ivy-clad ruins into mighty fortresses. The epitome of the knight's castle with its thick walls and towering keep dates back to the 12th and 13th centuries when castle building was in its absolute heyday. One prime example of this architectural phenomenon, Burg Eltz in the Eifel atop a rocky precipice, used to have pride of place on the 500 deutschmark note.

People have always erected structures in places that were hard to access as these were easier to defend. The inner ward of a castle was usually enclosed by a wall or enceinte, on the top of which archers could be stationed. Protection was provided by towers, bastions, machicolations and arrow loops. Depending on the size of the castle the owner – usually a noble – may have had a great hall erected for himself, his family and his servants. The castle – and in later periods the undefended palace or manor house – was also the economic centre of local power. With the dawn of new firearms and greater demands being made of comfort, the medieval castle gradually paled into insignificance.

Castle fans will be delighted with Rhineland-Palatinate. There are a vast number of medieval hilltop castles to 'collect' on the Rhine alone and also along the Moselle, Lahn and in the Pfälzer Wald – well, all over the federal state really. The spectrum ranges from impressive fortresses and imperial palaces to fortified churches, baroque stately homes and summer residences to fortified towns and mysterious ruins. Many private and state-run concerns have (successfully) devoted themselves to the upkeep of these historically valuable monuments, among them the extremely active Deutsche Burgenvereinigung or German Castles Association with its seat in the Marksburg in Braubach, the only high-lying castle on the Rhine never to have been destroyed.

Goethe's Lahneck, built in 1226 to guard the confluence of Lahn and Rhine, is now a UNESCO World Heritage Site, along with around 40 other castles, palaces and fortresses on the Rhine, from Burg Klopp in Bingen opposite Rüdesheim to Ehrenbreitstein in Koblenz about 65 kilometres/40 miles upstream. The Upper Middle Rhine Valley indeed boasts a density of defensive edifices that is unparalleled in Europe. Due to its strategic location and thus the ability to levy profitable tolls, the archdioceses of Cologne, Mainz and Trier all had property on the River Rhine, as did the counts palatine and the landgraves of Hesse. The silhouette of a castle visible for miles around, so reminiscent of a romantic fairytale for us now, was a shrewdly calculated indication of dominance, a symbol of someone's claim to power and protection of his vested rights.

Pillar of imperial might

A second big draw for castle-lovers is the Pfälzer Wald where countless ruined strongholds embedded in rolling green countryside perch atop rotund hilltops. In the Wasgau to the south the castle of Trifels dominates the summit of the Sonnenberg, a pillar of imperial might where English king Richard the Lionheart was once held captive. Bulbous rusticated ashlars in the keep, well tower, enceinte and great hall betray that this was the work of the Staufer dynasty. In the Dahner Felsenland between Pirmasens and Bad Bergzabern, popular with hikers, many castles have been hewn from the red sandstone, including the trio of Altdahn, Grafendahn and Tannstein. The local rock provided the perfect foundations for a defensive structure and was soft enough to be used for hidden chambers, passageways, wells and cisterns. Somewhere down here, an ancient legend will have us believe, lies buried treasure ...

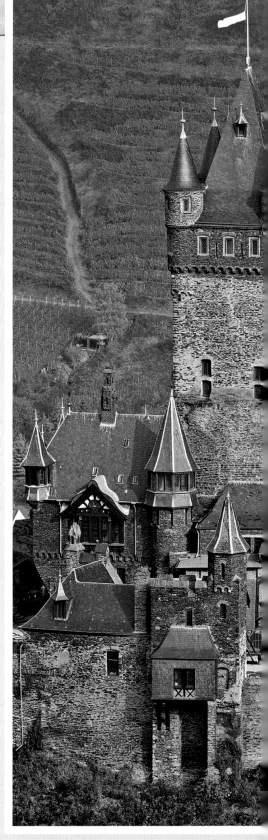

Left:
Founded in 1205, the Hardenburg once belonged to the counts of Leiningen. At 180 x 90 metres/ 590 x 295 feet it's the biggest castle ruin in the Palatinate.

Above:
Badly damaged during the Nine Years' War of 1688–1697, in a fervour of 19th-century Romanticism the late Gothic imperial castle of Cochem was partly restored and partly rebuilt in the neo-Gothic vein.

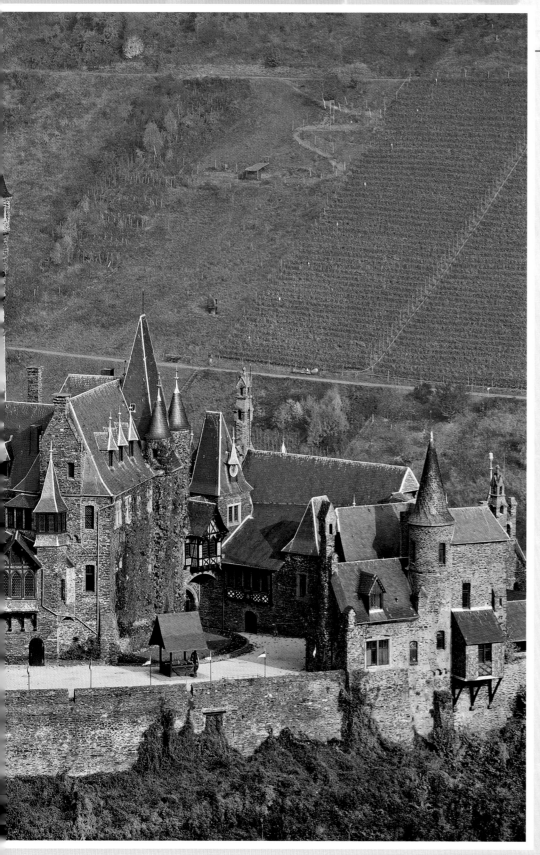

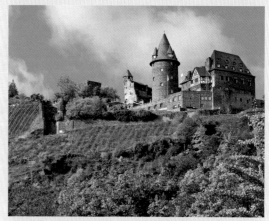

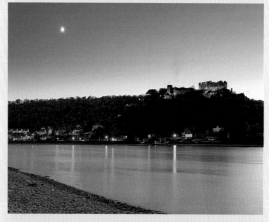

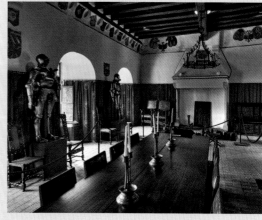

Photos, right, from top to bottom: Like none other the castle of Trifels near Annweiler is symbolic of the Staufer empire at the height of its power. Emperor Barbarossa even declared it his favourite castle.

Stahleck by name, steely by nature: the castle up above Bacharach was conceived as an impenetrable fortress and named as such, with "Stahl" for steel and "Eck" a reference to the rocky outcrop it was built on.

The ruins of Burg Rheinfels in St Goar once constituted the greatest fortress on the Rhine. Count Dieter V of Katzenelnbogen founded the massive edifice in 1245 to ensure that the tolls due him were readily handed over on the River Rhine below.

The great hall in Burg Eltz near Münstermaifeld was a place of celebration and assembly. The heavy oak beam ceiling, family coat of arms and historic armour help visitors to imagine what such occasions must have been like.

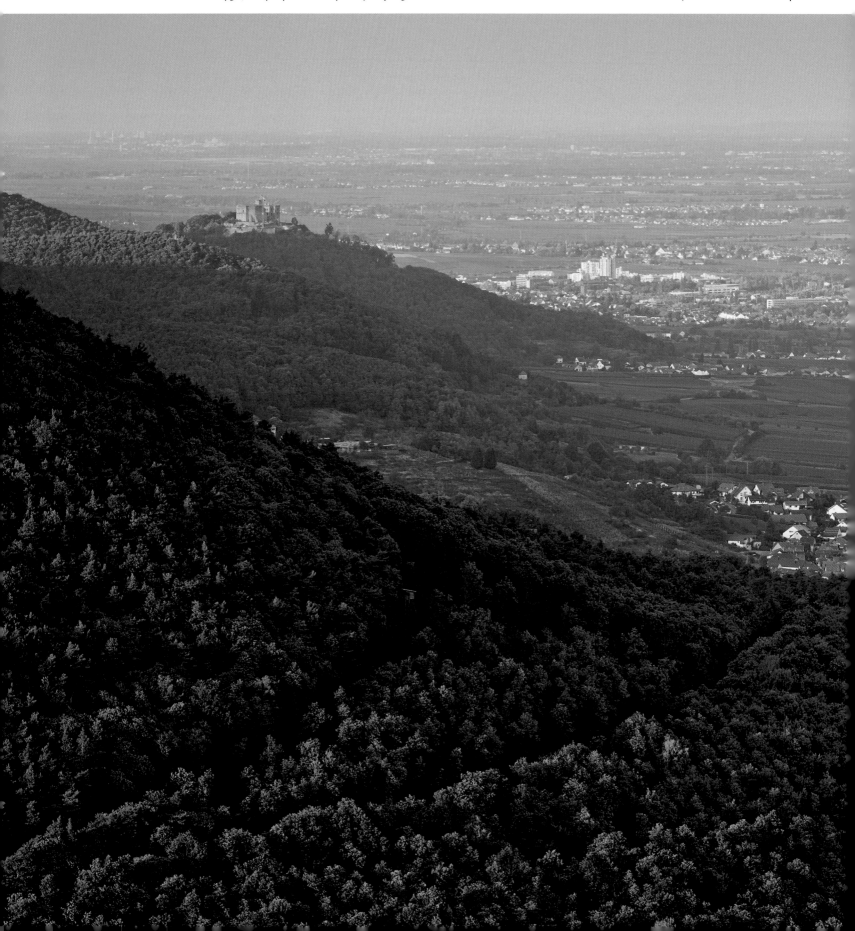

Below:
View from the Rietburg of the Hambacher Schloss. A peaceful battle cry of "Up to the castle!" once resounded here from the throats of 30,000 people who 'stormed' the latter in their striving for democratic rights and German unity. Germany's first tricolour flag in black, red and gold was raised on the castle keep on 27 May 1832.

Page 40/41:
The castles of the Altdahn group are surely among the best in the Wasgau or southern Pfälzerwald. All three were built to protect the local populace, with people seeking shelter in times of danger in the hidden caves and inaccessible caverns chiselled here out of the red rock.

Top right:
The Teufelstisch or devil's table in Hinterweidenthal in the southern Pfälzerwald is a distinctive rock 14 metres (46 feet) high. Legend has it that it was built by the Devil as an impromptu picnic table in the middle of the forest.

Centre right:
The historic Bundenthal train puffs lazily through the charming scenery of the Dahner Felsenland. The museum railway is busy in summer, providing hikers and daytrippers with a notable form of transport.

Bottom right:
One of the more bizarre weathered rocks in the Pfälzerwald is the Rappenfels near Hinterweidenthal. In this part of the forest you can often see jagged spurs of rock jutting out from the trees, around fifty of which are classed as natural monuments.

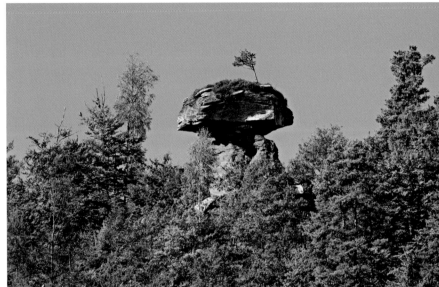

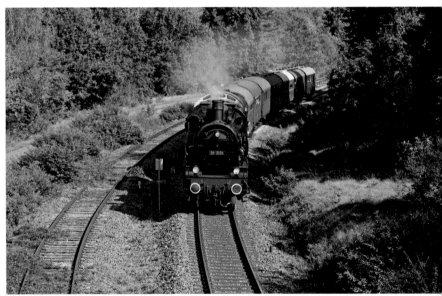

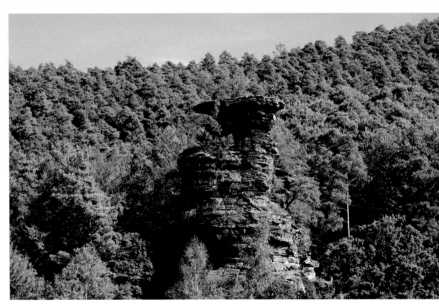

39

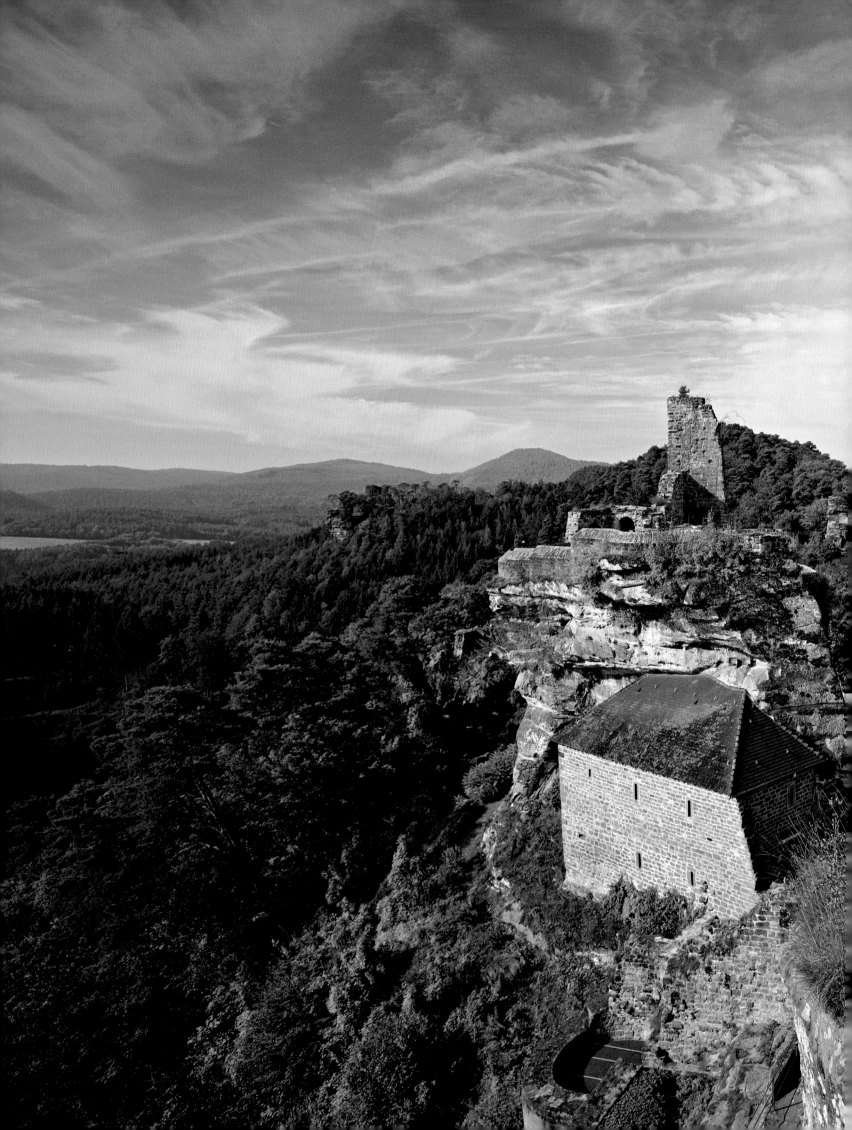

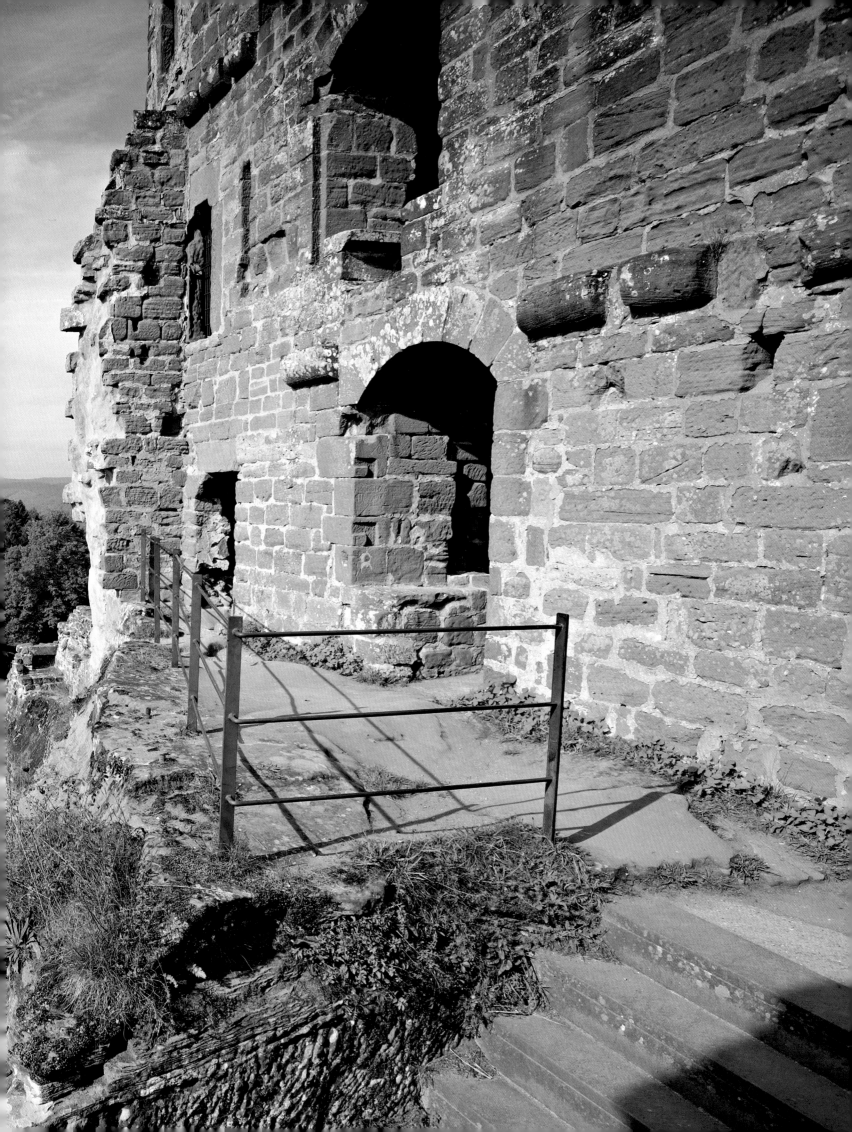

Above:
The Deutsches Weintor in Schweigen-Rechtenbach is the gateway to the Deutsche Weinstraße that weaves its way through ancient wine country. Like many double-barrelled German towns, the parish was formed in 1969 from the two independent communities of Schweigen and Rechtenbach.

Right:
The classy hotel of Deidesheimer Hof can be found presiding over the market place in Deidesheim an der Weinstraße. The fountain outside it dates back to 1851 and was erected in honour of Mayor Andreas Jordan by his family.

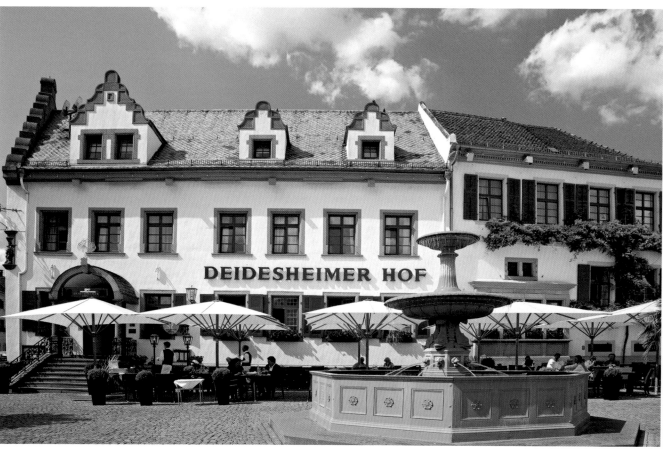

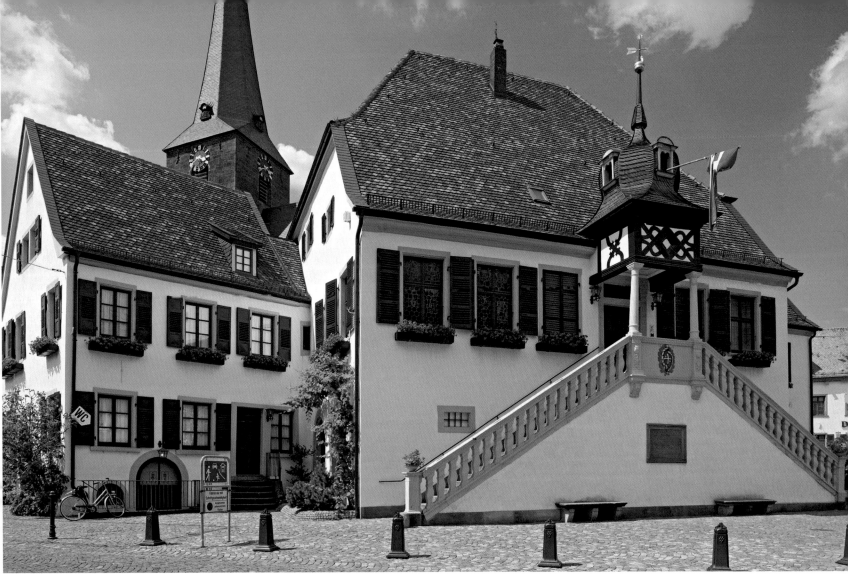

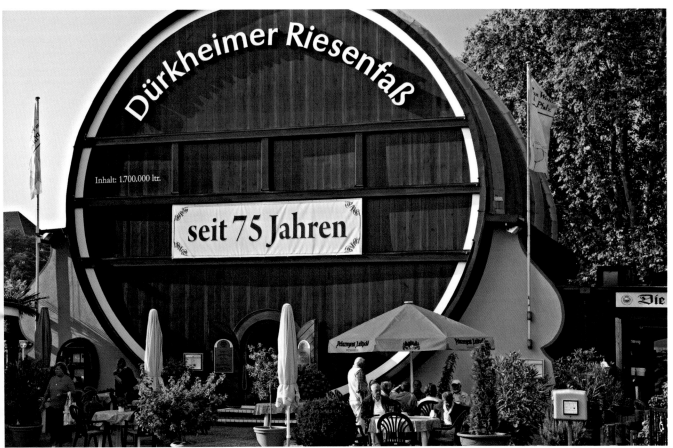

Above:
The baroque town hall in Deidesheim with its grand outdoor staircase now houses a museum of viniculture. Outside is where each spring a traditional billy goat auction is held as part of the Whitsuntide festivities.

Left:
The largest wooden wine barrel in the world can be found in Bad Dürkheim on the Deutsche Weinstraße. The vast container was never filled with wine, however, and is instead used as a very original tavern that can seat up to 600 guests on two storeys.

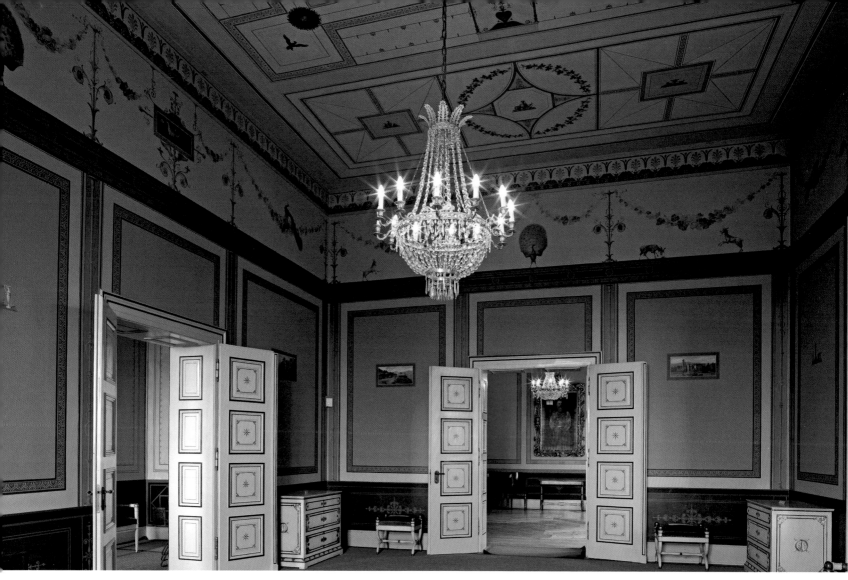

Above:
Up above the villages of Edenkoben and Rhodt an der Weinstraße and below the ruined Rietburg is the romantic palace of Ludwigshöhe. It was erected by King Ludwig I of Bavaria as a summer residence in the style of an Italian villa.

Right:
Villa Ludwigshöhe now belongs to the federal state of Rhineland-Palatinate. It provides space for the Max Slevogt gallery and a collection of ceramics. The king's ornate dining room is now use by the Villa Musica for top-notch concerts of classical music.

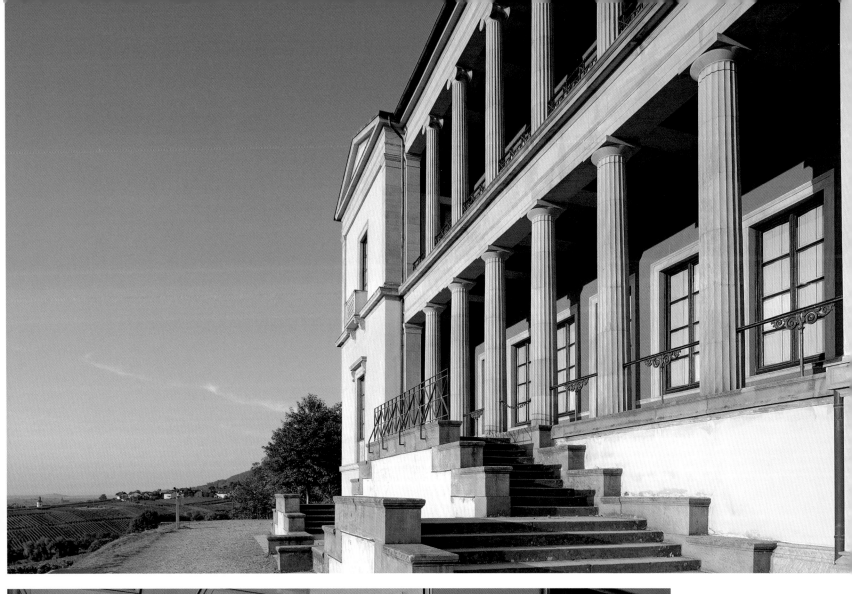

On the exterior Villa
Ludwigshöhe is represen-
tative of the neoclassical
fads of the day with its
strict, simple structures.
The main building has four
wings that surround a
shady courtyard. A garden
was found by King Ludwig
to be superfluous, as
"all the land around, as
far as the eye can see,
is a vast garden".

Left:
On the top floor of Villa
Ludwigshöhe you can
admire the early works
of Max Slevogt. Besides
many portraits there are
also landscapes and still-
life pictures from the
artist's legacy, plus sever-
al paintings by the German
Impressionists Max Lieber-
mann and Lovis Corinth.

At the foot of the Haardtberge, surrounded by vines, lies the historic wine village of St Martin. A climatic health resort, it's the only wine-growing location in Germany to be named after the patron saint of vintners. Each year the statue of the saint is passed on to a different winery, drawn by lot, where he is given pride of place on the estate.

Right page:
The entire centre of St Martin is a protected monument. Decorated archways, manors and half-timbered dwellings bearing religious statues line the pretty streets.

46

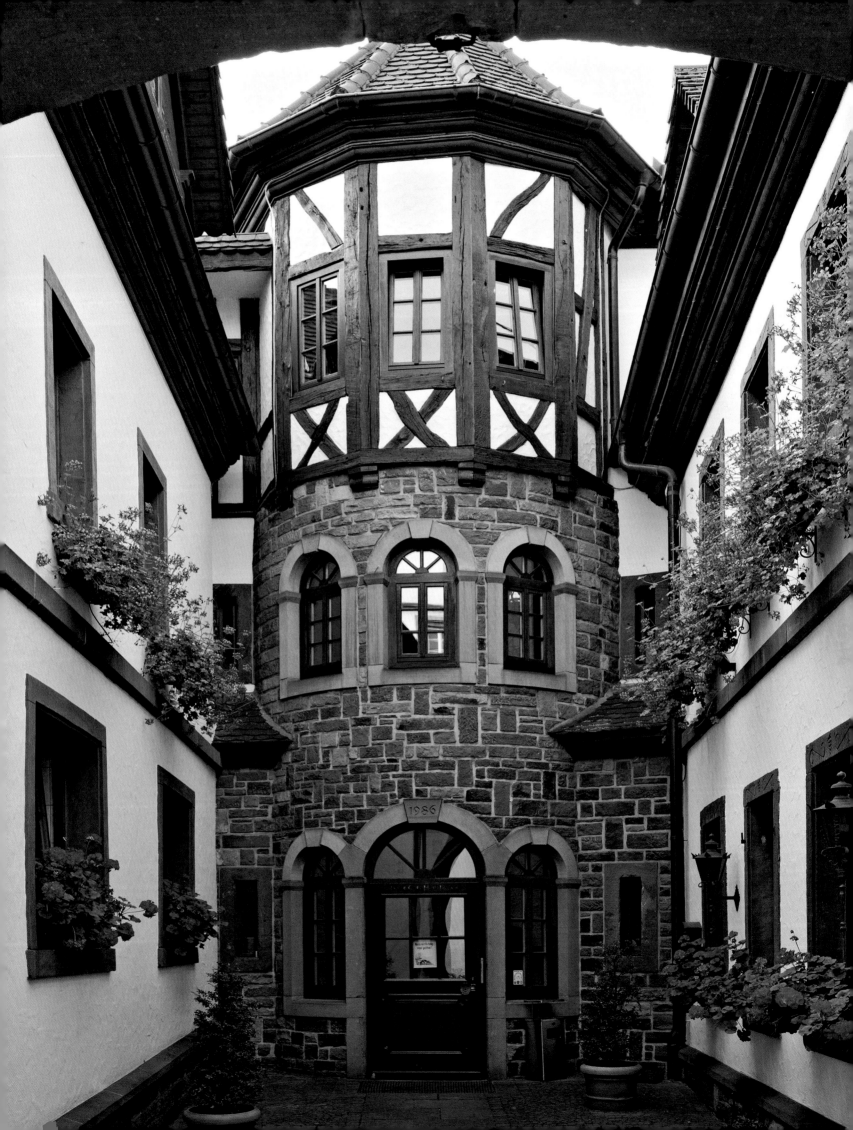

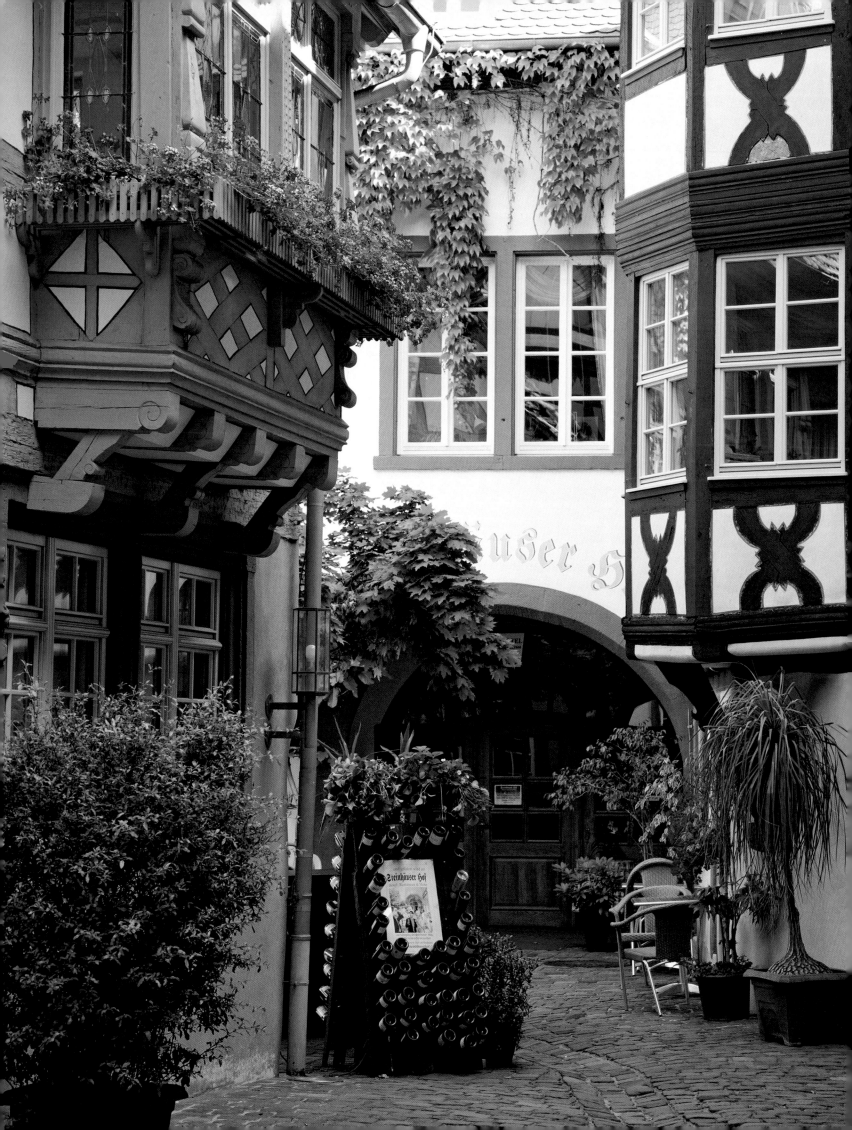

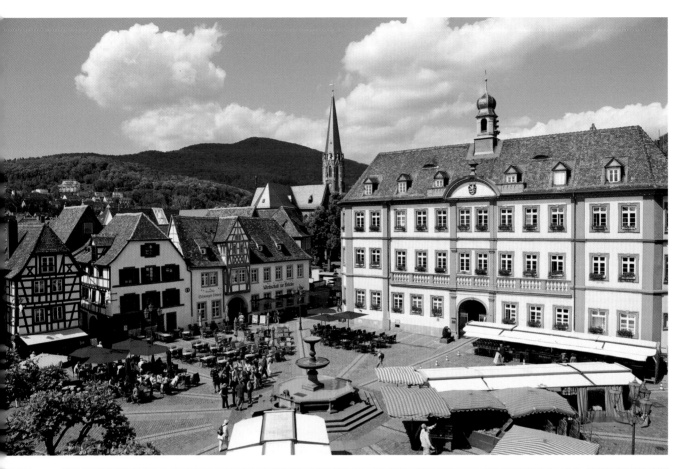

Left page:
Max Slevogt, a native of the Palatinate, once said, "Once you've fallen for the Palatinate, you're a Palatine of the highest order". True to his sentiment Neustadt and the Deutsche Weinstraße have made a Palatine of many a holidaymaker, happy to return to their favourite haunt year after year.

What was once a Jesuit college from 1729 is now the town hall of Neustadt an der Weinstraße. Like the rest of the town the square in front of it is a feast for the eyes, with its expertly restored half-timbered houses and many Renaissance edifices.

Each year in September the sleepy town of Neustadt becomes the setting for the crowning of the German wine queen, the highlight of the wine harvest festival. Candidates must be from a vintner's family and unmarried.

49

SAUMAGEN AND *GRUMBEERE* – REGIONAL SPECIALITIES

Rhineland-Palatinate's culinary cliché has the charming name of *Saumagen*: sow's stomach. You don't have to nominate it your favourite food like former German chancellor Helmut Kohl did but wouldn't it be interesting to know just what exactly landlord Artur Hahn once served such prominent guests as Mikhail Gorbachov, King Juan Carlos or François Mitterand in the heraldic chamber of the Deidesheimer Hof?! *Saumagen* is a traditional dish eaten by poor country folk which used up the scraps left over after the slaughtered pig had been dismembered. The cleaned stomach lining is filled with a mixture of meat, sausage meat and diced potatoes. To this egg, carrots and various herbs and spices are usually added. It's served in slices with sauerkraut or gherkins, mashed potato or bread and all washed down with an obligatory glass or two of Riesling.

Other dishes typical of Rhineland-Palatinate also originated in simple country kitchens that had to make do with what could be grown in the clay, slate soil: turnips, cabbage, beans, carrots, leeks and especially potatoes. *Grumbeere*, to give them their local name, are popular all over the federal state; the Palatinate loves its *Hoorische Knepp* (Palatine potato dumplings), the Rhineland its *Doeppekooche* (potato fritters), the Hunsrück its *gefilde Klees*, dumplings made from cooked and raw potatoes and filled with meat. *Gebreedelde*, Palatine fried potatoes, are also legendary, and often dished up with bits of bacon or liver sausage.

Traditional Palatine cooking may be hearty – coarsely ground sausages, liver dumplings and meatballs don't exactly smack of nouvelle cuisine – but especially in the south of the region the proximity to France is clearly palpable. *Woihinkelscher*, chicken cooked in wine, for example, conjures up images of France's *coq au vin*. The mild climate encourages figs to thrive; exotic fruits such as kiwis and nashi pears are often used in gourmet restaurants. You can also eat vineyard snails here and delicious sweet chestnuts or *Keschde* which found their way to the Palatinate with the Romans and their vines.

Wine is of course an indispensible ingredient, hardly surprising in a federal state that contains six of Germany's thirteen wine-growing areas. Snacks designed to heighten the enjoyment of the local vintage are also typical of the Rhineland, with *Zwiebelkuchen* (onion flan), bread pretzels and *Spundekäs* (cream cheese with paprika) helping to make the next *Römer* of wine taste even better ... There is even a rhyming verse by Mainz Fassenacht poet Adolf Gottron heralding the merits of the latter, which he claims is particularly tasty after the eighth glass: "Ein jeder wääß, zum achte Gläsje / Gehört dem Mensch e Spundekäsje."

Paradise for gourmets

Without a doubt, Rhineland-Palatinate is sheer paradise for gourmets. Silvaner from Rhine-Hesse, Riesling from the Middle Rhine or the Moselle, Pinot gris from the Nahe Valley, Müller-Thurgau from the Palatinate and Pinot noir from the Ahr: here, there's something for everyone.

Wine connoisseurs from Germany and abroad are often just as enthusiastic about the elegant, invigorating produce of the comparatively small wine-growing area of the Middle Rhine as Heinrich Heine once was; he claimed "Der Rheinwein stimmt mich immer weich" or "Rhine wine gives me a soft heart". Blessed with plenty of sun on the steep, warm slopes of the Rhine, 70% of the vines cultivated here are Riesling, with Müller-Thurgau, Kerner, Pinot gris, Pinot blanc, Pinot noir, Dornfelder and Portugieser also popular.

In Germany's oldest wine territory on the Moselle and Saar archaeological finds have proved that vines were planted by the Romans here as long ago as in the 1st century AD. Today 5,000 wine estates in 125 wine villages tend about 60 million vines to produce fine, fruity Riesling from the world-famous steep slate vineyards or Elbling and Auxerrois from the Muschelkalk of the Upper Moselle. Wine from the Moselle even helped to prevent an imperial crisis in the Middle Ages; when Konrad III had himself suddenly crowned king in Koblenz, the first Staufer to do so, his princely critics were successfully placated with wagonloads of Moselle wine.

Left:
Mild temperatures and plenty of sunshine provide outstanding climatic conditions for excellent Nahe wines. Regional food and drink can best be enjoyed at a local winery.

Above:
Wafer-thin pizza with bacon, onions, cheese and cream (Flammkuchen) and Riesling taste fantastic in this setting high up above Oberwesel: the Günderodehaus from the TV series "Heimat".

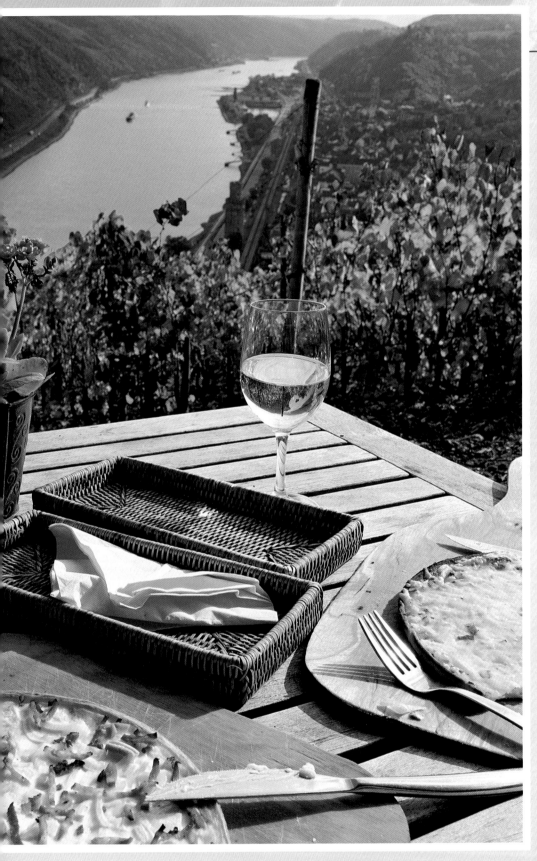

Top right:
If you fancy making Saumagen yourself, you need plenty of patience, as this Palatine delicacy has to stew in salted water for a good three hours. It weighs several kilos and feeds eight to ten people.

Centre right:
Saumagen is best accompanied by a hearty Riesling or dry Silvaner.

Right:
The vintners at the Bergdolt estate in Dutt-weiler have been tending their vines for many generations. They pay particular attention to the quality of their vintages.

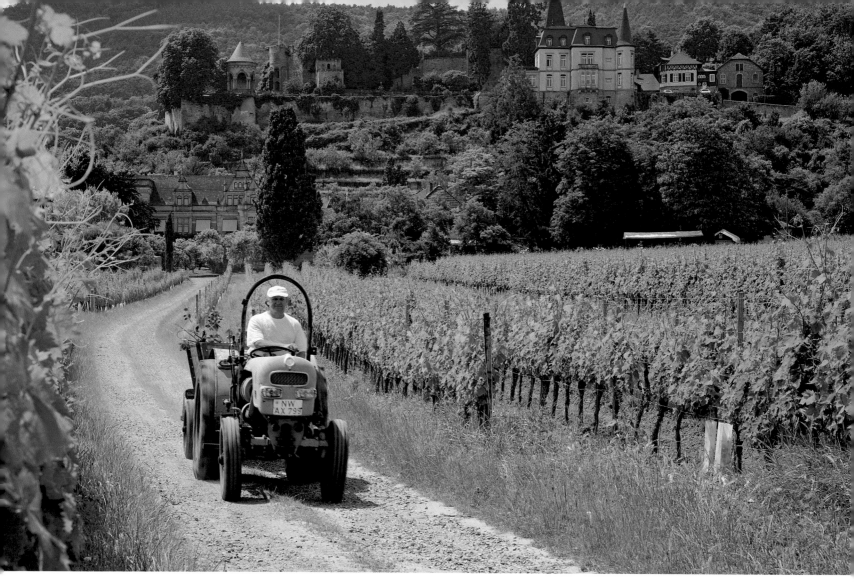

Above:
The Müller-Catoir winery up above Neustadt has been in the family since 1744. Autumn marks the start of the grape harvest in all eight of their vineyards. Haardter Bürgergarten, shown here, is an outstanding location with unusually deep, heavy soil that produces vigorous wines.

Right:
The fine vintages produced in Neustadt-Haardt have made it famous far beyond the boundaries of the Palatinate. You can find out more about the local produce on an autumn break at one of the region's wine estates, even helping out with the grape harvest!

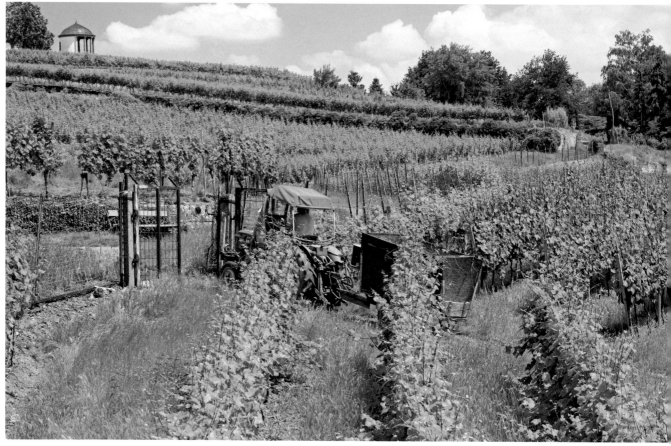

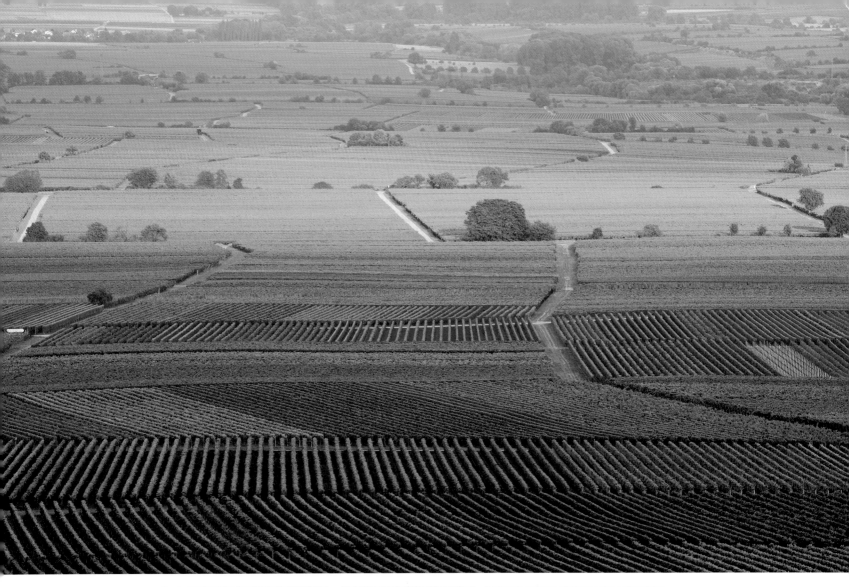

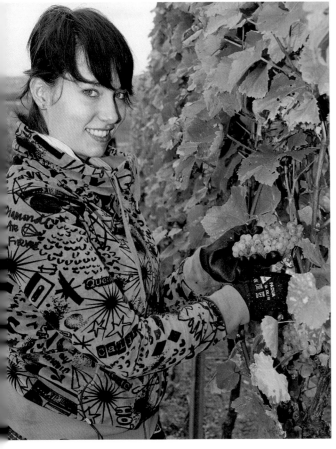

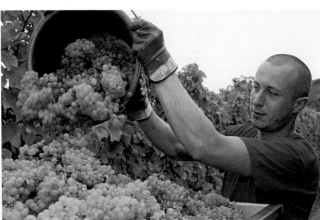

Above:
It's thought that wine has been cultivated near the romantic little town of Rhodt on the Südliche Weinstraße since the time of the Romans. In the Middle Ages the village was famous for its Traminer – and still is.

Left:
The harvest is the best and hardest period in the wine year – and also the most exciting. Traditionally, grapes are picked by hand. The ripe fruit is cut from the vines using sharp vineyard secateurs, collected in buckets or vats and immediately taken by tractor to the press. At the end of the day the pickers can look forward to a well-earned picnic in the vineyard.

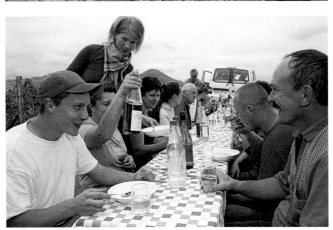

53

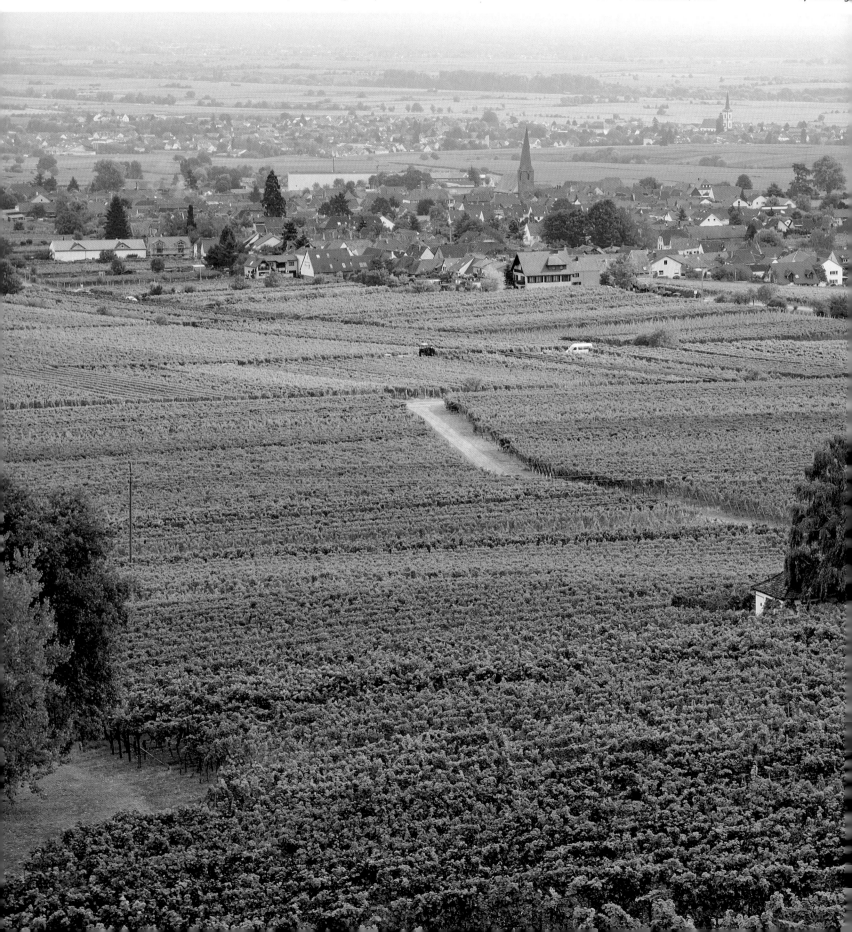

Below:
No less than 80% of the buildings in Rhodt are protected by a preservation order. The villagers have done much more than just maintain the ancient fabric of their houses, however, frequently winning the local Most Beautiful Village competition.

Top right:
The little village of Ungstein, first mentioned in 714, is surrounded by vineyards. During the Ungsteiner Weinsommer, local vintners invite visitors to partake in a presentation of their wines (with music) at the Roman villa rustica of Weilberg

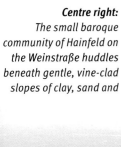

Centre right:
The small baroque community of Hainfeld on the Weinstraße huddles beneath gentle, vine-clad slopes of clay, sand and limestone. Very early on in its history the village began using its Pinot blanc, Scheurebe and Muscatel grapes to make sparkling wine.

Bottom right:
The pretty wine village of Burrweiler lies at the foot of the Annaberg with its pilgrimage chapel dedicated to St Anne. Its cellars contain wines of international renown that are greatly appreciated by connoisseurs far and wide.

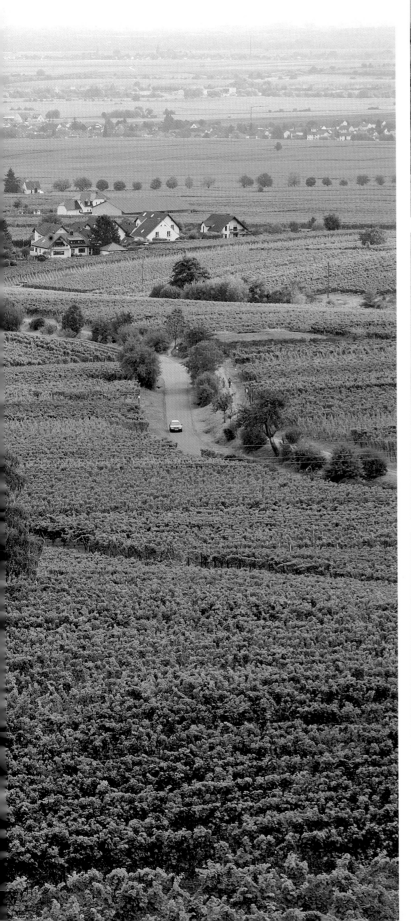

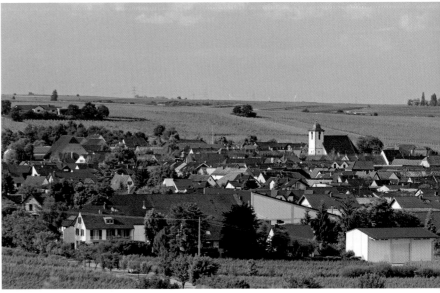

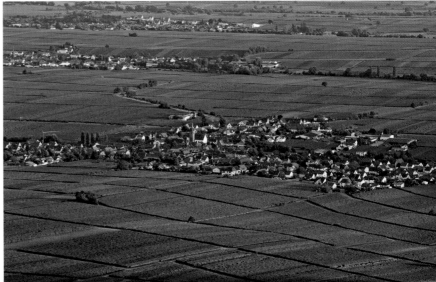

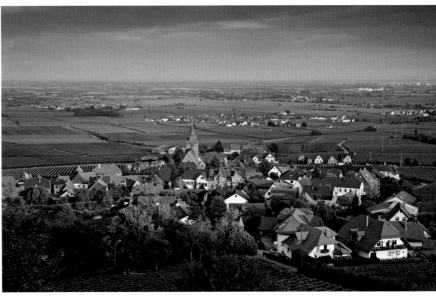

Rhine-Hesse, Nahe and Hunsrück

For over a thousand years this mighty cathedral has dominated the silhouette of Mainz. It falls under the patronage of St Martin of Tours, with the east choir dedicated to St Stephen. The church is thus officially called the Cathedral of St Martin and St Stephen but locally known as the Martinsdom or St Martin's Cathedral.

Rheinhessen or Rhine-Hesse, once part of the grand duchy of Hesse, covers around 1,400 square kilometres/540 square miles between the federal capital of Mainz and the towns of Alzey, Bingen and Worms. The region on the bend in the Rhine, the settlement of which dates back to the Neolithic Age, became border territory under the Romans, with Mainz the provincial capital of Germania Superior and soldiers from all corners of the Roman Empire flocking to the Rhine. As a place of passage the densely populated area has been subject to influence from many different parts, yet the cosmopolitan people of Rhine-Hesse have clung to their identity and now, in return, export their top-quality wines to all corners of the globe.

The River Nahe, which borders on Rhine-Hesse to the west, meanders 112 kilometres/69 miles through dark forest, rocky massifs and open water meadows towards the Rhine. On the Upper Nahe near Idar-Oberstein semi-precious stones were mined up until the end of the 19th century and today visitors can go down Europe's only accessible pit of this type and dig for treasure themselves. On the Glan, which runs into the Nahe at the foot of the Disibodenberg, is the pretty little town of Meisenheim. The Nahe passes Bad Münster am Stein before reaching Bad Kreuznach and later Bingen, where it finally joins the Rhine.

The elongated Hunsrück Mountains form a square between the Nahe in the south, the Saar in the west, the Moselle in the north and the Rhine in the east. Since the *Heimat* television serial made the region famous from Japan to America, more and more holidaymakers and daytrippers are coming to visit the place where infamous robber Schinderhannes once did his evil deeds. You can also spend many rejuvenating hours wandering along the award-winning Saar-Hunsrück-Steig through high-lying forest, boggy moorland, juniper heathland and riverine valleys.

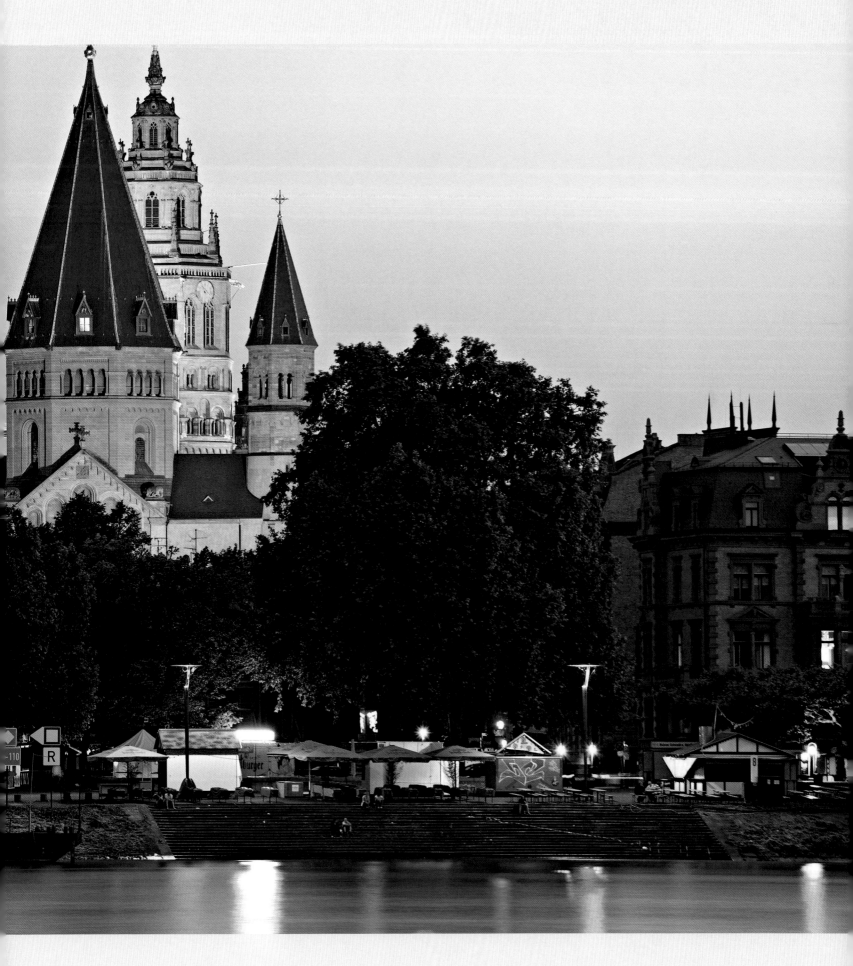

Right:
For centuries the splendid residences of well-heeled Mainz citizens lined the north side of the market place. Completely destroyed in the Second World War, these market houses were at first reconstructed without their historic façades. At the insistence of the locals, these were later added in homage to their original models.

Below:
The streets of Old Mainz were once perused by one Johannes Gensfleisch, otherwise known as Gutenberg (c. 1400–1468). The city's most famous personality, it was he who promoted the printing of books, paving the way for the Reformation. There is a museum dedicated to his work close to the cathedral.

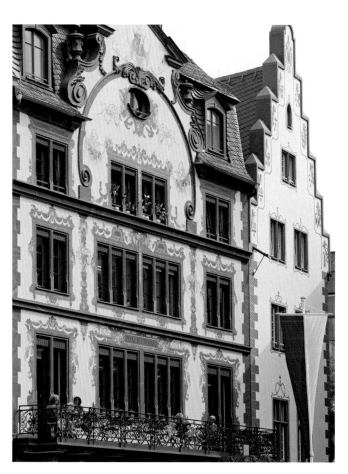

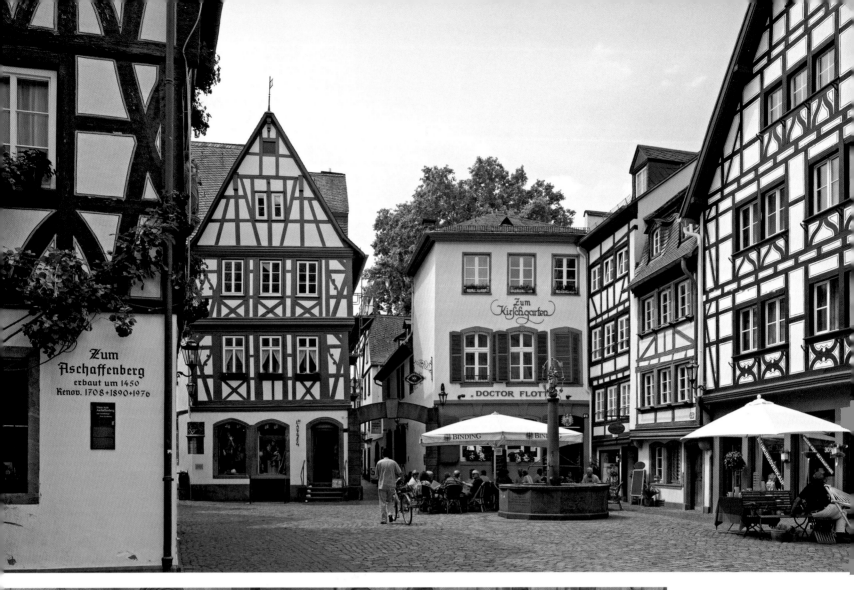

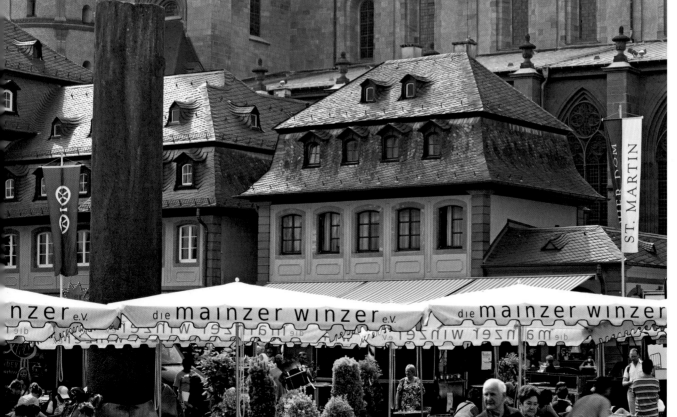

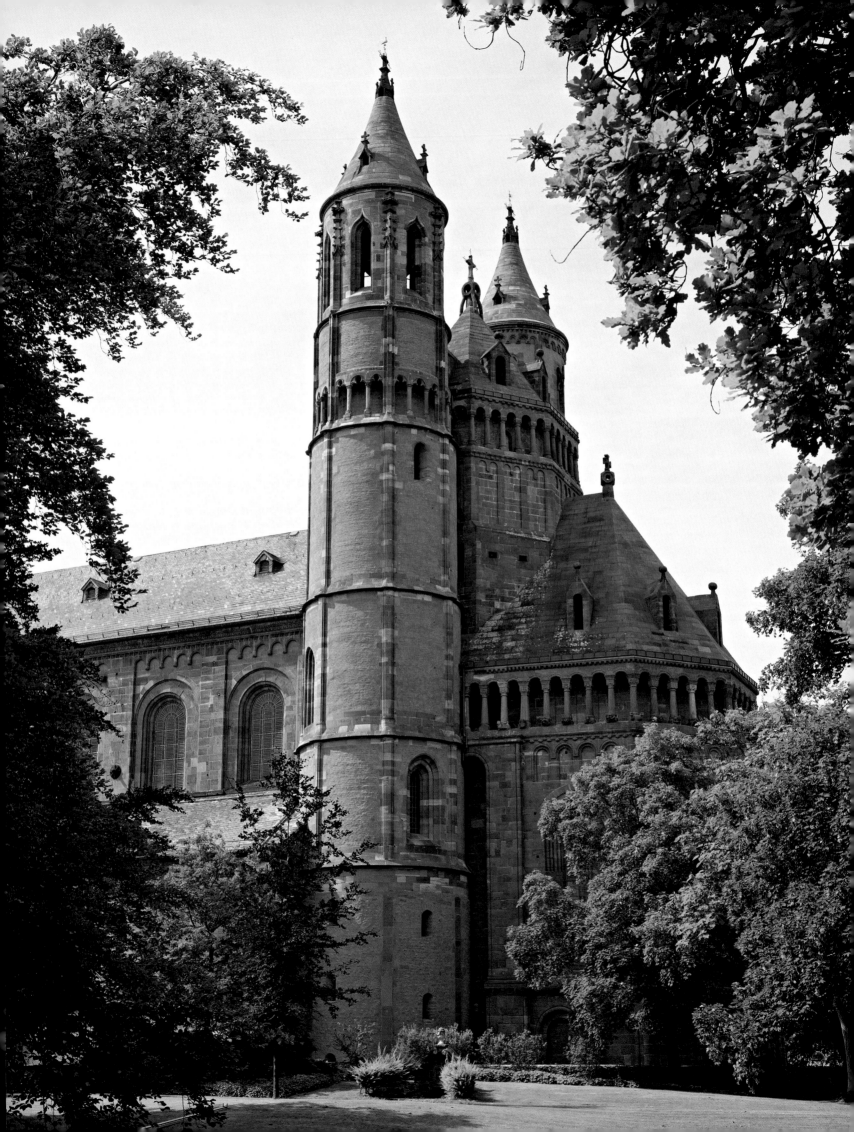

Left page:
The impressive imperial cathedral in Worms was originally built with four towers and two domes. Now the Catholic parish church, it was made a basilica minor by the pope in 1925.

Far left:
You come across the Saga of the Nibelungs every which way you turn in Worms. Here we see Hagen of Tronje who sunk the precious Rhinegold treasure in the Rhine.

Left:
East of Worms the Nibelungenbrücke joins the two banks of the Rhine. The Nibelungenturm, built between 1897 and 1900, was originally a tower house. It's now an extremely elaborate scout hut.

Left:
The fountain on Schloss-platz in Worms is a copy of the Renaissance Rathaus-brunnen in Nuremberg. The baroque church of the Holy Trinity in the background was erected between 1709 and 1725.

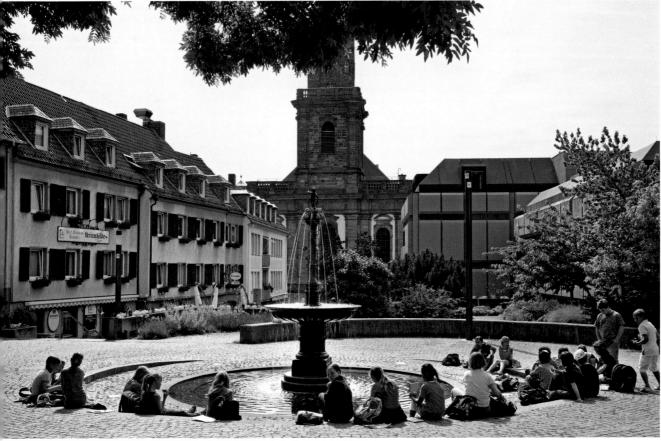

Monuments for all time – the imperial cathedrals

They pierce the skies like monuments for all time: the three imperial Rhenish cathedrals in Mainz, Speyer and Worms, all of them architectural masterpieces, still dominate the silhouettes of their respective cities centuries after they were built. They were erected along the shores of the mightiest river in Europe at the points where major trade routes and international roads intersected.

Six kings were crowned at Mainz Cathedral which also hosted the biggest festival of the Middle Ages when at Whitsun in 1184 Emperor Barbarossa celebrated his sons' knighthood amid much pomp and ceremony. The dioceses has now announced a new grand celebration for 2036, 1,000 years after the first basilica was permanently finished. Yet these seemingly indestructible edifices all too often fell victim to fire, war and abuse, often used as barracks, stables and barns. The story of the cathedral in Mainz also begins with a disaster in 1009; constructed on marshy ground, the vast structure burned to the ground shortly before or after its consecration. Willigis, the archbishop of Mainz and also archchancellor of the German Empire who laid the foundations in 975, immediately initiated its reconstruction. The cathedral was ready for use again in 1036.

Destruction also always represented opportunity which was seized to extend and refurbish these houses of God in the fashion of the day. During the baroque period, after being struck by lightning the west crossing tower was given a new polygonal stone spire several storeys high, designed by Franz Ignaz Michael Neumann, one of Balthasar Neumann's sons. It still lends Mainz Cathedral its characteristic appearance. The east choir with its massive walls over two metres/six feet thick is the oldest part of the church, with the late Romanesque west choir built between 1200 and 1239. The nave was remodelled on that of Speyer Cathedral which had then been finished. In the 13th century side chapels with enormous tracery windows were added and the 15th century saw the laying out of a cloisters and the installation of Gothic belfries in the towers.

In 1803 it was decided to pull down the former place of worship which had been badly damaged by the siege of 1793, secularised and finally demoted to a magazine store for weapons. The cathedral in Speyer was also due for demolition. It is only thanks to the courageous intervention of Mainz bishop Colmar that two of the most significant sacred buildings north of the Alps are still standing today. The imperial cathedral in Speyer, downriver from Worms, was made a UNESCO World Heritage Site in 1981. It is dedicated to saints Stephan and Mary, the patron saint of Speyer or Patrona Spirensis. Its sheer size (134 metres /440 feet long, 38 metres/125 feet wide in the nave and 33 metres/108 feet high in the central nave) makes it the largest surviving Romanesque church in Europe now that Cluny has long been destroyed. The monumental nave was planned as a kind of mausoleum, with all of the Salian emperors and also Staufer and Habsburg rulers buried here.

Key scene

The highest hill in the middle of Worms is crowned by the cathedral of St Peter's, built between 1130 and 1181. With its thick walls and round arches it echoes its nearby cousins in Mainz and Speyer yet is slightly smaller at just ca. 110 metres/360 feet in length. The extremely simple west choir is heralded as the most mature architectural achievement of the late Romanesque period in the Rhine Valley. Worms and its cathedral were the scene of several dramatic historic events: Leo IX was made pope here in 1048, in 1122 the Concordat of Worms ended the Investiture Controversy over sacred and secular power, at Christmas in 1146 this is where Bernard of Clairvaux called for men to join the Second Crusade and in 1521, following the Diet of Worms, Emperor Charles V passed the Edict of Worms that banned the reading and dissemination of the writings of Martin Luther. A key scene from the Nibelungs saga also takes place outside the main entrance to the basilica; it was here that queens Kriemhild and Brünnhilde are said to have argued as to who should be first to enter the church ...

Left:
If you believe the Nibelungs saga, at the north entrance to Worms Cathedral Kriemhild and Brünnhilde once argued as to who should be first to enter the church.

Above:
Despite being destroyed several times over and many periods of rebuilding, the cathedral in Mainz has lost none of its magnetism.

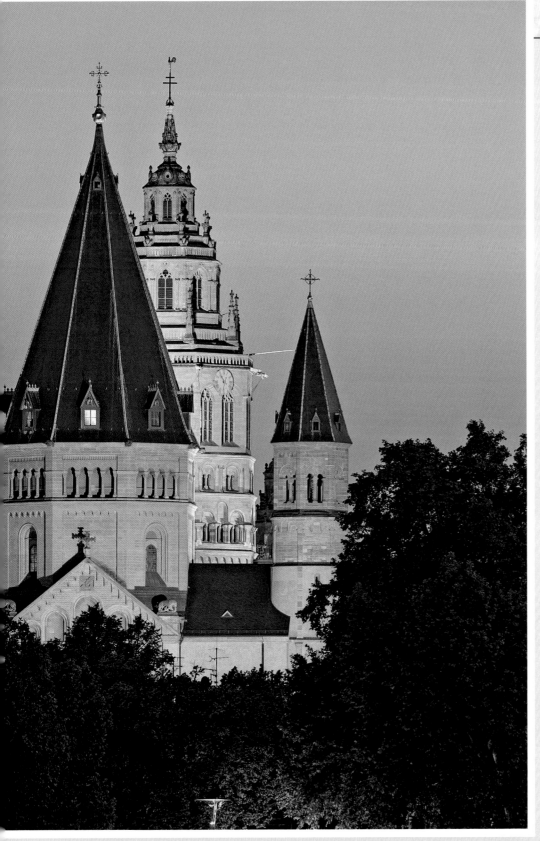

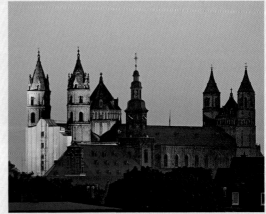

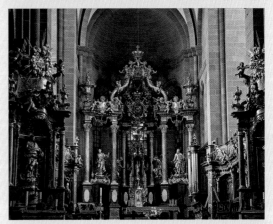

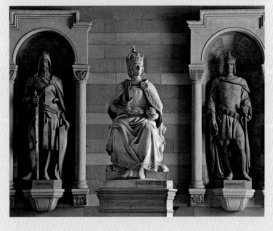

Pictures, right, from top to bottom: "I walk around and observe the cathedral with complete joy", wrote Jewish religious philosopher Martin Buber in 1933, completely enthralled by the harmonious structure of Worms Cathedral.

The impressive high altar in the east choir of Worms Cathedral was created by Balthasar Neumann after the original had been destroyed by the plundering troops of Louis XIV of France in 1689.

The inside of Mainz Cathedral is an absolute treasure trove for art historians. Its best pieces include the Willigis Portal, the tombstones of the archbishops, the late Gothic cloisters and the baroque choir stalls.

King Rudolf of Habsburg can be found in Speyer Cathedral no less than twice: both as a statue in the porch and as an allegedly very lifelike relief on his tomb in the crypt, in which he was interred in 1291.

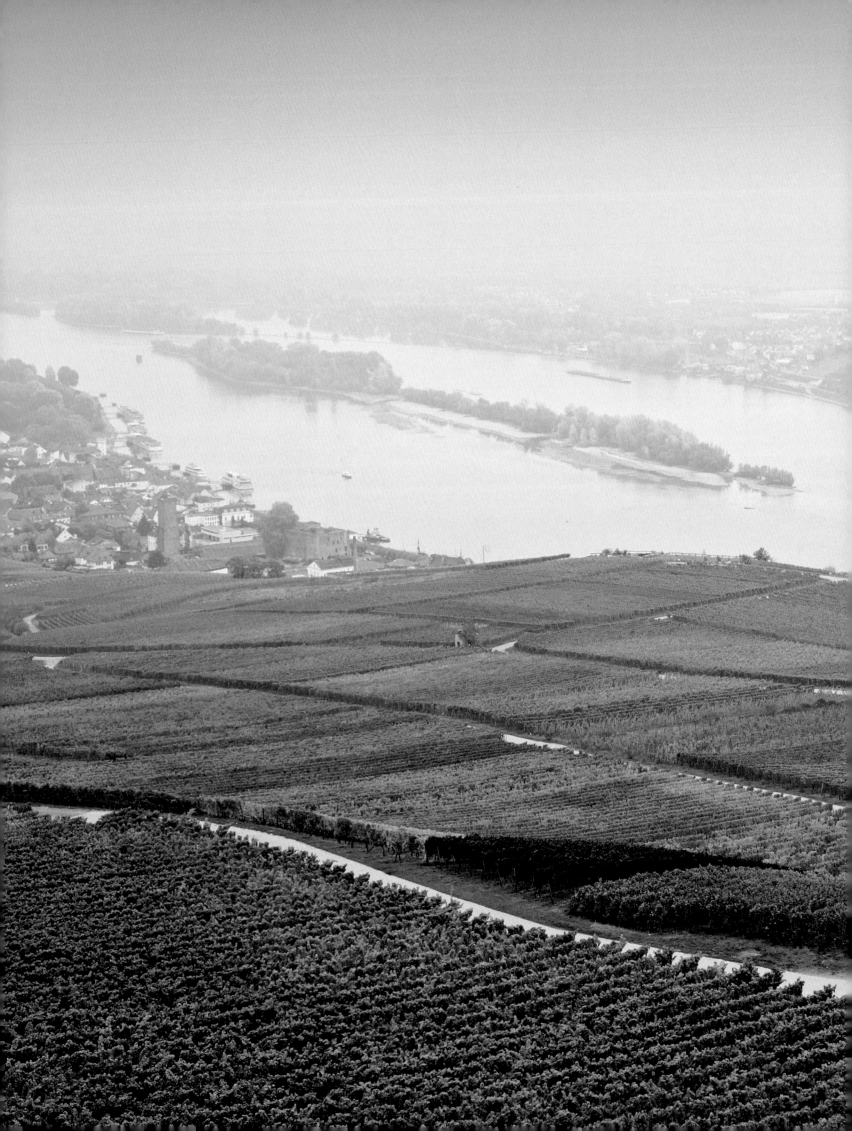

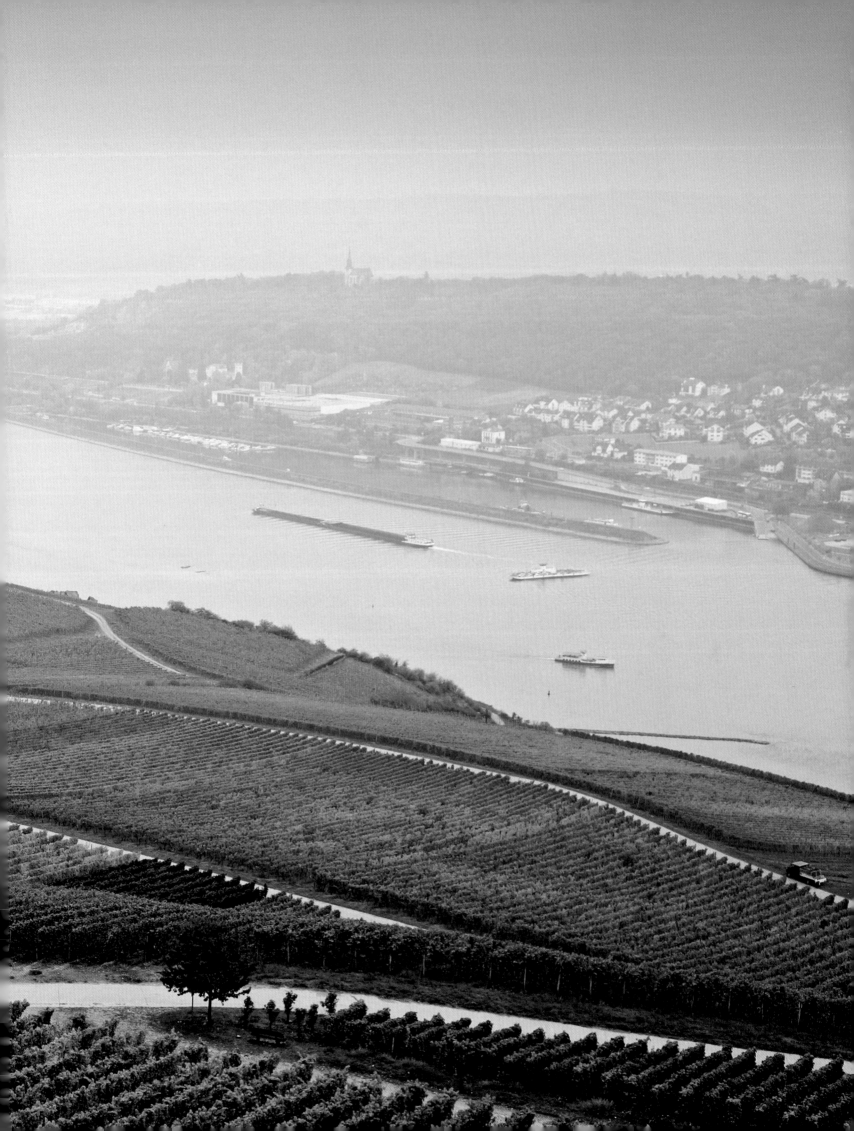

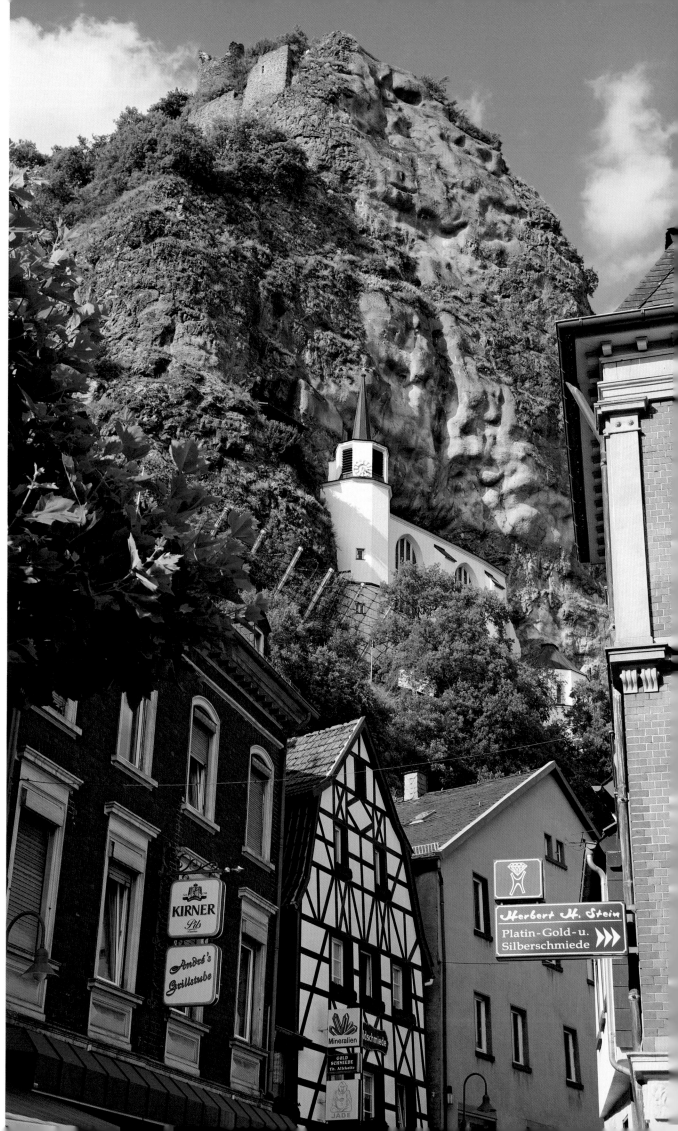

Page 64/65:
From the Niederwald Monument there are expansive views of Bingen and Rüdesheim which form the south gateway to the Upper Rhine Valley, made a UNESCO World Heritage Site in 2002. The next 60 km/40 miles of river are embellished by an extraordinary wealth of cultural monuments.

The ruins of Bosselstein high up above Idar-Oberstein once housed the nobles of Oberstein who as de Lapide, de Petra or von Steyn can be traced back over 600 years. It's one of the oldest castles in the Nahegau. The first fortified dwelling the nobles of Stein built was the lower Burg im Loch, a cave castle that was turned into a church in the 15th century.

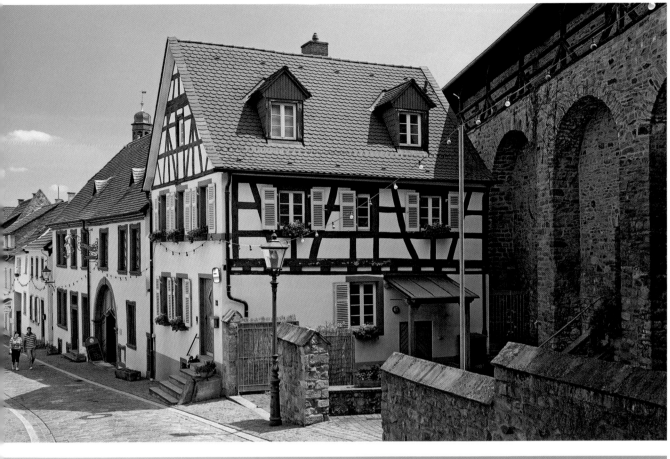

In the Middle Ages Kirchheimbolanden in the north of the Palatinate was protected by a town wall, ditch, towers and gates. For centuries the town within prospered. Just half of the wall walk with its wide stone arches survives, now fully restored and open to the public.

It's well worth making the climb up from the market square in Oberstein to the church set into the rock face and the ruins above. From the castle there are marvellous views of Idar-Oberstein, famous for its semi-precious stones, the Nahe Valley and to the southwest the hills of the Hunsrück.

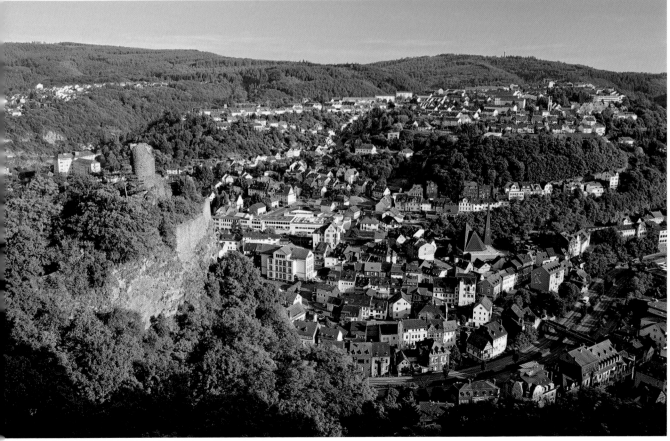

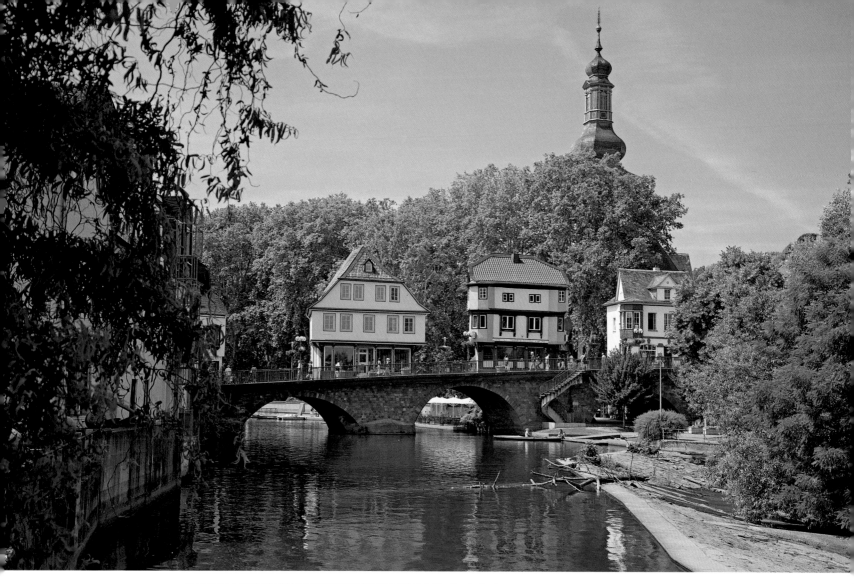

Above:
Bad Kreuznach's undisputed local landmark are its bridge houses, built in the 15th century over the River Nahe. Erected to provide more accommodation for the town, for five centuries their location proved extremely lucrative, with the buildings primarily used for trade.

Right:
The Römerhalle museum in Bad Kreuznach has Roman artefacts from the town and surrounding area on display. Its biggest features are the two mosaic floors from a Roman villa, with a gladiator depicted on one and an ocean scene on the other.

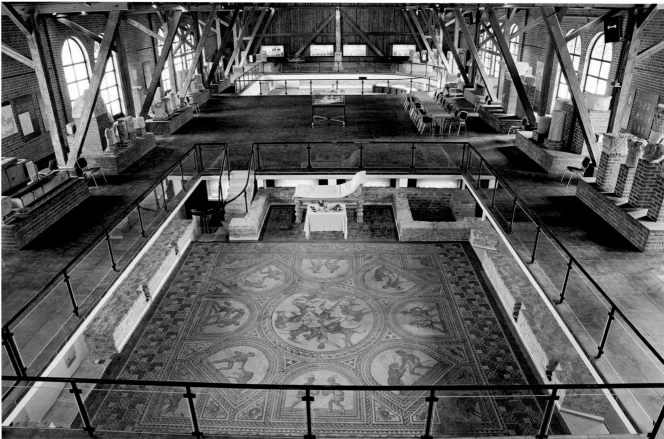

Page 70/71:
Bad Münster am Stein-Ebernburg was made a climatic health resort in 1988. In the rain shadow of the Soonwald and Hunsrück hills, the town is sited in one of the warmest areas in Germany with the least rainfall. The Rotenfels Massif behind it provides further protection.

Left:
The Schloss in Alzey was probably built as an imperial castle at the beginning of the 12th century. Destroyed during the 17th, the palace was restored to its former glory when it was rebuilt at the beginning of the 1900s.

Below:
Fischmarkt in Alzey is the site of the town hall and the 'secret capital' of Rhine-Hesse. The three-storey Renaissance building sports a distinctive stairwell.

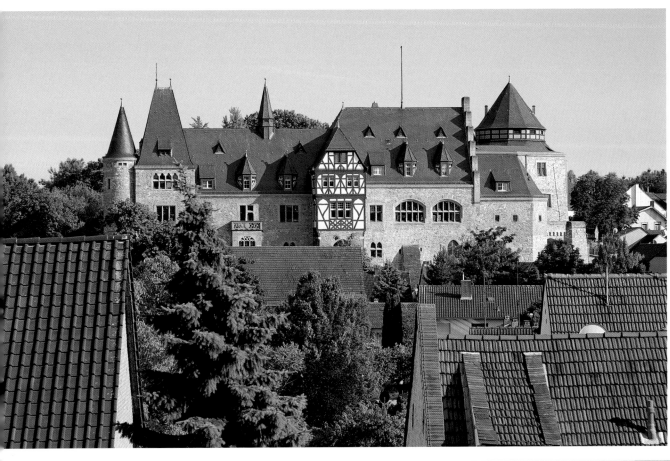

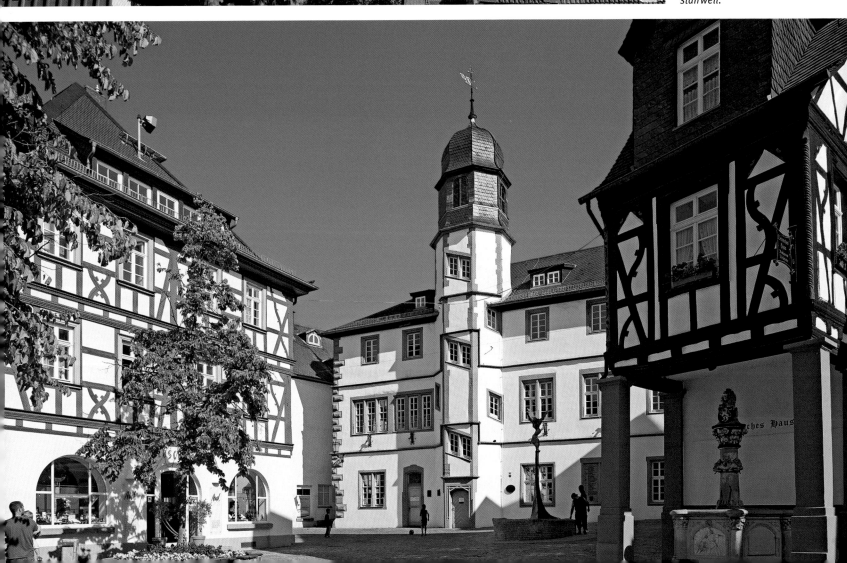

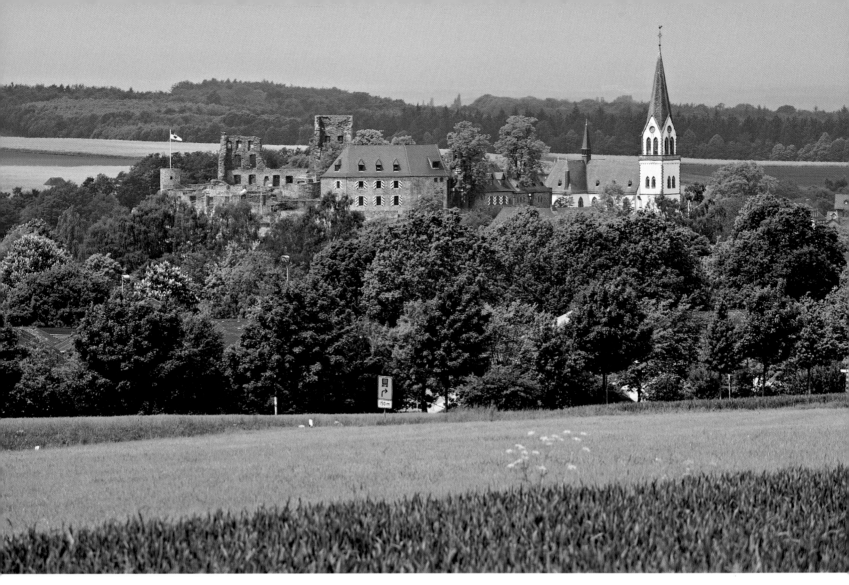

Above:
The old castle of the counts of Sponheim closely guards the ancient market town of Kastellaun in the Hunsrück. Much time and money has been invested in the restoration of the ruins in the heart of town.

Right:
The historic market place at the centre of Kirchberg, the oldest town in the Hunsrück. Celts, Romans, Franks and later the counts and princes of the Middle Ages have all left their mark here.

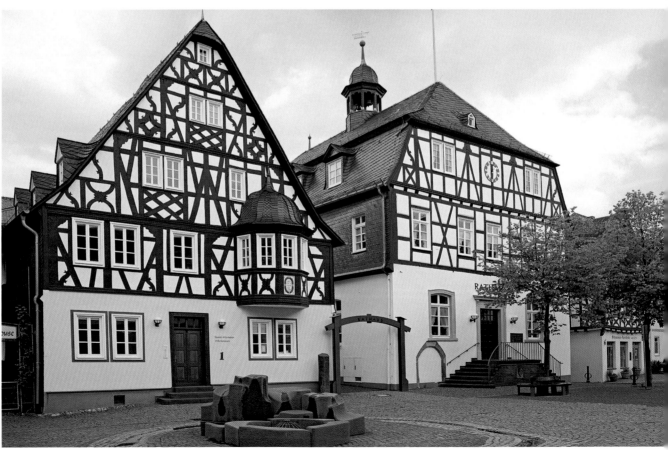

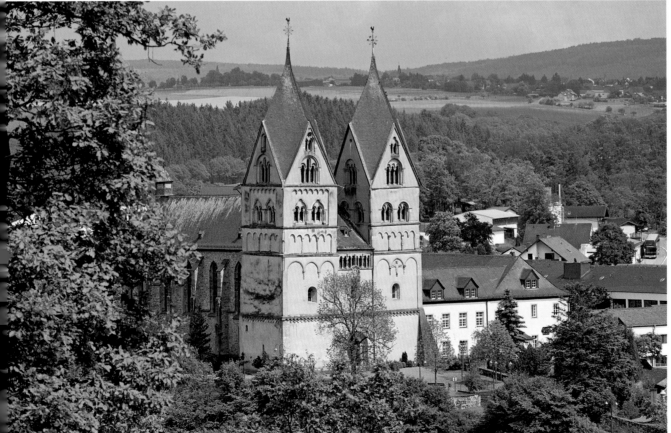

Above:
Nature-lovers and active holidaymakers will enjoy the Hunsrück with its wealth of beautiful scenery and well signposted network of hiking trails that take you past ancient mills set in fields of bright yellow rape, colourful butterflies and wild flowers. Gorge-like valleys and areas of moorland only heighten the attraction of the region.

Left:
St Christopher's in Ravengiersburg seems to leap out at you from the Simmerbachtal. The monastery church, known locally as the cathedral of the Hunsrück (Hunsrück-dom), dates back to the 11th and 12th centuries.

Along the Moselle and Saar rivers

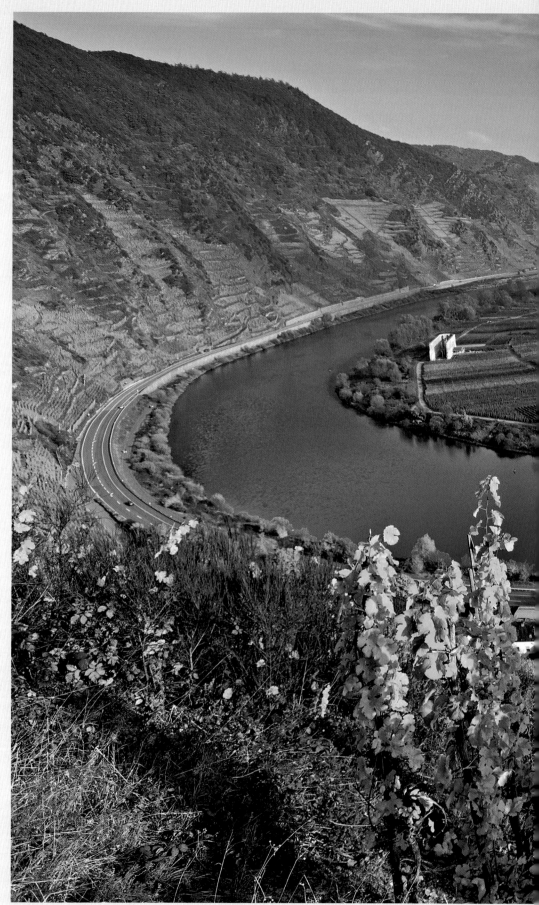

The Moselle twists and turns its way through fertile scenery (here near Bremm) until it spills into the Rhine at Koblenz. From the vineyards there are grand views of the river and Calmont in Bremm.

In broad, lazy meanders and tight, narrow bends the Moselle, the longest tributary of the Rhine, winds its way through countryside that positively delighted the Romans. "Everything flatters the eye", Roman statesman and poet Ausonius wrote in his *Mosella* travel journal from 371 AD. Tucked away in the woods of the surrounding ridges, wine villages and vineyards line the banks of the river but keep a respectful distance, as since habitation of the valley floods are a frequent occurrence.

Bernkastel-Kues, once home to philosopher Nicholas of Kues, boasts a market place that is the epitome of old-fashioned, chocolate-box German architecture. The spa town of Traben-Trarbach profits from its healing springs that gush out from beneath the slate mountains. The slate soil of the Moselle-Saar-Ruwer wine region has also proved beneficial, producing internationally acclaimed wines year after year after year.

The River Saar flows just 27 kilometres/17 miles through Rhineland-Palatinate yet this is the most diverse section of its entire course, high above which an 800-kilometre/500-mile network of hiking trails has been laid out. The town of Saarburg is still guarded by its castle of the same name, reached along steep paths and steps. Added momentum is provided by the rushing waterfall that crashes through the very centre of the old town.

The Eifel is no less diverse, boasting large areas of cool forest, deep ravines, rolling plateaux, peaty heathland and volcanic craters. Both Celts and Romans have left their mark on the region. In the 7th and 8th centuries important religious, scientific and economic impetus was pumped into the surrounding area by the monasteries of Echternach and Prüm.

vivre and cosmopolitan attitudes and for taking a sense of pride in their history. "Trier was built before Rome; may it continue to exist and enjoy eternal peace" is the Latin inscription on the Rotes Haus.

Bottom right: The electoral palace in Trier was built onto the Roman basilica in the 17th century under electors Lothar von Metternich and Phillpp von Soetern. The gardens run south of the palace to the Kaisertherme or imperial Roman baths.

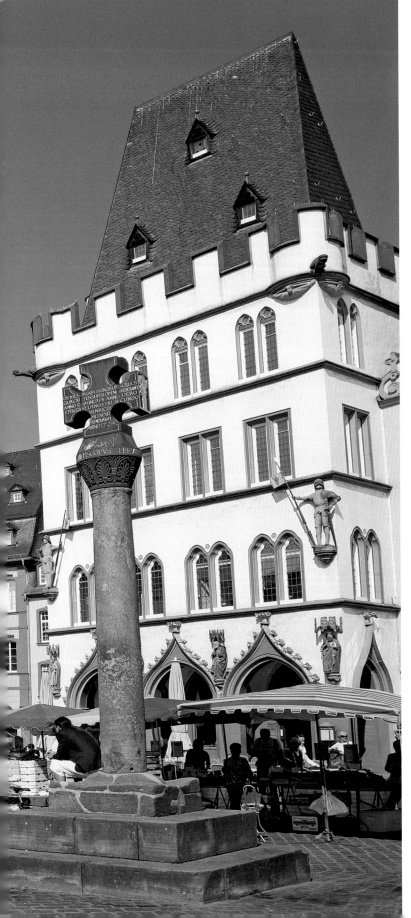

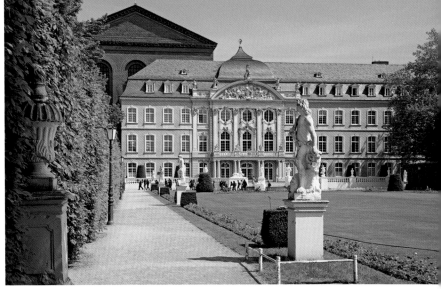

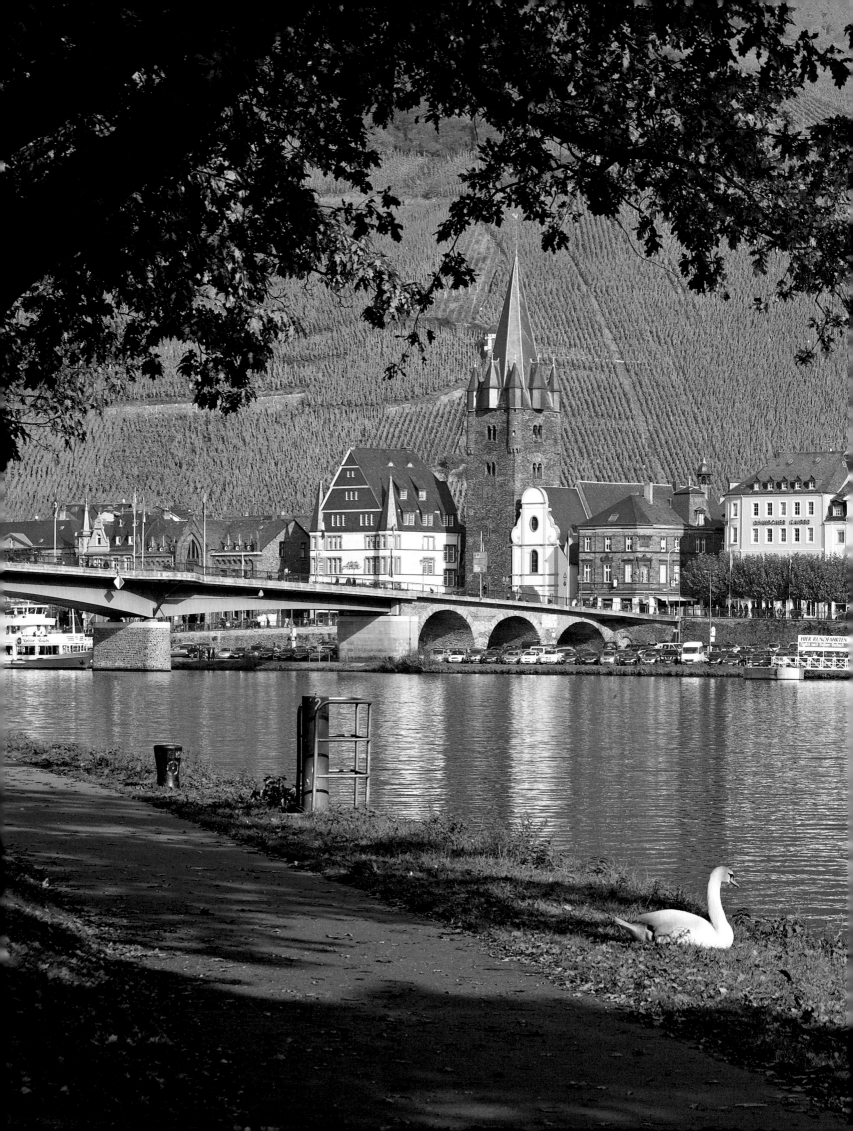

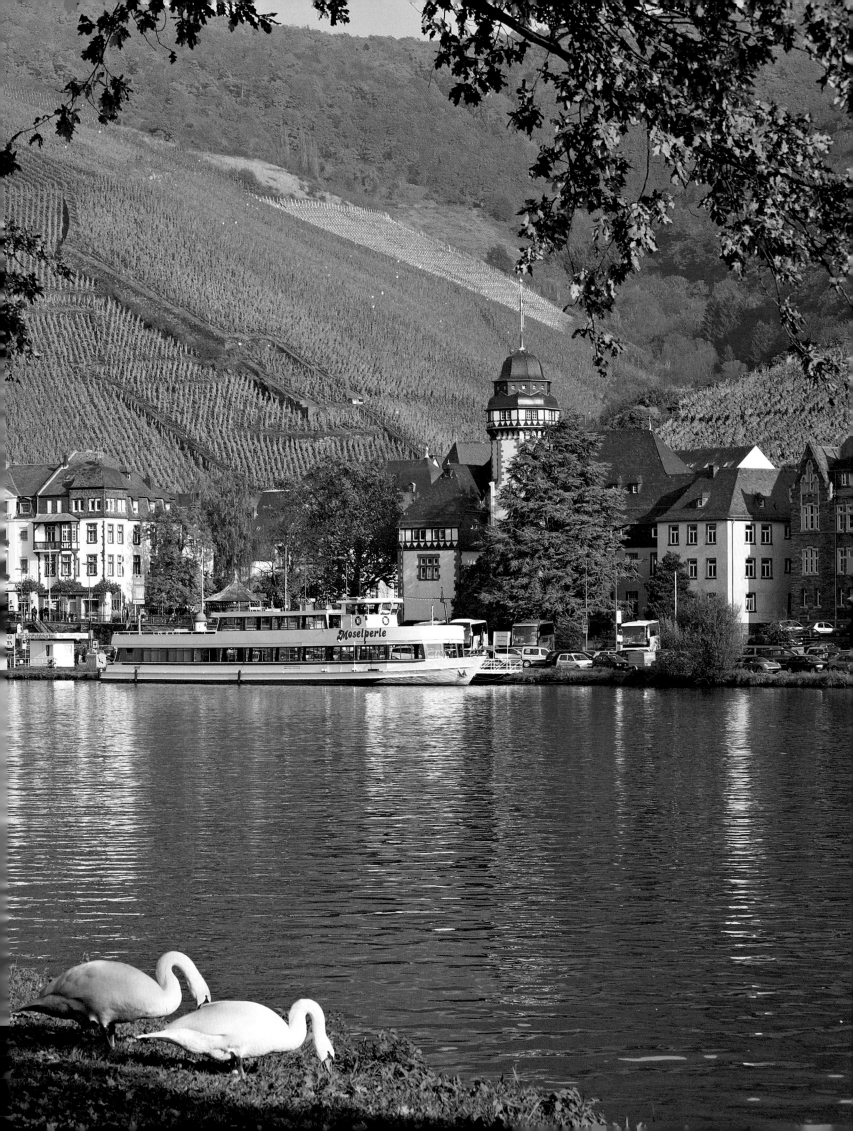

Page 82/83:
The two towns of Bernkastel-Kues are joined not just by a hyphen but also a bridge and are among the most popular places on the Moselle. Findings from Kues prove that the first settlers came here in the 4th millennium BC. The banks of the river on the Bernkastel side (called Gestade or the strand) are dominated by the mighty steeple of St Michael's, once a defensive tower and part of the town wall and only later incorporated into the parish church.

At the heart of Bernkastel-Kues is its sloping market place with its fetching array of half-timbering. Like the parish church, the fountain outside the town hall is dedicated to St Michael.

Kues is famous as the birthplace of Nicolaus Cusanus or Nicholas of Cusa (1401–1464). At his former home a permanent exhibition provides information on the life and work of the great theologian and philosopher who founded a hospital for the needy in his home town. There is still a residential home for the elderly here.

Right page:
Many a romantic tavern entices you to rest awhile in the narrow cobbled streets of Bernkastel-Kues. One of the best known is Spitzhäuschen, almost 600 years old.

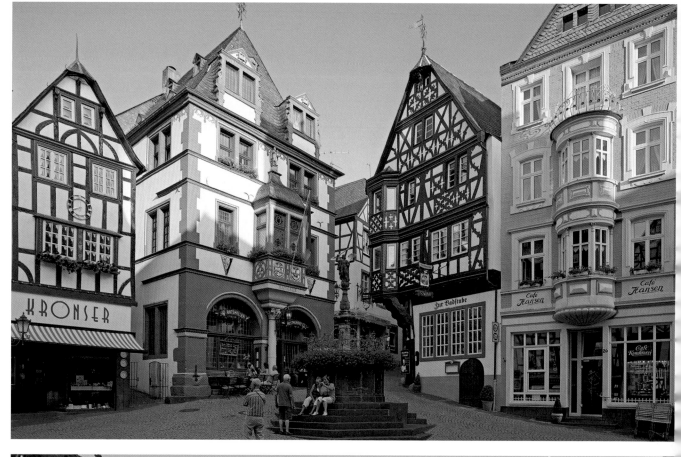

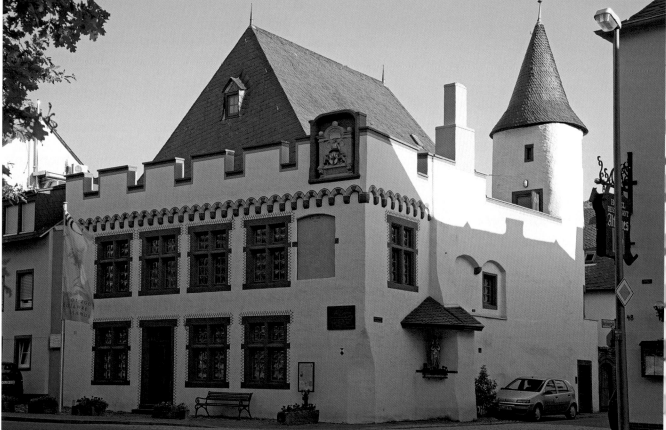

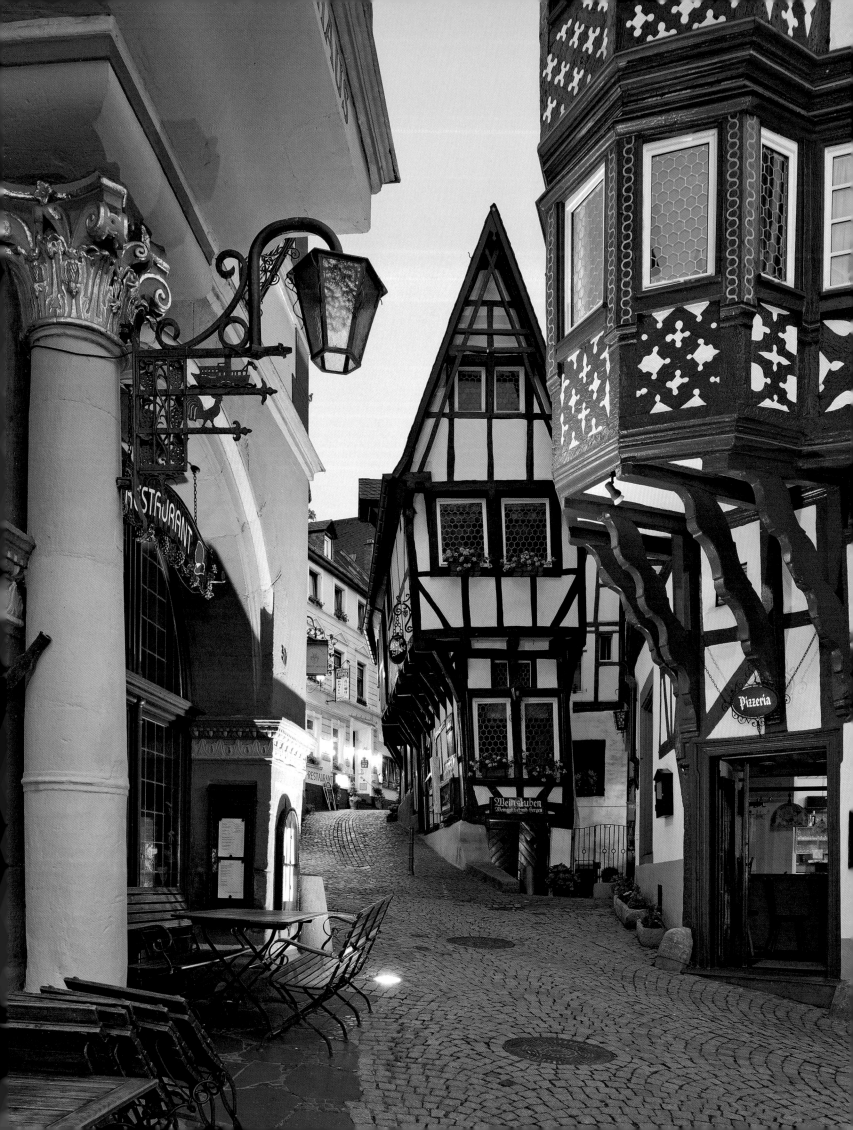

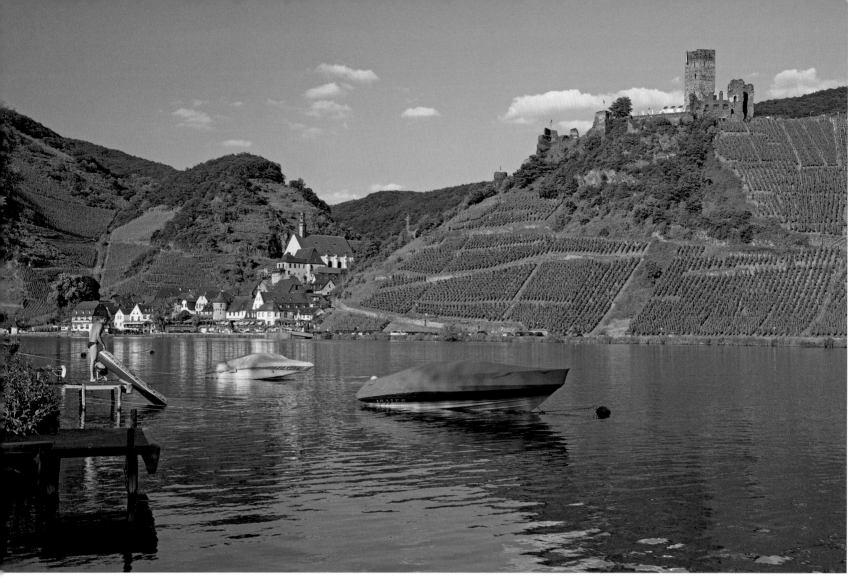

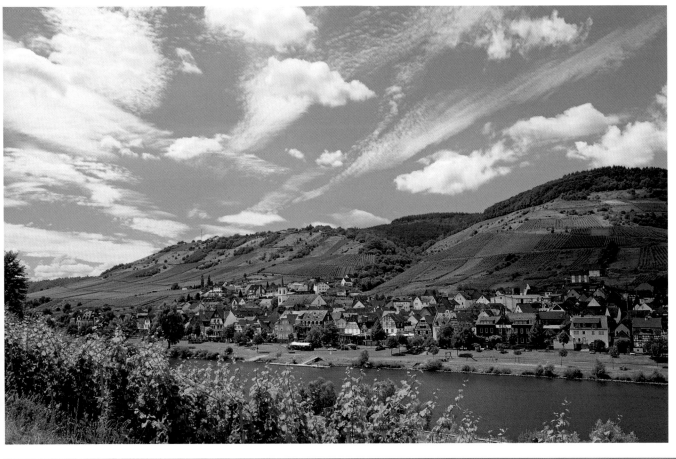

Left:
The wine village of Reil on the Moselle is surrounded by steep vineyards that creep up the slopes to the woods of the Eifel. One of its most famous, legendary wines is Reiler vom heißen Stein whose greatness can be tested (and tasted) at the local wine festival in August.

Below:
The castle in Beilstein on the Moselle is named after its most famous one-time owner, Austrian state chancellor Count von Metternich.

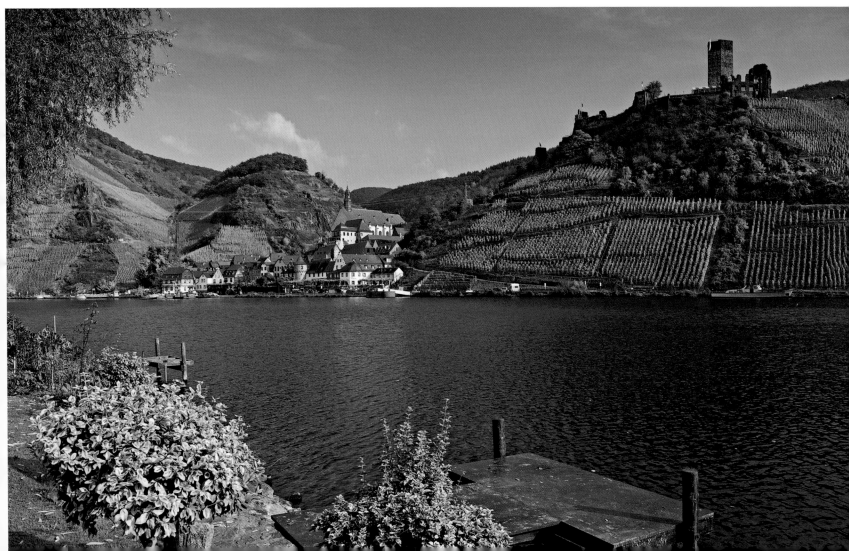

Right:
Autumn has turned the precipitous vineyards near Enkirch into a blaze of colour. The area can be explored along many hiking trails that trace both the banks of the river and the giddy heights of the surrounding hills.

Below:
Special tools are needed when working in very steep vineyards. Some of these are on display at the museum in the historic town hall of Zell on the Moselle. Here you can discover why there is a vineyard named after a black cat (Zeller Schwarze Katz). It's said that a hissing and spitting cat once defended 'its' barrel of wine in a local cellar which was later found to contain the best vintage in the house.

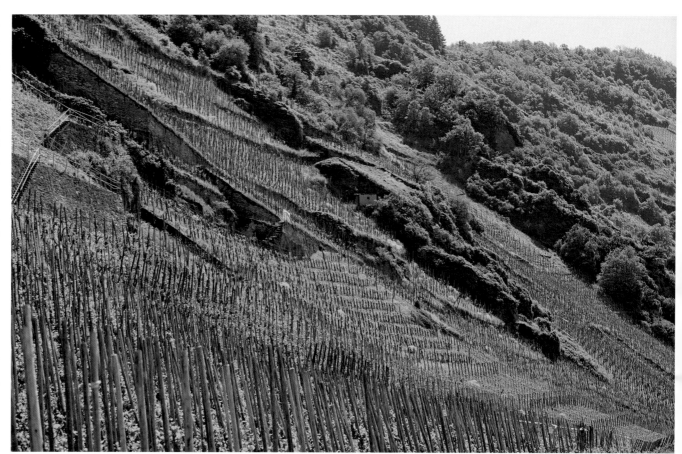

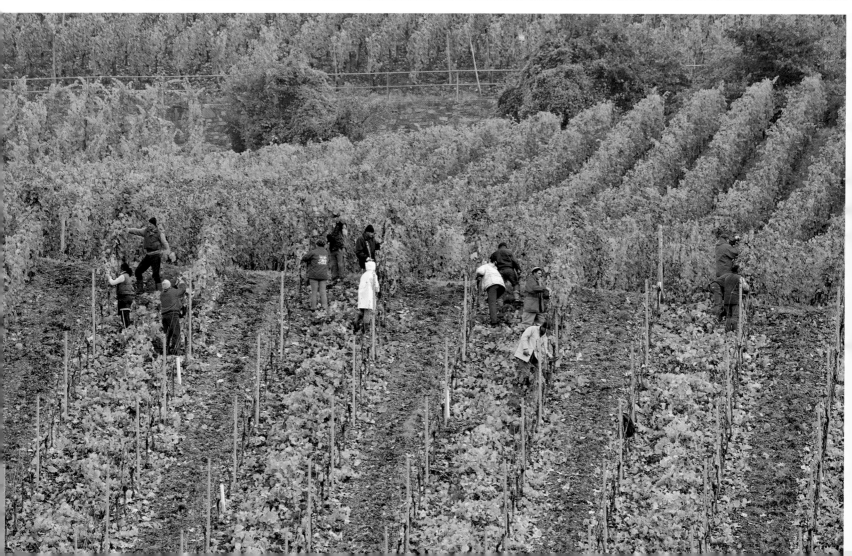

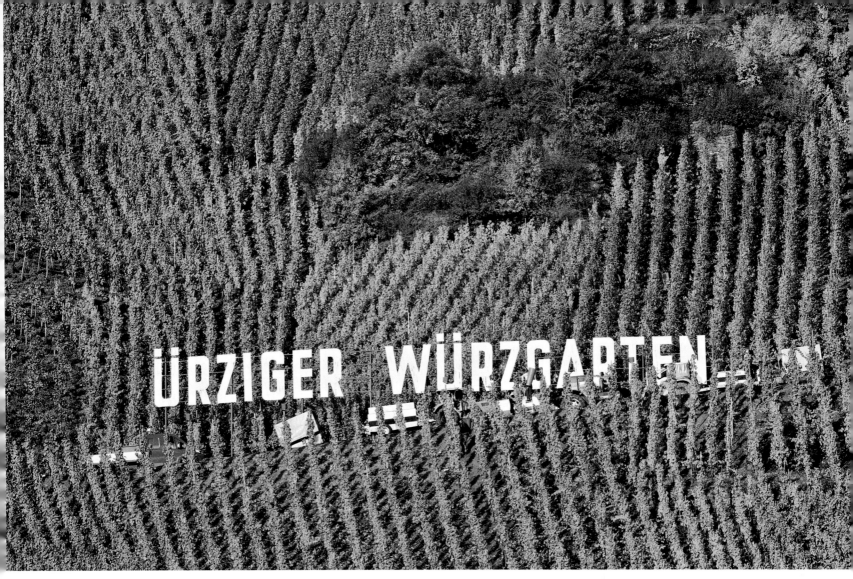

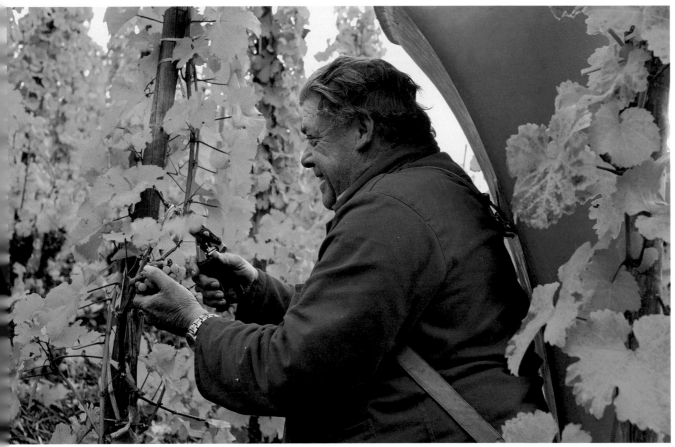

Above:
Just outside Ürzig, enclosed by deciduous forest, the vineyards bear the name of Würzgarten or spiced garden. The wines it produces really do have a unique character, the result of years of careful cultivation on red sandstone and slate soil.

Left:
In October the harvesting of Müller-Thurgau, burgundy and Elbling begins on the Moselle, the latter a very old species of grape not often grown elsewhere. Riesling, which ripens late, is still the undisputed king of the Moselle, Saar and Ruwer wine-growing region. Its long ripening period makes it particularly elegant and mineral with a fine fruity bouquet.

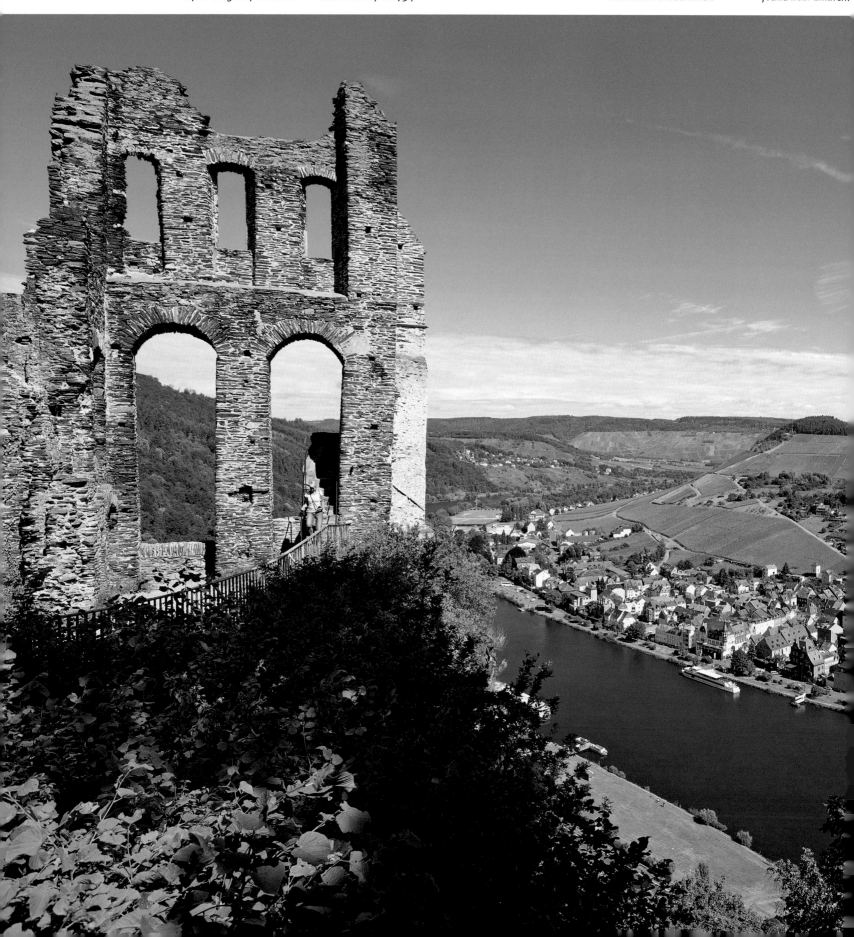

Below:
From the ruins of the Grevenburg you look down on the two towns of Traben-Trarbach on the left and right of the River Moselle. Built in 1350 and of great strategic importance, the fortress was seized by no less than 13 new owners until it was blown up in 1734.

Top right:
Pleasure steamers run regular trips up and down the Moselle between Bernkastel-Kues and Cochem in the summer. Amateur sailors can use the many locks between Koblenz and Trier free of charge; this one can be found near Enkirch.

Centre right:
Schloss von der Leyen is the only moated castle on the River Moselle. The ancestral seat of the princes of von der Leyen

was turned into a palace in 1560 and extensively restored in 1907. It now houses an exhibition run by the state archives of Rhineland-Palatinate.

Bottom right:
The River Saar turns through an angle of 180° at Orscholz. If you want to admire it from on high, the place to go is the viewing point at Cloef.

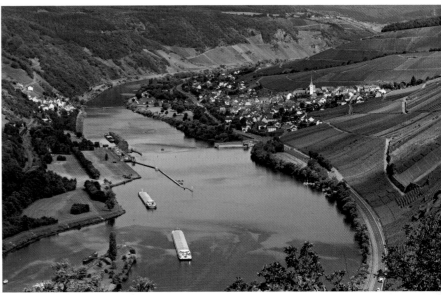

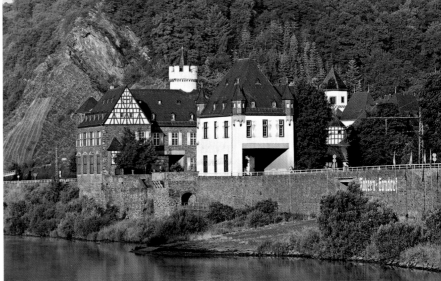

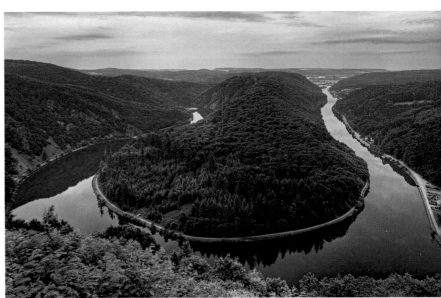

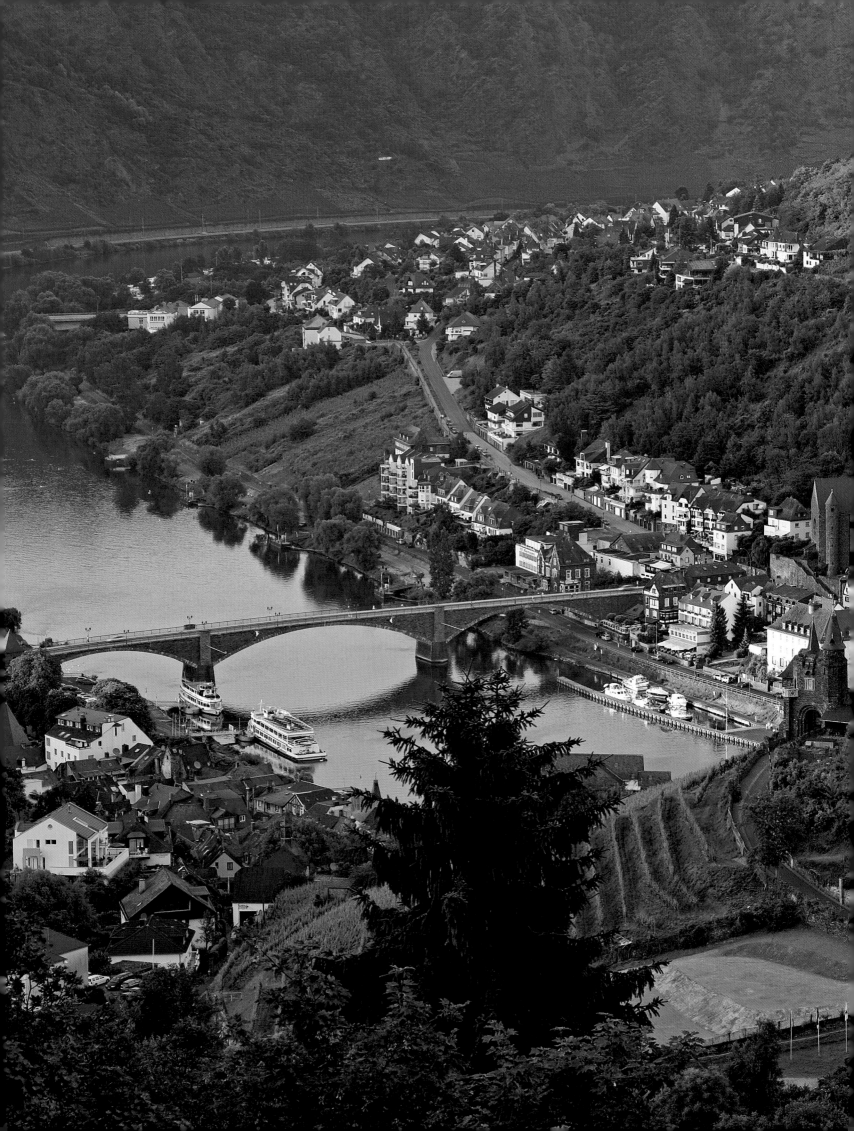

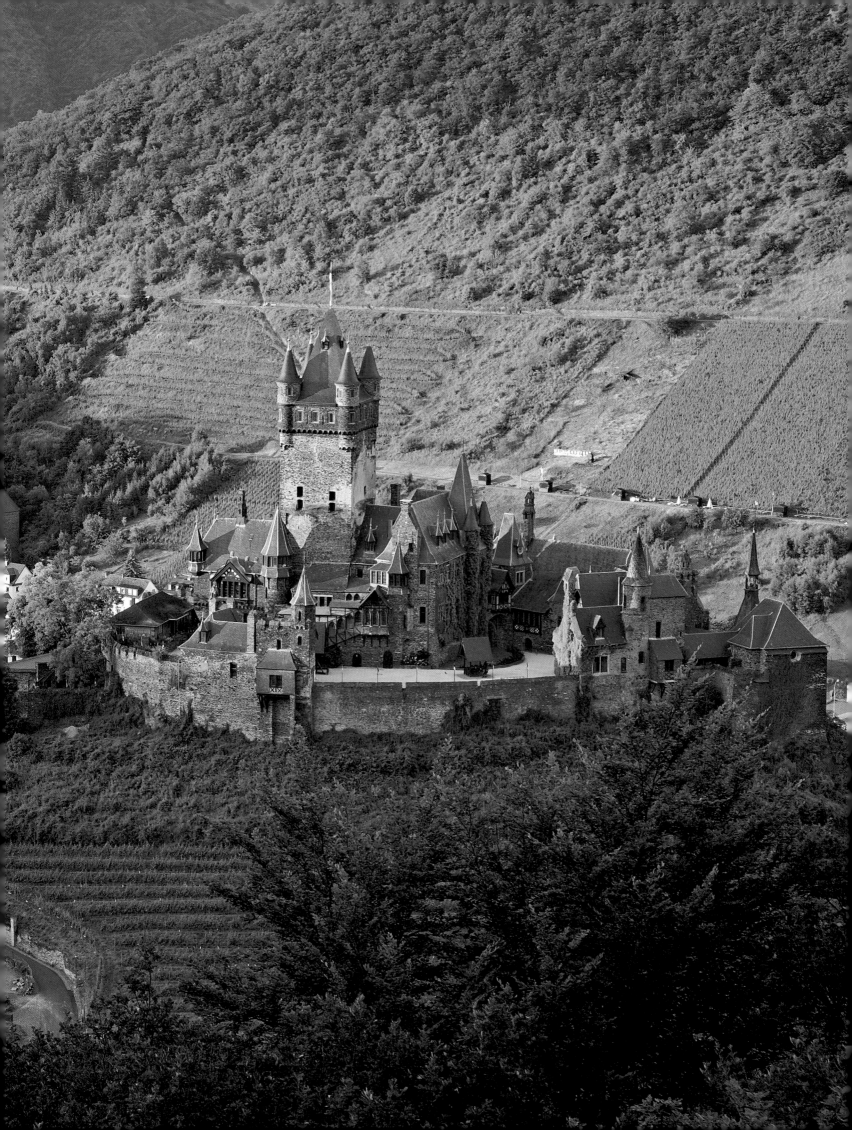

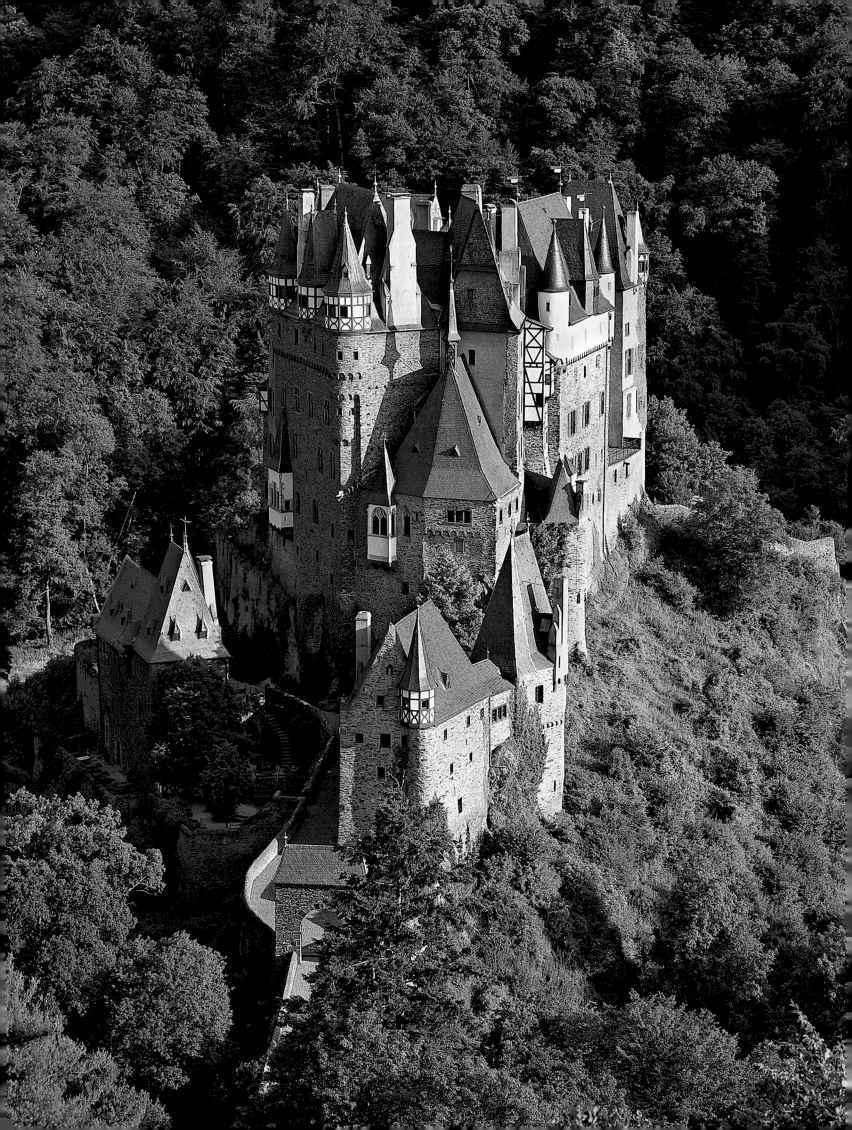

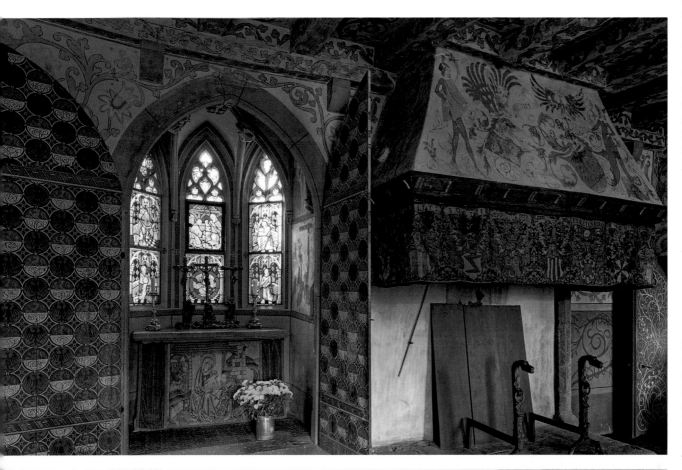

Page 92/93:
In c. 1000 AD Count Palatine Ezzo had an imperial castle built on a rocky spur high up above Cochem. After the troops of Louis XIV had conquered both town and fortress and razed them to the ground, a distinguished business-man from Berlin and keen castle fan bought the ruin in 1866 and had it rebuilt, using it as a summer resi-dence for himself and his family.

You can't visit Burg Eltz without seeing the Rübenach bedroom. The lavish furnishings include a splendid four-poster bed from the 16th century and extremely decorative, floral wall paintings.

The late medieval kitchen in Burg Eltz still has all the character of 1540. In those days iron rings were fixed to the kitchen ceiling to hang up food where the rats and mice couldn't get to it.

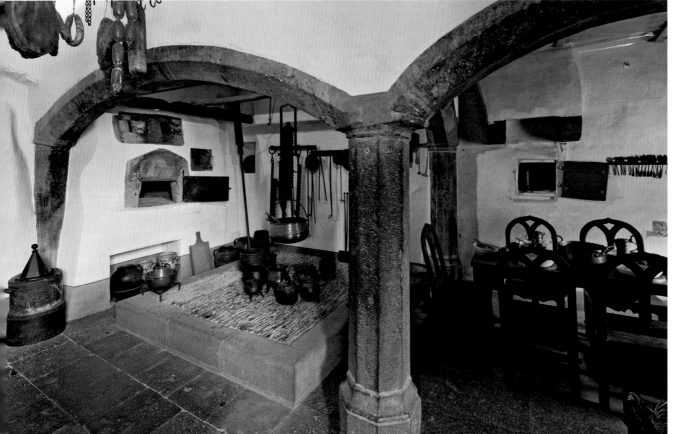

Left page:
Art historian Georg Dehio called Eltz "the epitome of the castle". It's one of the best known and most visited castles in Europe. Its multitude of towers, turrets and oriels are clearly visible from the air, poking up above the green swathes of the Elzbachtal.

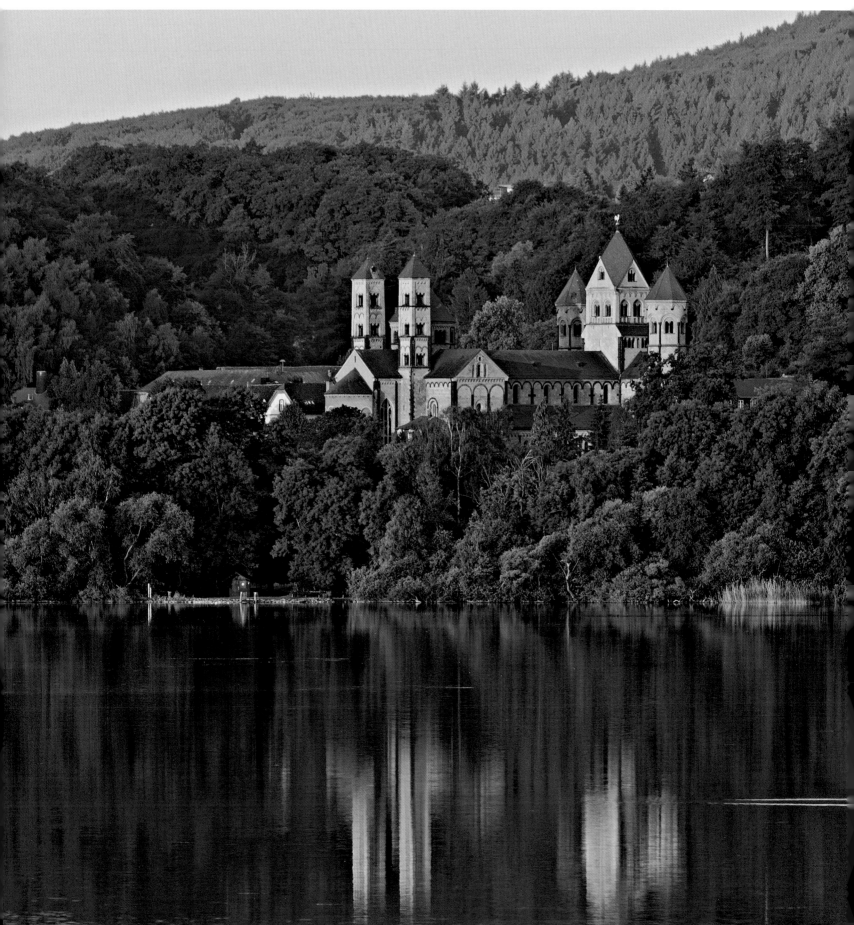

Below:
The abbey of Maria Laach is situated in one of the youngest landscapes of Europe: the volcanic Eifel Hills or Vulkaneifel.

The lake and elevations surrounding it were formed in c. 10,000 BC. The land and lake that belong to the abbey are still tended by monks.

Above right:
The Romanesque crypt in the Benedictine abbey of Maria Laach is buried under the choir. Here lies the monastery's first abbot, a (copied) stone mosaic of whom can also be found here. The number

three, the Christian symbol of perfection, is a predominant feature of the design; there are three aisles, three bays, three windows in the apse and three steps leading up to the altar.

Bottom right:
The simple interior of the abbey is dominated by a ciborium (wooden baldachin) that spans the main altar. It dates back to the days of Abbot Theoderich II (1226–1295). Stylistically the ciborium, once elaborately decorated, can be placed at the transition of the Romanesque to the Gothic.

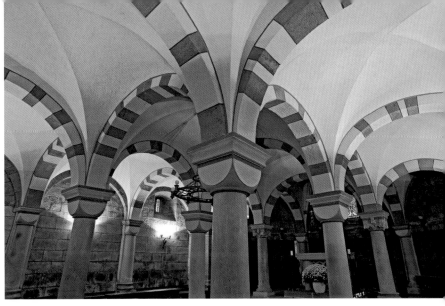

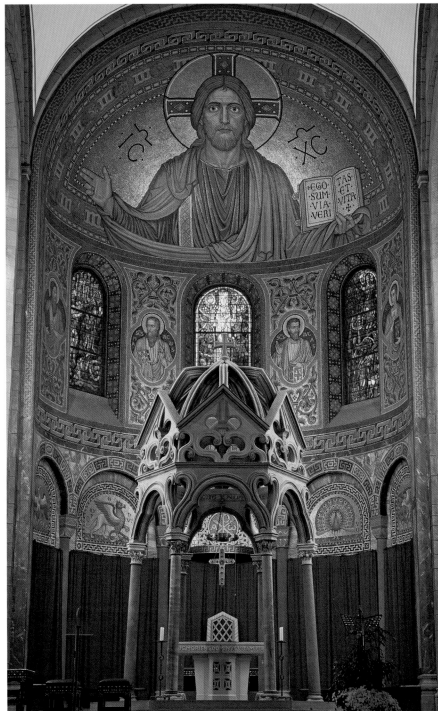

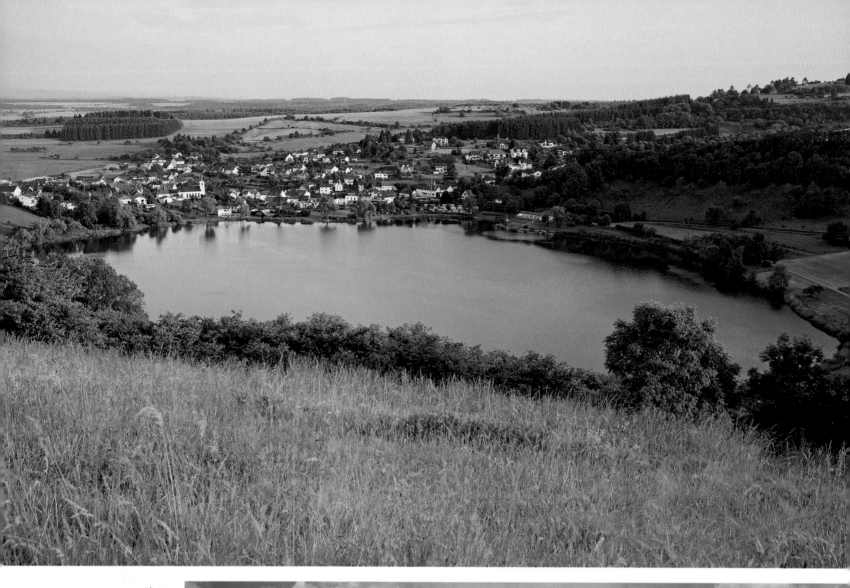

Schalkenmehrener Maar
in the Eifel is the southern-
most of the three Dauner
Maare or volcanic lakes
created by an explosion of
volcanic gas around
11,000 years ago. It's the
oldest and largest of the
three, ca. 21 m/70 ft deep
and 575 m/1,890 ft wide.

Right:
The delightful scenery of
the Eifel is best explored
on foot, for example on a
hike up the Hohe Acht, at
747 m/2,450 ft the highest
elevation in the area. The
Kaiser Wilhelm viewing
tower at its summit was
erected in 1909.

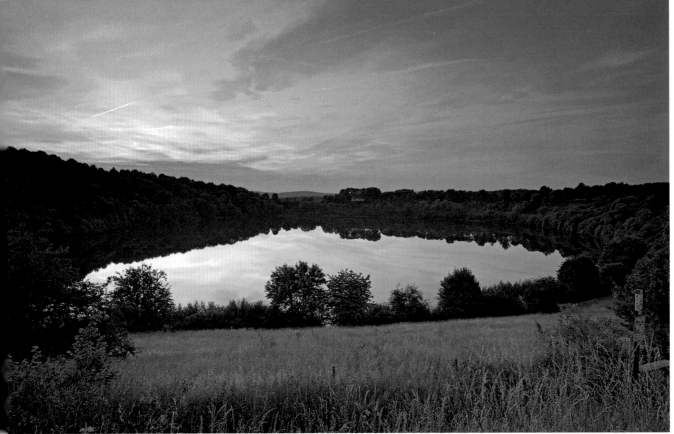

Above:
Its expansive, unspoilt scenery and proximity to the River Moselle and the volcanic maars make the Eifel extremely attractive to daytrippers, holiday-makers and nature lovers. Popular activities include hiking, cycling, riding, fishing and golf.

Left:
Weinfelder Maar, also known locally as the Totenmaar or dead maar, is one of the most beautiful crater lakes in the Eifel. A couple of kilometres southeast of Daun, it's now a nature conservation area. Legend has it that the chapel on the shores of this silent lake was erected by a count in thanks for the wondrous salvation of his child.

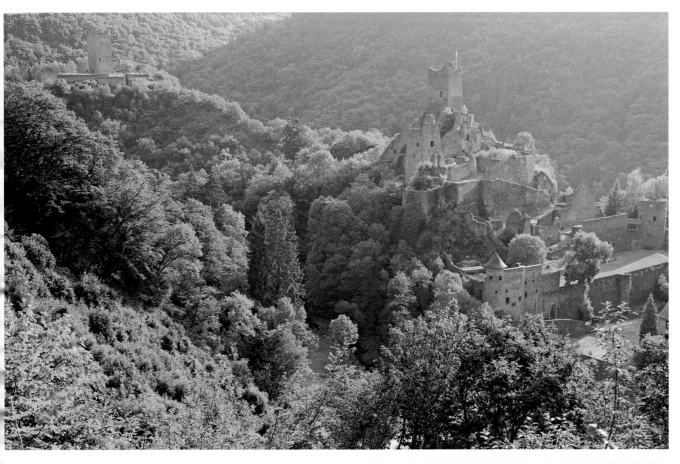

Left page:
Teufelsschlucht or devil's gorge near Irrel in the Südeifel national park was created towards the end of the last ice age ca. 10,000 years ago when several walls of rock collapsed. You can study the bizarre formations close to on an adventurous trail that winds between the narrow ravines and crevices.

Manderscheid's local landmark are its two castles. The Oberburg or upper castle is the elder of the two and said to date back to the 10th century. It passed to the archbishops of Trier in c. 1150. The Niederburg or lower castle, first mentioned in 1133, then became the seat of the lords of Manderscheid. Its distinctive silhouette is a defensive symbol of past power and dominance.

The rapids of the River Prüm near Irrel were formed during the last ice age when giant rock formations were split asunder. A covered bridge provides a dry view of the raging waters below. In summer green and peaceful, the mood changes come autumn when the torrid waterfalls are used for national and international canoeing competitions.

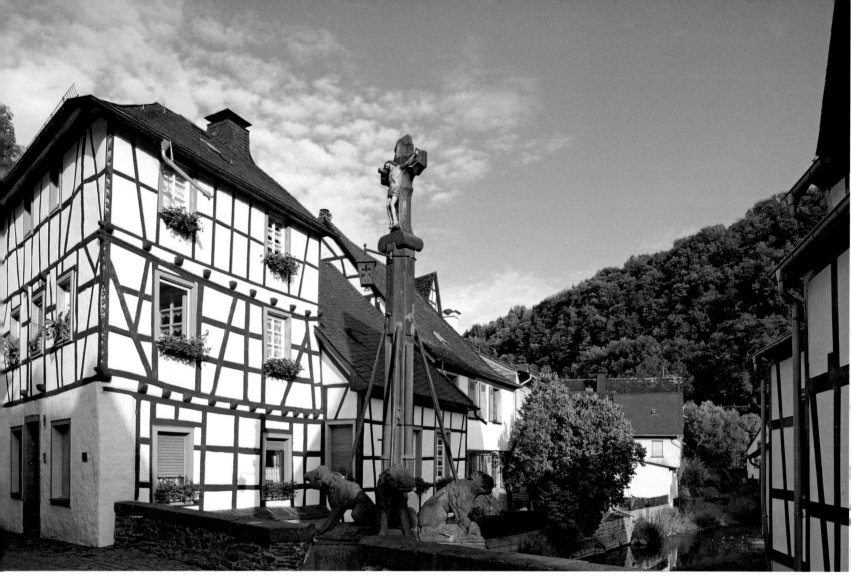

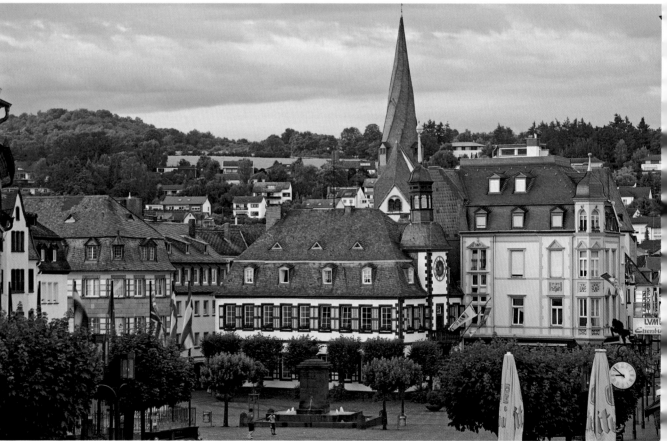

Above:
This stone bridge over the River Elz in the beautiful little village of Monreal in the Eifel is guarded by a lion. Perfectly harmless, the noble stone creature is a notable example of late Gothic stonemasonry chiselled in reference to the Löwenburg or lion's castle nearby.

Right:
Pisa isn't the only place with a crooked tower. In the Eifel town of Mayen the steeple of St Clement's parish church from the 14th century also has a decorative twist caused by a structural error.

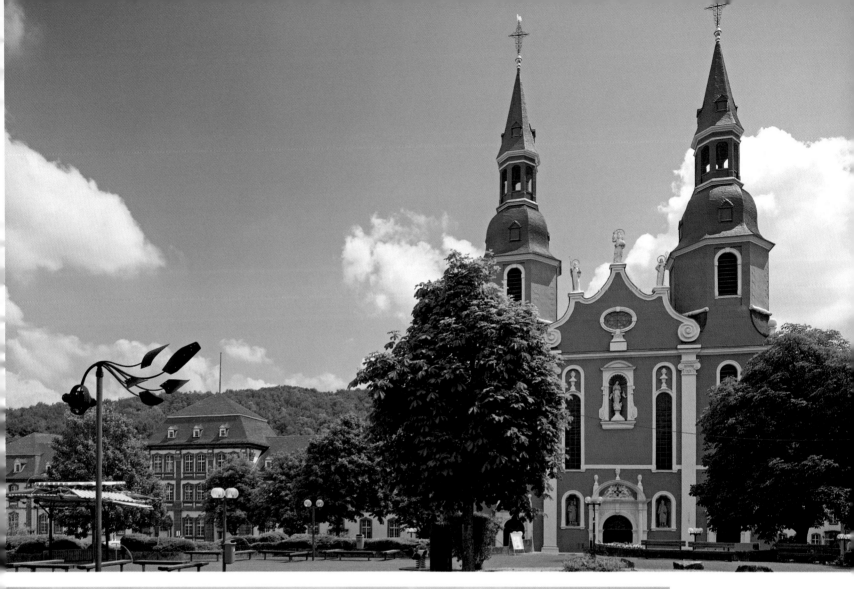

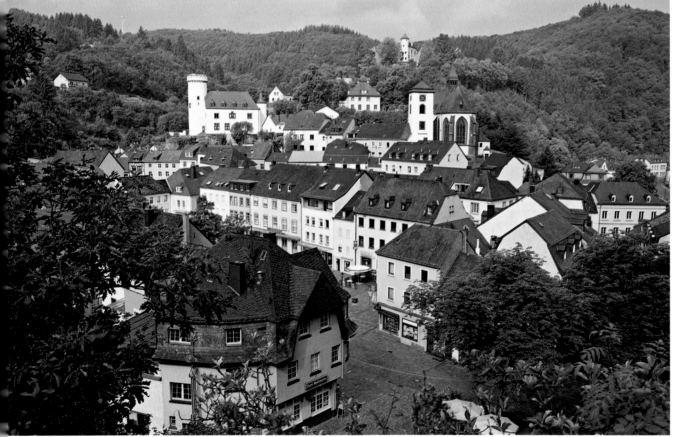

Above:
The centre of the climatic
health resort of Prüm is
dominated by the mighty
façade of St Salvator's
Abbey which docks onto
the former monastery.

Left:
Tucked away in the
sheltered valley of the
Enzbach you come across
Neuerburg in the middle of
Germany and Luxembourg's
joint national park.

Page 104/105:
The twin town of Bad
Neuenahr-Ahrweiler in
the valley of the Ahr is
Germany's red wine
'paradise'. Ahrweiler has a
multitude of half-timbered
edifices and a medieval
town wall; Bad Neuenahr
is famous for its hand-
some spa gardens and
white patrician houses.

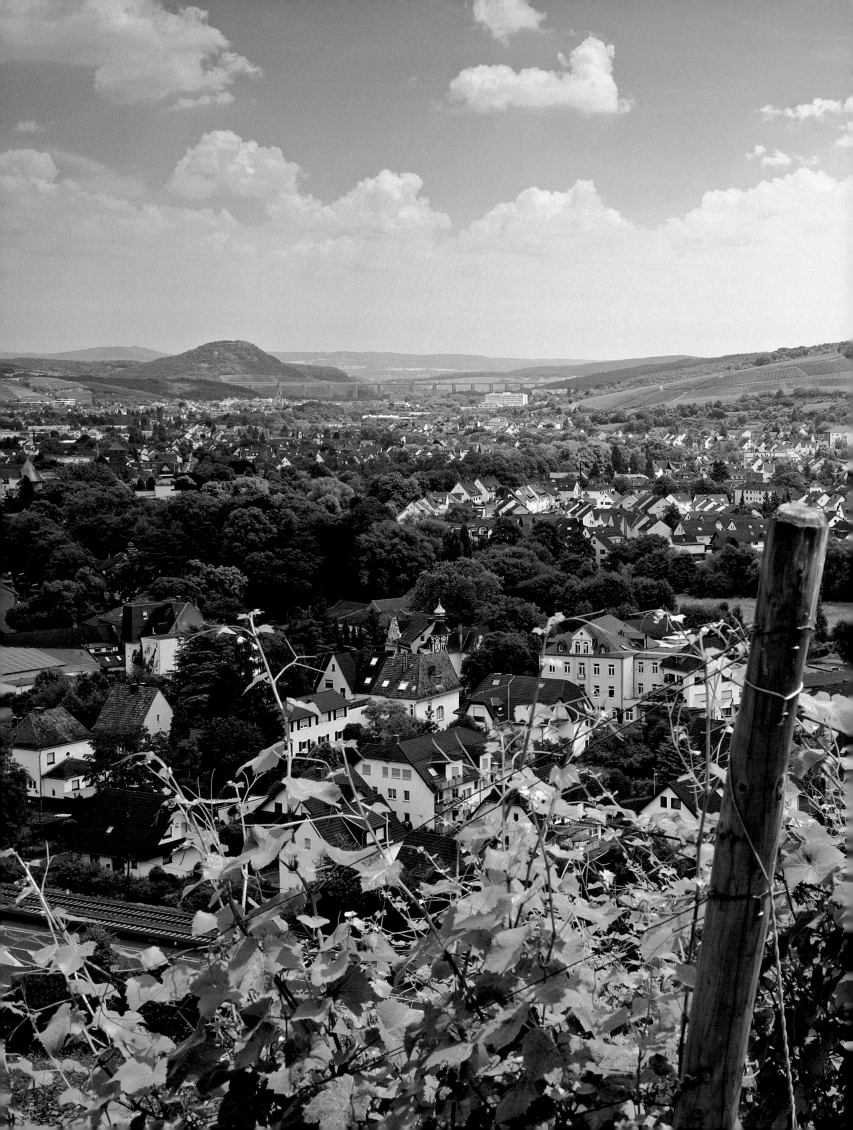

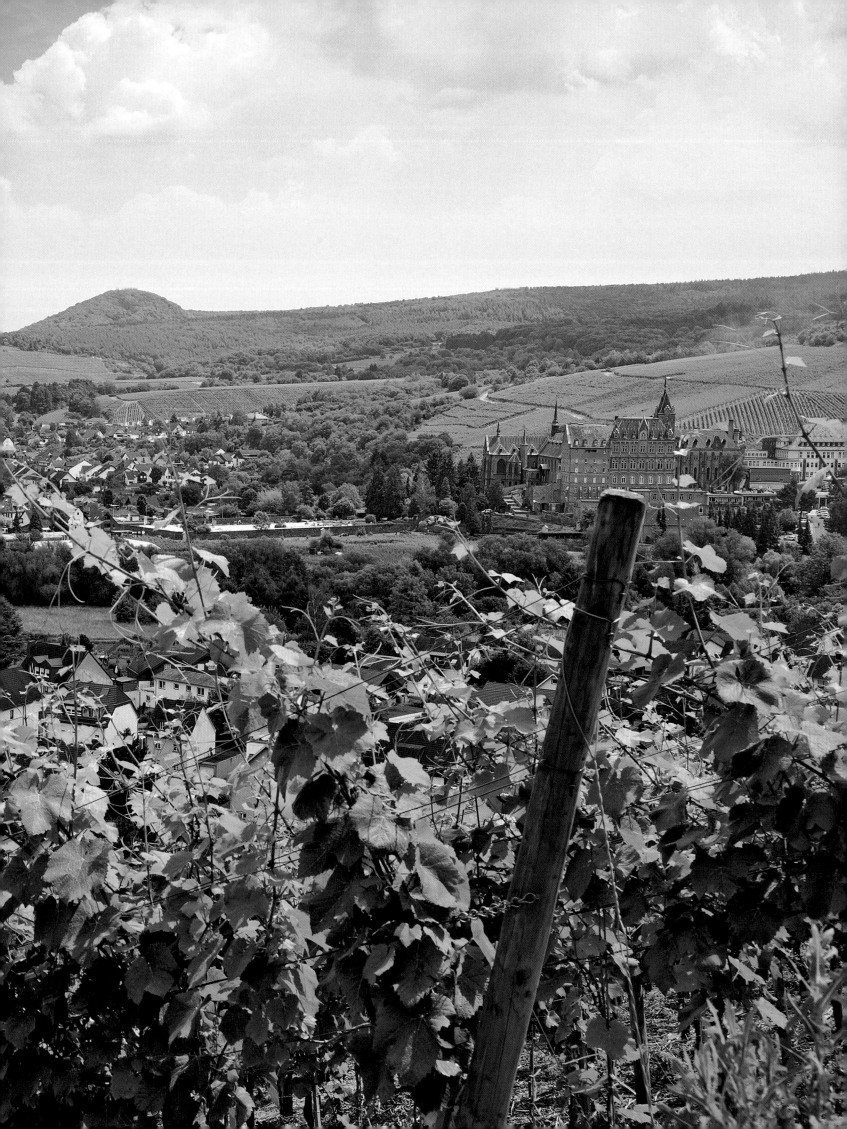

The Middle Rhine, Lahn and Westerwald

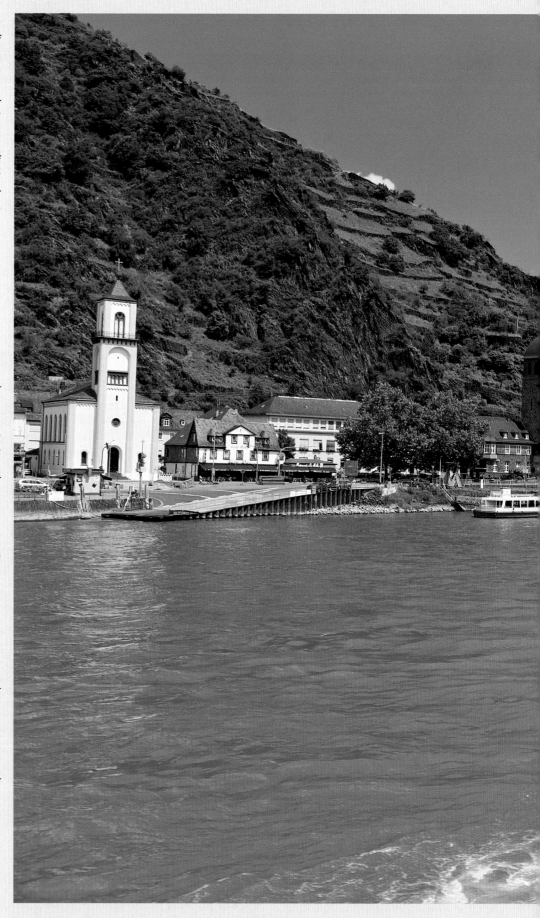

Along the narrow banks of the Rhine St Goarshausen squeezes itself in between the river and sheer walls of rock. Perched on a precipitous outcrop Burg Katz hails it neighbour the Loreley. The castle was built in the second half of the 14th century by Count Wilhelm II of Katzen- elnbogen.

When cultural philosopher and early Romantic Friedrich Schlegel travelled the Rhine Gorge in search of unadulterated scenery and knightly virtues in the 19th century he found it "a complete picture in itself and a considered work of art by a fine mind". Many of today's visitors feel the same; whether driving along its shores, from a train window or aboard a pleasure boat, along the Upper Middle Rhine between Bingen and Koblenz a unique composition of precipitous vineyards, jagged cliffs, romantic castles and pretty villages awaits at every turn.

Five kilometres/three miles south of Koblenz the River Lahn enters the Rhine. Once you've visited the mighty fortress of Ehrenbreitstein, paid your respects to Emperor Wilhelm I on his horse at the Deutsches Eck and had a look around the basilica consecrated in 836 in what the Romans named Confluentes, you could then pedal your bike along the Lahn cycle track or set off along the Lahnhöhenweg hiking trail. Don't forget to try the local vintages between Diez and Lahnstein, for wine has been cultivated on the Lahn since the 13th century, with Riesling and Pinot noir now the most popular grapes.

In the lower reaches of the Lahn Valley to the north the hills of the Westerwald begin their gentle ascent. This formerly poor area has now morphed into a well-tended stretch of countryside with crystal-clear rivers that is increasingly concentrating on reviving its ancient traditions. The district town of Montabaur is worth a visit for its charming historic centre and stylishly restored half-timbered houses. The middle of Hachenburg has the oldest stone tavern in Germany, the Hotel zur Krone, where you can savour good solid Westerwald cooking.

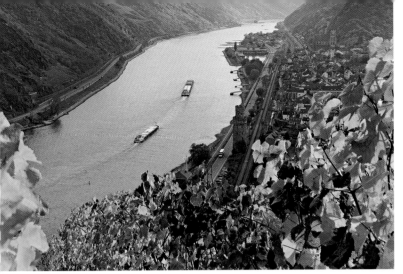

Left:
The perfect time to travel the Rhine is when the last warm rays of sun kiss the ripening grapes in the sloped vineyards. At the Günderodehaus (of "Heimat" fame) you can sit back and enjoy the glittering river snaking past beneath you, idly lapping the shores of medieval Oberwesel with its complete set of town walls.

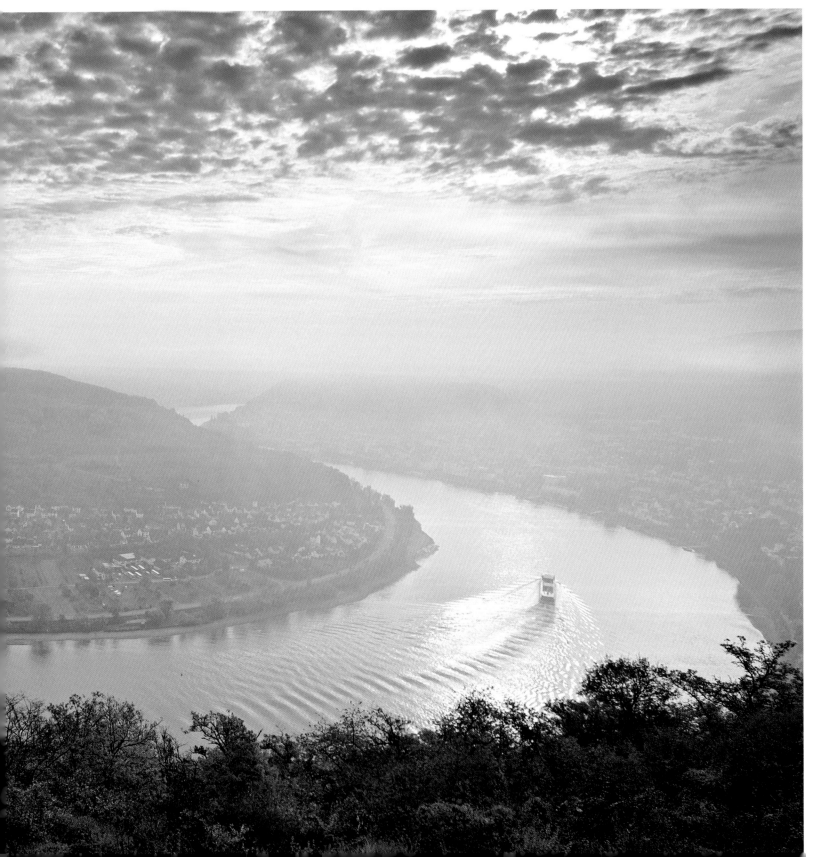

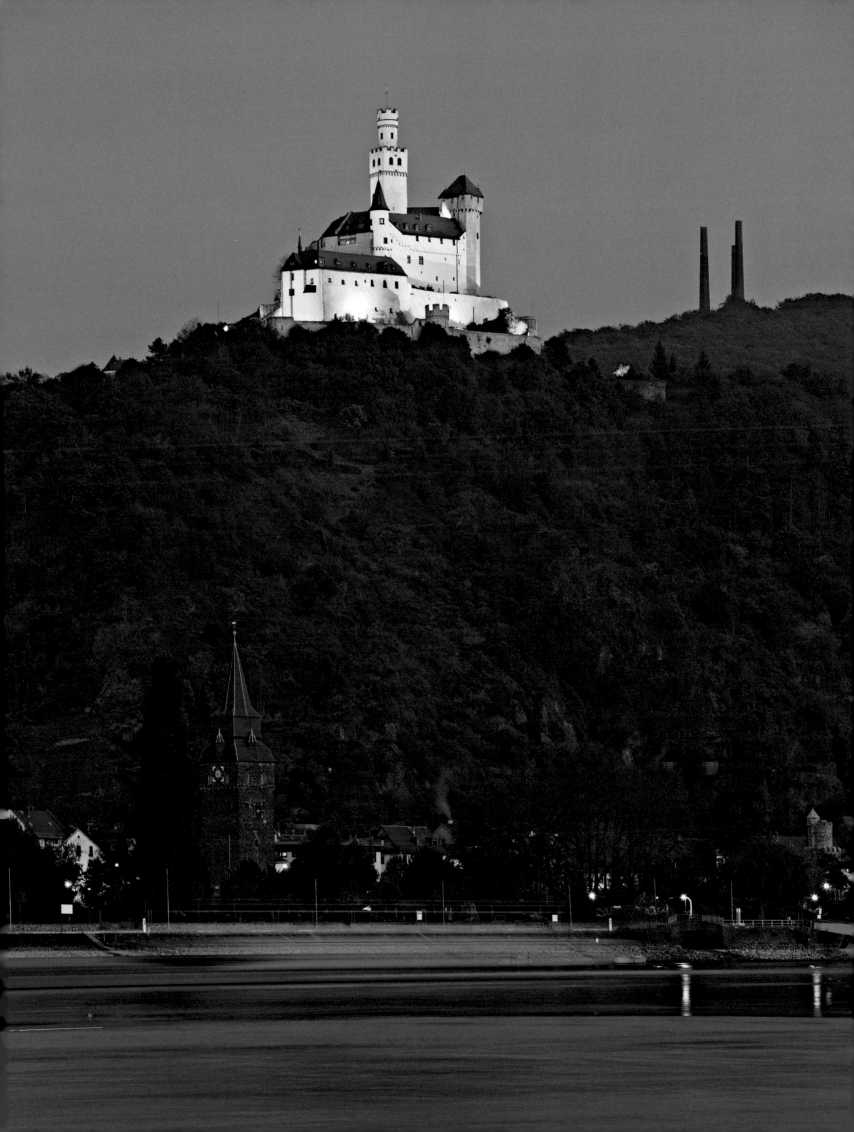

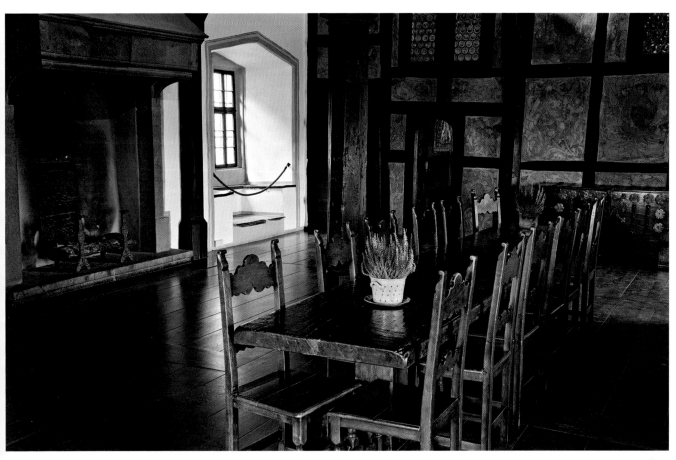

Left page:
It's hard not to think of knights in shining armour and various other fairytale characters on seeing the Marksburg for the first time. Especially at night what is undoubtedly one of the most beautiful Rhine castles appears particularly magical.

The castle lord and his family used to eat their meals at a long table in the great hall that was carried in full of food and taken out again at the end of the meal. The expression "to clear the table" thus once had a very literal meaning here ...

The homely kitchen at Marksburg Castle was once the place where food was prepared for the lord, his guests and his servants. Today groups of up to 60 can take part in a medieval banquet here with all the trimmings, complete with candles, costumes and a roaring fire in the hearth.

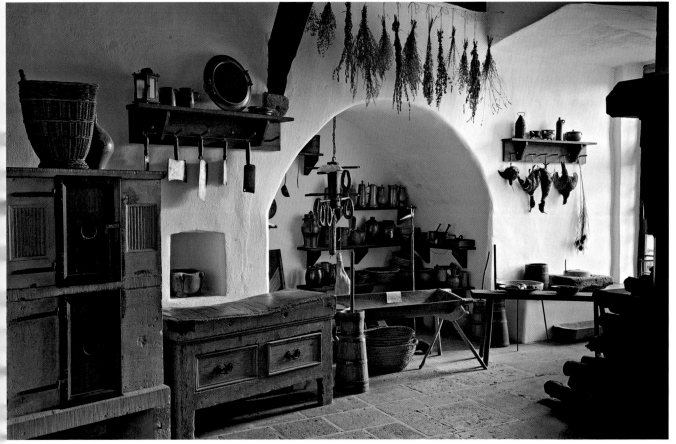

Page 112/113:
Opposite Assmanshausen on the Hessian banks of the Rhine – famous for its red wine and Höllenberg vineyard – is Burg Rheinstein, built by the archbishop of Mainz to collect tolls. It's symbolic of the Romantic fad for 'restoring' medieval castles – with plenty of 19th-century embellishments.

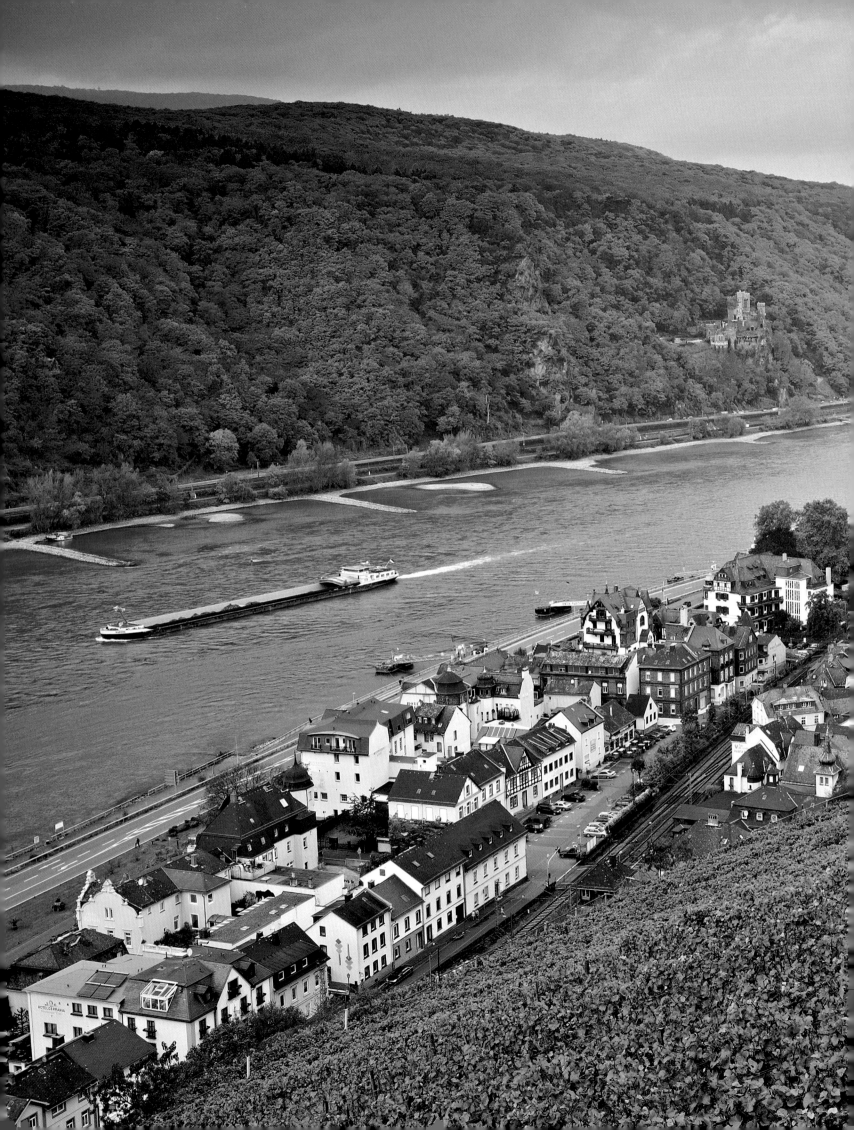

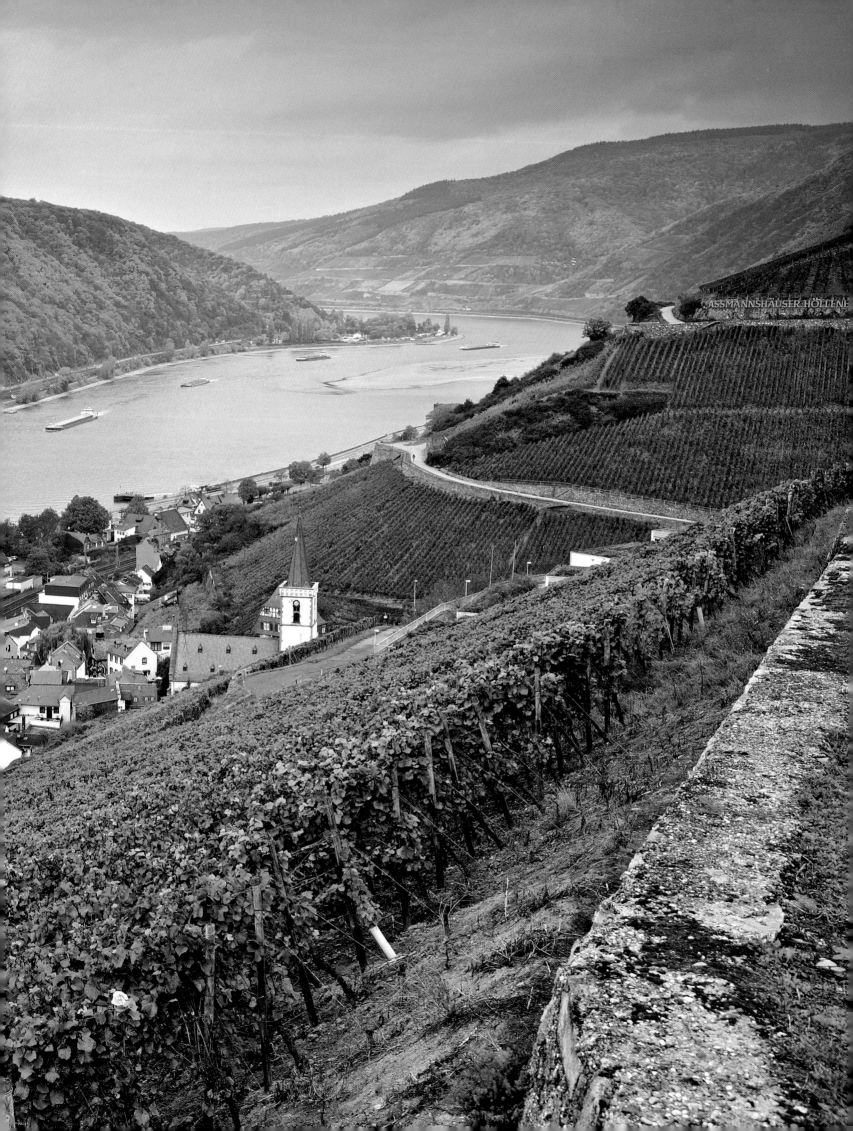

ASSMANNSHÄUSER HÖLLENB

Above:
In the 19th century French Romantic Victor Hugo described Bacharach as one of the most beautiful towns in the world. Its ruined pilgrimage chapel, the Gothic Wernerkapelle, is just one of its many redeeming features.

Right:
The half-timbered façades of Bacharach are a big attraction, among them the Posthof with its charming courtyard and the Altes Haus on the market place. Large sections of the town walls have also been preserved.

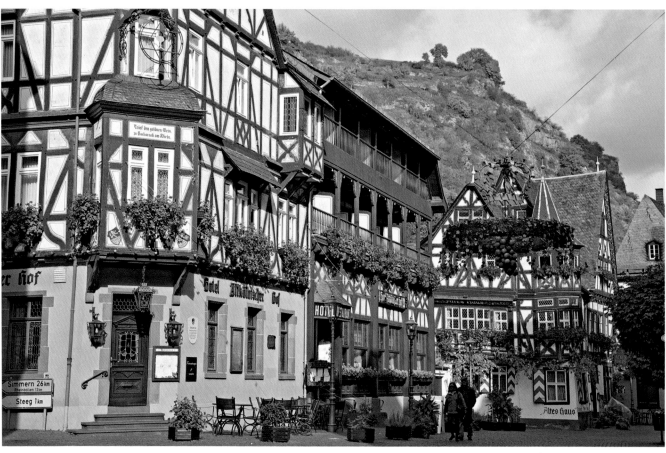

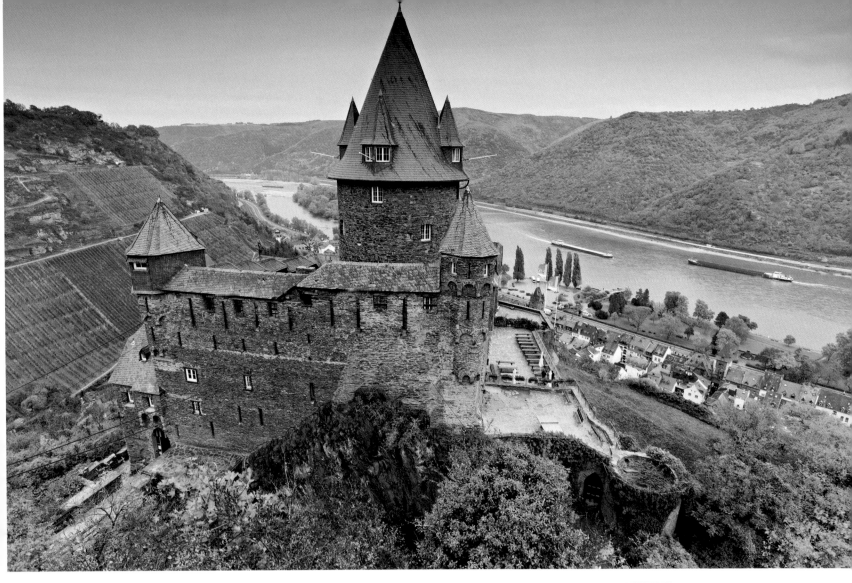

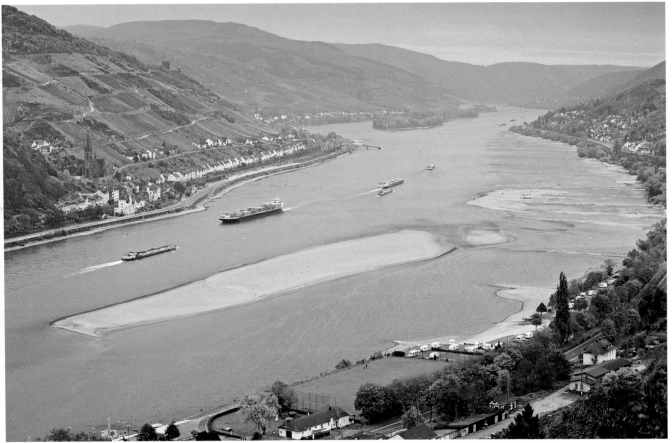

Above:
The Rhine castle up above Bacharach is called Stahleck, built in the 11th century and restored in the 20th. In the past few years it has become something of a hot tip for bridal couples who can celebrate their wedding in what's claimed to be the most beautiful youth hostel in Germany.

Left:
The houses in the traditional wine village of Lorch on the border of Hesse and Rhineland-Palatinate huddle at the foot of the slate slopes of the Rhenish Massif. When the level of the Rhine drops and the sandbanks become wider, skippers have to be especially careful when navigating the gorge.

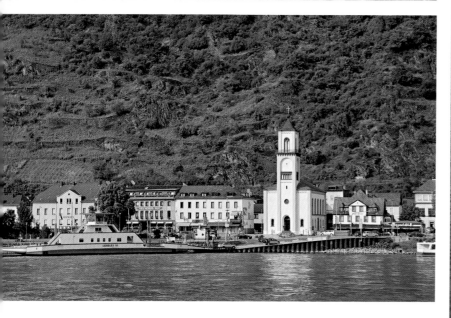

The Rhine is not without its family feuds. The neighbouring castles of Sterrenberg and Liebenstein near Bornhofen are one such example, where two brothers are said to have engaged in bitter conflict. Sterrenberg, the more northerly of the two, is the oldest castle on the Rhine still standing, first mentioned in 1034.

Houses, hotels and holiday homes jostle for space on the banks of the Middle Rhine in Boppard. From the windows you can almost see into the cabins of the Rhine barges that regularly glide past.

Bottom left:
St Goarshausen next to the Loreley is the perfect place to board ship for a leisurely cruise or lace up your hiking boots before climbing up the Rheinsteig trail. Whichever you prefer, be sure to take at look at the historic little village with its medieval walls first!

Below:
The Rhine is not just a romantic backdrop; it's also the most travelled waterway in Europe. Many of the craft that use it are floating hotels and river cruisers.

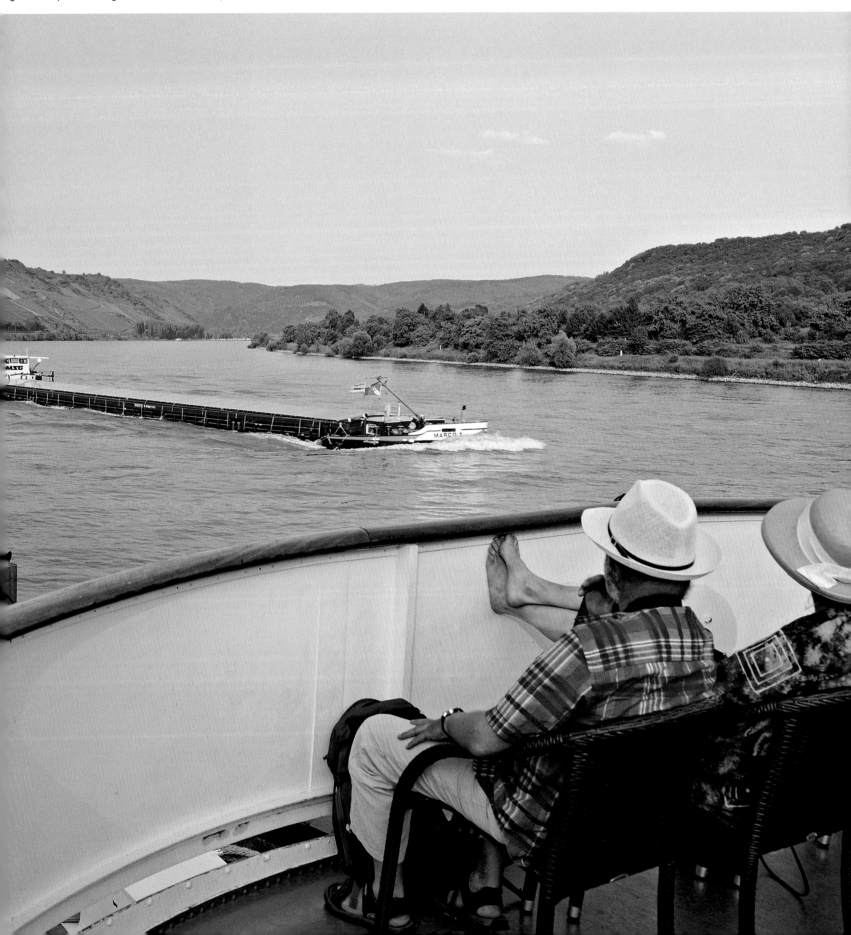

THE LORELEY ET AL –
SHIPPING ON THE RHINE

The most famous boat trip on the Rhine had an unhappy end, as we all know: "The doomed in his drifting shallop, / Is tranced with the sad sweet tone, / He sees not the yawing breakers, / He sees but the maid alone." To conclude, the waves swallow both the sailor and his craft and the person responsible – according to Heinrich Heine in his famous poem, translated here by Mark Twain – is the bewitching Loreley.

Such distractions cannot be heeded by Rhine skippers, for the 28 kilometres/18 miles of the Middle Rhine between Sankt Goar and Rüdesheim are dotted with protruding rocks and shallows. At the Loreley, a steep slate cliff, the Rhine is up to 25 metres/82 feet deep and 113 metres/370 feet wide; there was once a sandbank here where the swirling masses of water with their different speeds formed dangerous whirlpools. Even today along the stretch between Oberwesel and Sankt Goarshausen sailors are warned against oncoming traffic by special illuminated signals.

Even in the Middle Ages the river was a popular waterway. People and wagons were transported in punts and barques; open boats with flat bottoms and often also rigging floated down the Rhine laden with wine, wood or other goods and were dismantled at their destination and used as building materials or fuel. Market ships sailed along the river once a week on market days, travelling to Koblenz from the 13th century onwards and to Mainz a century later.

In times of conflict this major thoroughfare between the north and south of Europe was often seen as a source of income and a bone of contention. When in the late Middle Ages the ecclesiastical electoral princes of Trier, Mainz and Cologne were joined in their position of power by the count palatine, the heavily frequented trade route was increasingly targeted by the competing noble families. In the event of a feud the river was quickly cordoned off, with territorial warlords exerting pressure on rivals or rebellious towns by demanding duties, confiscating goods or levying high taxes. At the old toll stations such as the Pfalzgrafenstein in Kaub and the Mouse Tower in Bingen the ships in the valley had to drop anchor and pay their dues according to a system of tariffs. Today these picturesque buildings are popular photographic motifs and the Middle Rhine is a safe German waterway, extended between 1964 and 1976 at great cost. When travellers from all over the world now show their coin, it's purely for pleasure: for a trip on one of the cheerfully flagged pleasure boats, for example, or for sou-venirs that will remind them of the countless sights that line the gorge's shores. The prospect of fortified customs posts and robber-barons' hidey-holes, romantic panoramas and – last but not least – good Rhine wine draws an estimated 20 million daytrippers a year to the busiest river in Europe.

Paddle steamer

Tourism hit the River Rhine big time with the advent of the steam ship. In 1817 the first paddle steamer, the Caledonia, chugged as far as Koblenz and a comfortable and speedy form of transport was born. Ten years later the Preußisch-Rheinische Dampfschifffahrtsgesellschaft (Prussian-Rhenish Steam Shipping Company) sent its first paddle steamer to Mainz and in the following decades the Rhine became the most popular tourist attraction in Europe. A bookseller from Koblenz who went by the name of Karl Baedecker was largely responsible, with his 1828 publication *Rheinreise von Basel bis Düsseldorf* (Travelling the Rhine from Basle to Düsseldorf) sparking off a veritable run on Rhine excursions.

Today's romantics still have plenty to marvel at. Sheer cliffs, orderly vineyards, quaint villages, mighty castles and towns such as the wonderfully half-timbered Bacharach and the chic Boppard all catch your eye. Part of the attraction is also coming into close contact with all kinds of watercraft, from enormous container ships to freighters, floating hotels, bunker boats and the speedboats operated by the river police to rowing boats and canoes. Only the pilot boats, once an absolute necessity, are now few and far between. Radar, sonar and signal buoys have made them redundant, with the last pilot station at Kaub closed in 1988.

Left:
Canoeists and rowers love the Lahn, with many a natural spectacle to be enjoyed from the middle of the river. Travelling through the locks in such small craft is also a great experience.

Above:
In the soft light of a late summer day it seems hard to imagine that in 1792 Goethe was once caught in a fierce storm on the Moselle, only just managing to get to shore in Trarbach.

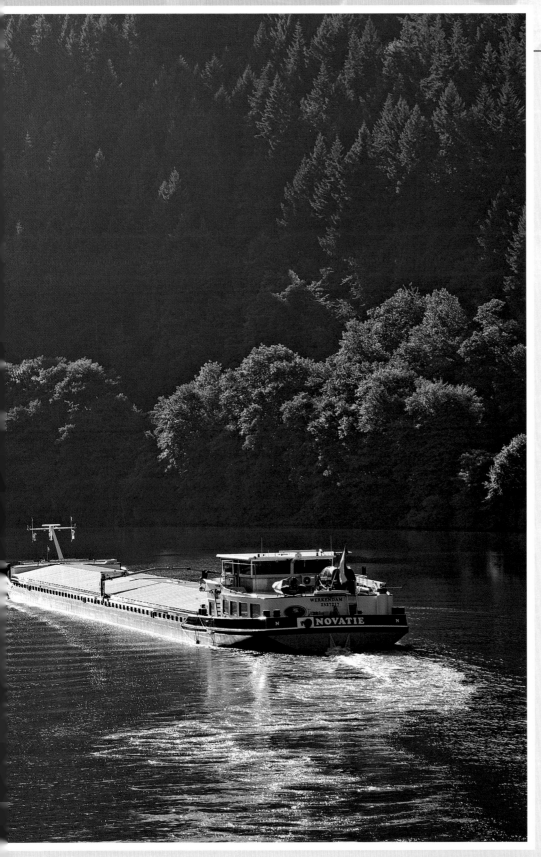

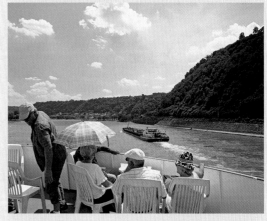

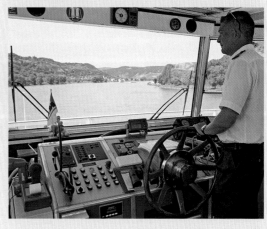

Photos, right, from top to bottom: With a bit of luck you might catch sight of a historic freighter on the Rhine, with Koblenz's unmistakeable Moselle river front in the background.

The Lahn is one of the most beautiful stretches of river for water sports in Germany. It's perfect for less experienced skippers, too, with a gentle current and its many locks easy to manage.

The most comfortable way to enjoy the Rhine's many castles is to gaze upon them from the sun-kissed deck of a river cruiser.

On the bridge you can see just how advanced the control and navigation technology is now generally deployed on Rhine barges and pleasure cruisers.

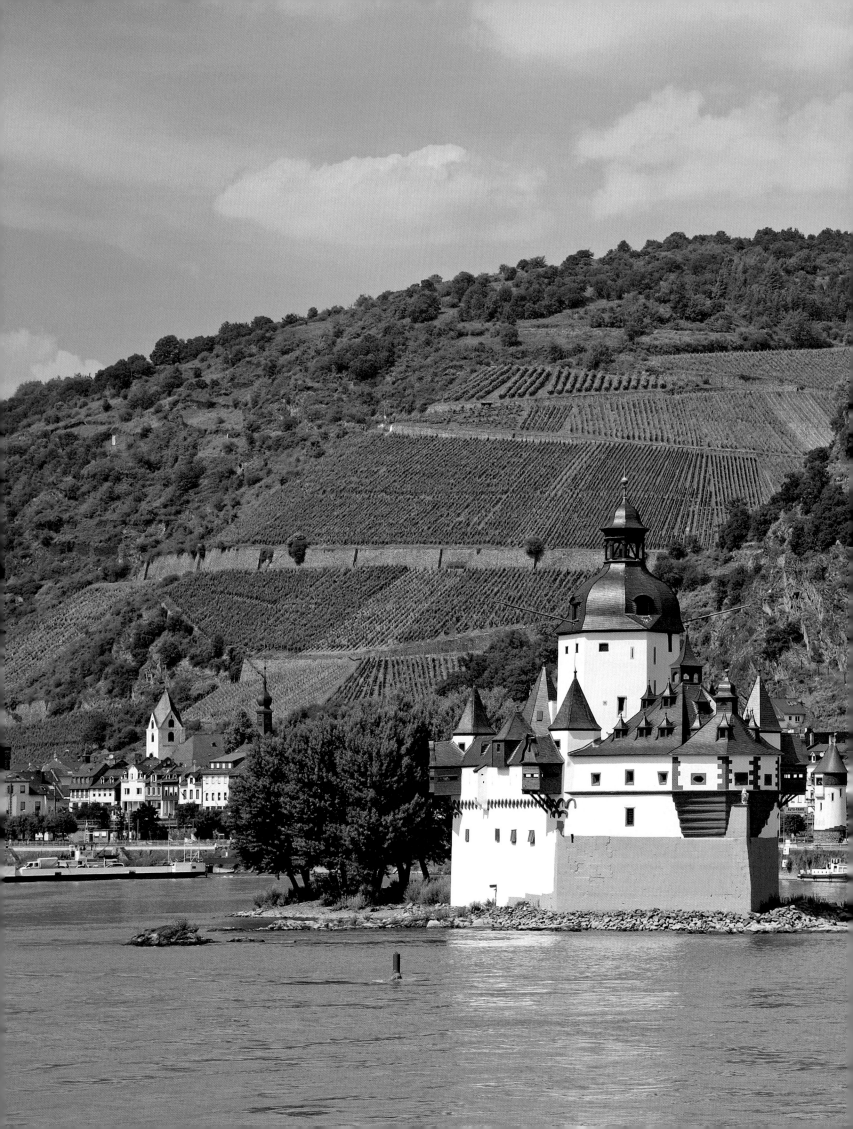

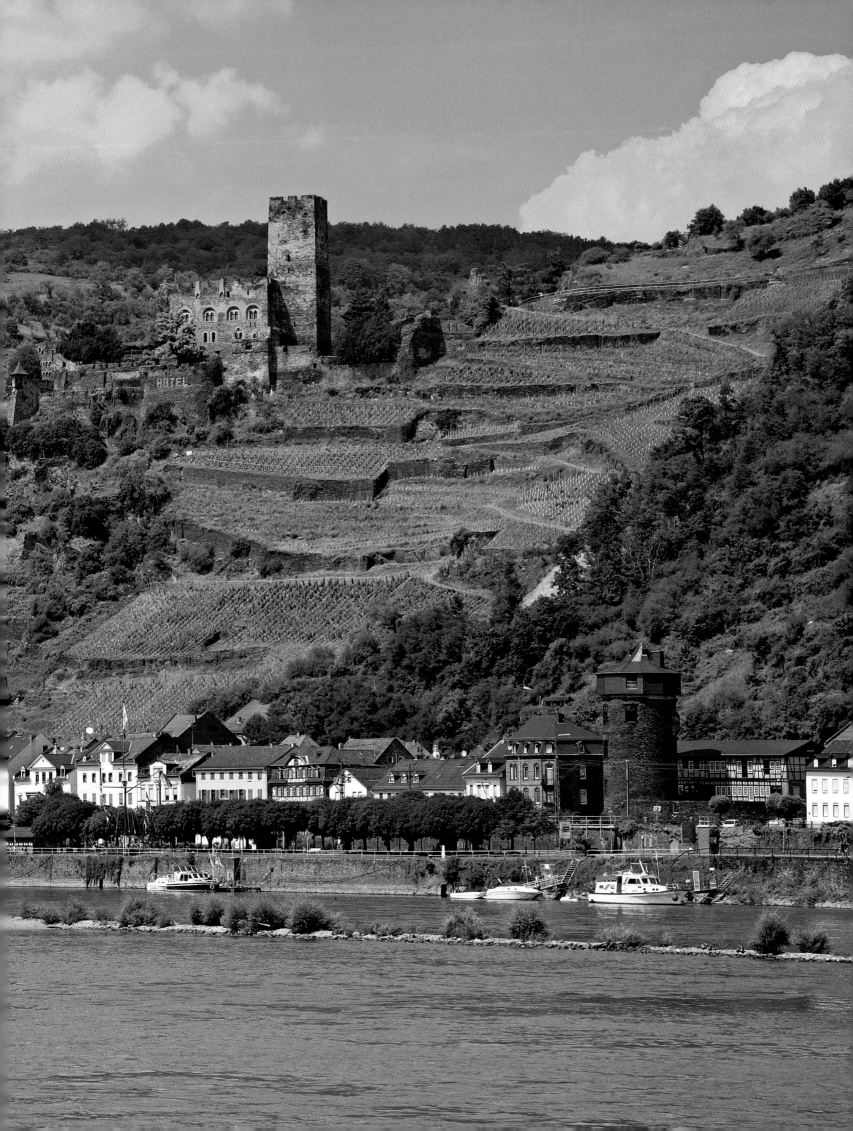

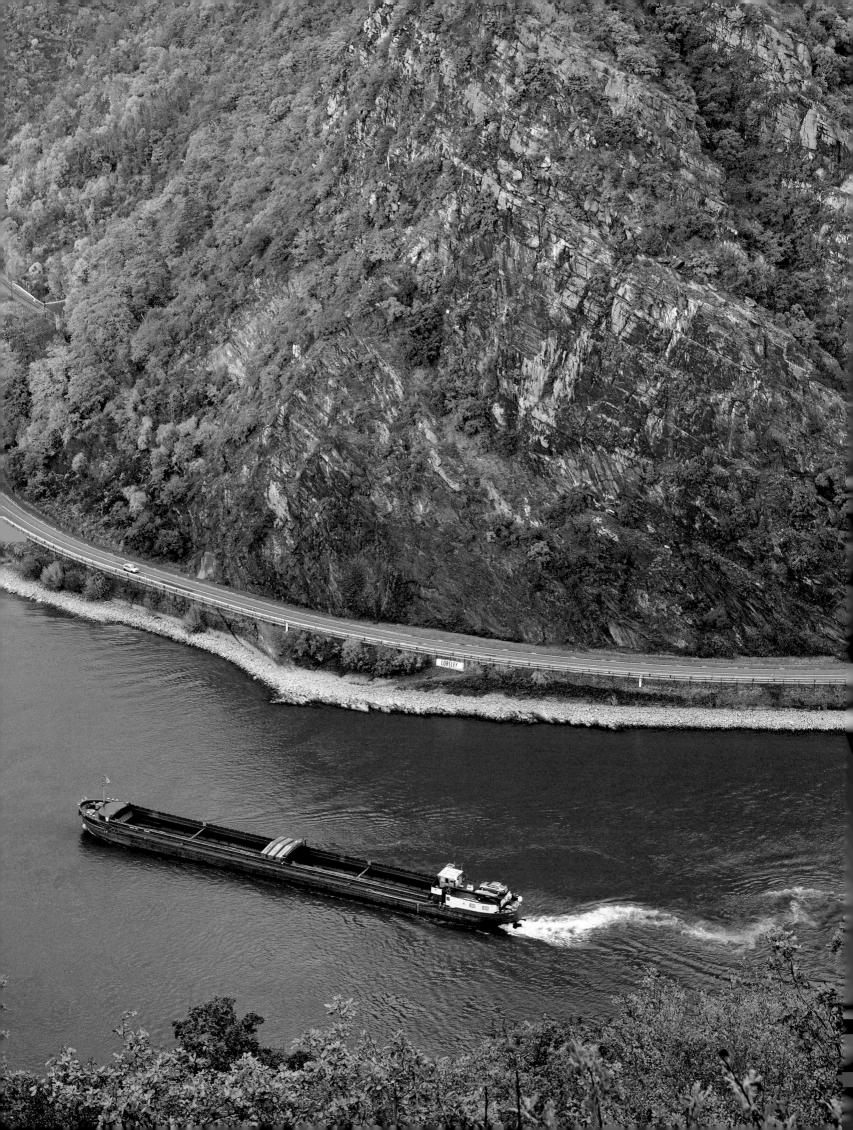

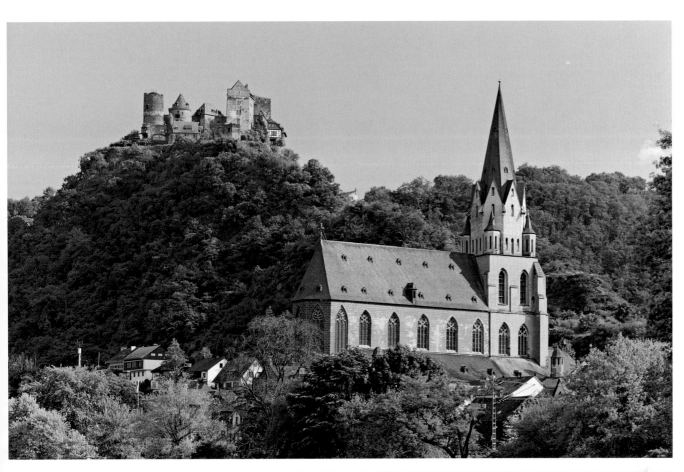

Page 120/121:
Like a defensive stone ship Burg Pfalzgrafenstein lies grounded yet undefeated on an Rhine Island offshore from Kaub. Its strategic position in the middle of a strong current meant that it was never destroyed, despite the region's many wars. High up above it is Burg Gutenfels, once a Staufer stronghold.

Up above Oberwesel is Burg Schönburg, like most of the castles in the Upper Middle Rhine Valley destroyed by the French during the Nine Years' War. The castle also has a vine named after it, the Schönburger Rebe, which is a white grape with a distinctive pink tinge.

Every two years sleepy Oberwesel becomes a riot of medieval colour during the Spectaculum when it relives its glorious past. The inventions of our modern age are banned for several days as the Rhine village is taken over by costumed artisans and actors demonstrating ancient crafts, customs and culinary delights.

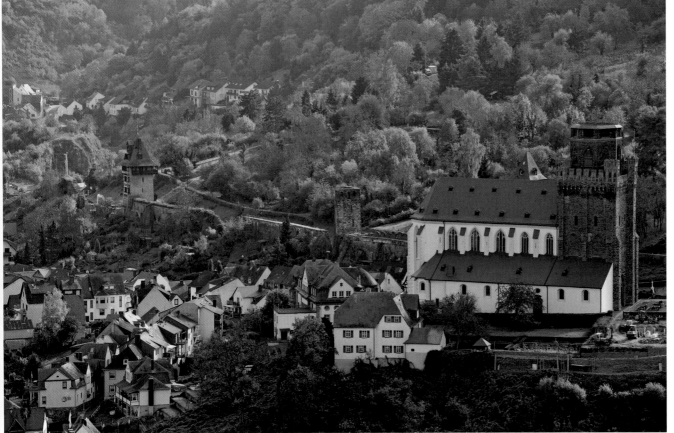

Left page:
In 1801 the name "Loreley" appeared in a Romantic ballad by Clemens Brentano. The poet's tale of the golden-haired maiden whose sweet voice lured sailors to their death has made this particular chunk of Rhineland rock famous the world over.

Right:
The Deutschherrenhaus (now a museum) and the Romanesque basilica of St Castor, consecrated in 836, are just two of the many edifices which make a visit to Koblenz an absolute must on any holiday to the Rhine or Moselle.

Below:
This complex of buildings on Jesuitenplatz, once a Jesuit monastery and school, has been used as Koblenz's town hall since 1895. The differing façades which date from the late Renaissance to the early baroque document how the construction has evolved over the centuries.

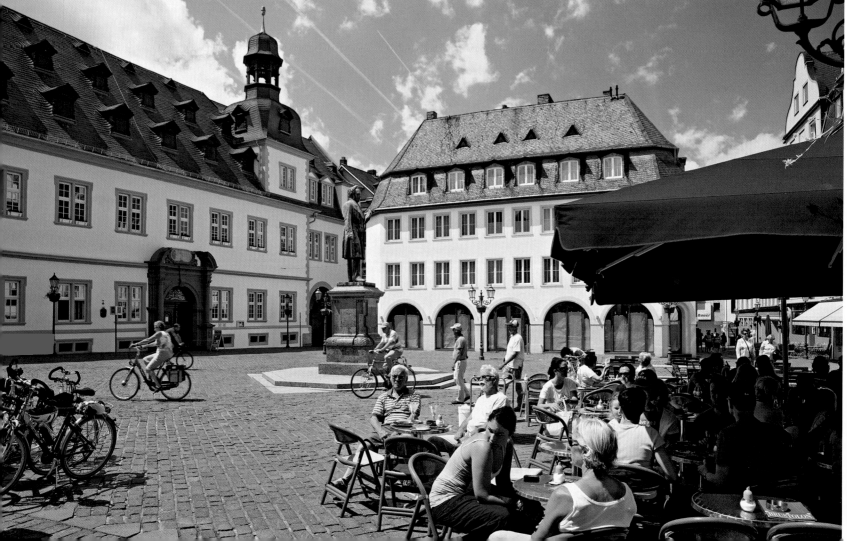

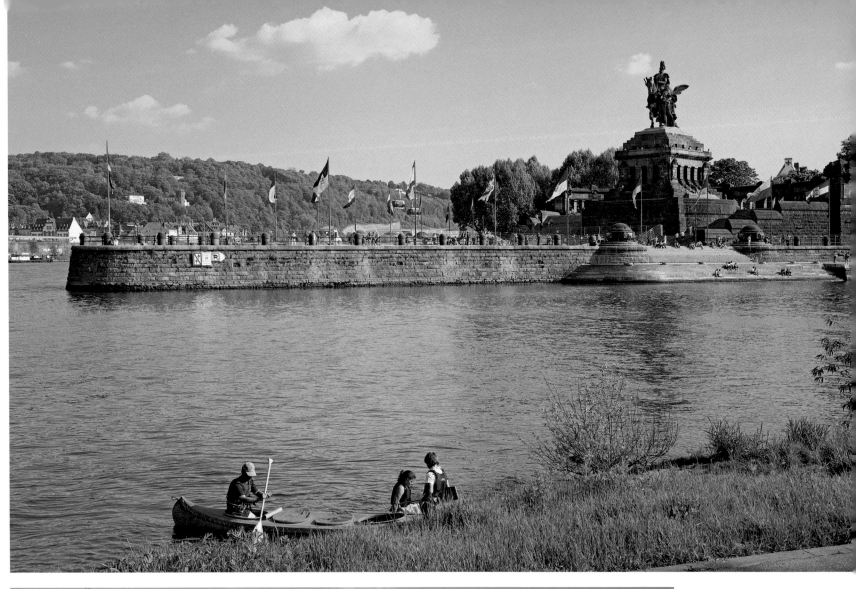

Above:
This spit of land at the confluence of the Rhine and Moselle was named Deutsches Eck after the Teutonic Order of Knights who settled in Koblenz in 1216. In 1897 an enormous statue of Kaiser Wilhelm I was erected here and later destroyed in the Second World War. It was only reinstated in 1993.

Left:
Over the centuries the fortress of Ehrenbreitstein has grown and grown. Perhaps its most spectacular feature is its location high up above Koblenz, with impressive views of the Rhine and Moselle valleys.

Above:
The neo-Gothic residential palace of the Sayn-Wittgenstein-Sayn dynasty is built on the foundations of an older castle that was once the family seat. Surrounded by wonderful parkland, the palace was extensively restored in the 1990s.

Right:
The romantic grounds of Schloss Sayn also have a touch of the exotic about them in their butterfly garden. Thousands of bright winged creatures from South America, Africa and Asia flutter merrily around the tropical plants that thrive in the palace's two glass pavilions.

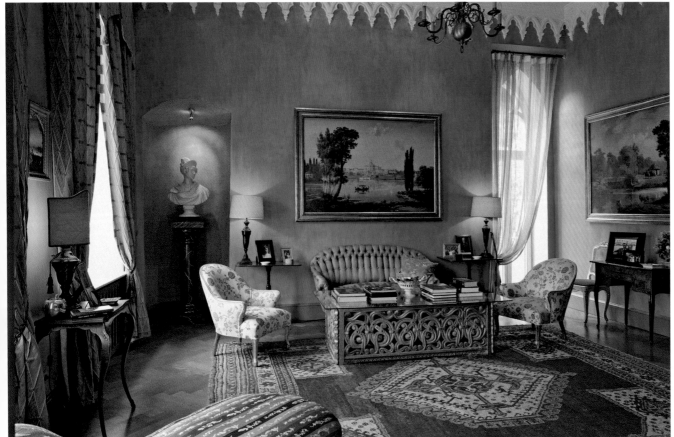

Above:
Much of the decoration in the newly designed rooms of Schloss Sayn is from Italy. The blue cabinet room or dining room contains many Venetian mirrors and the elephants collected by Princess Marianne.

Left:
The Green Salon at Schloss Sayn has a Russian theme. The family once had land in Russia, with the paintings on display here illustrating their former estates. There is also a bust of Princess Charlotte of Prussia.

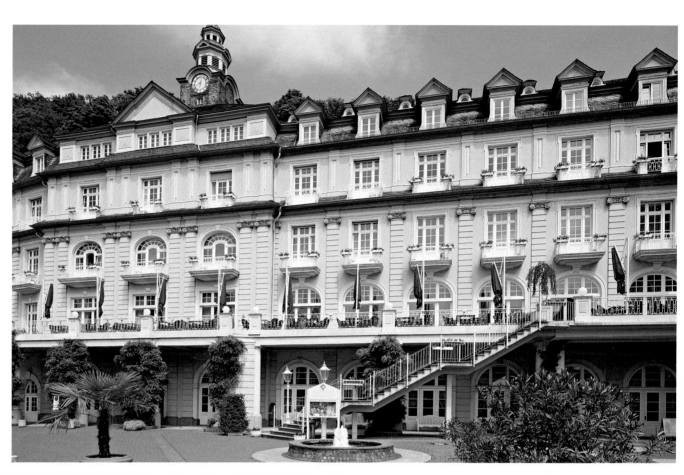

Right:
In the 19th century Bad Ems was the place to come for some top class rest and respite. Artists, politicians, emperors and tsars all imbibed the healing waters in the spa's chic pump room, built in 1712. Turgenev, Dostoyevsky, Wagner and Goethe once promenaded here, catapulting Bad Ems to fame and fortune.

Below:
At the beginning of the 20th century the yellow water tower on the Lahn once supplied Bad Ems with water and is now something of a local landmark. The saline springs in Bad Ems are still used to help relieve respiratory ailments.

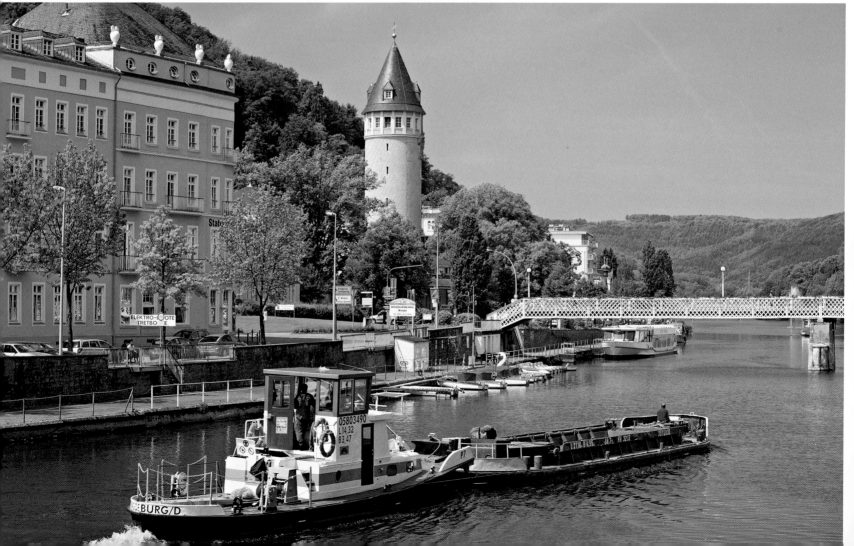

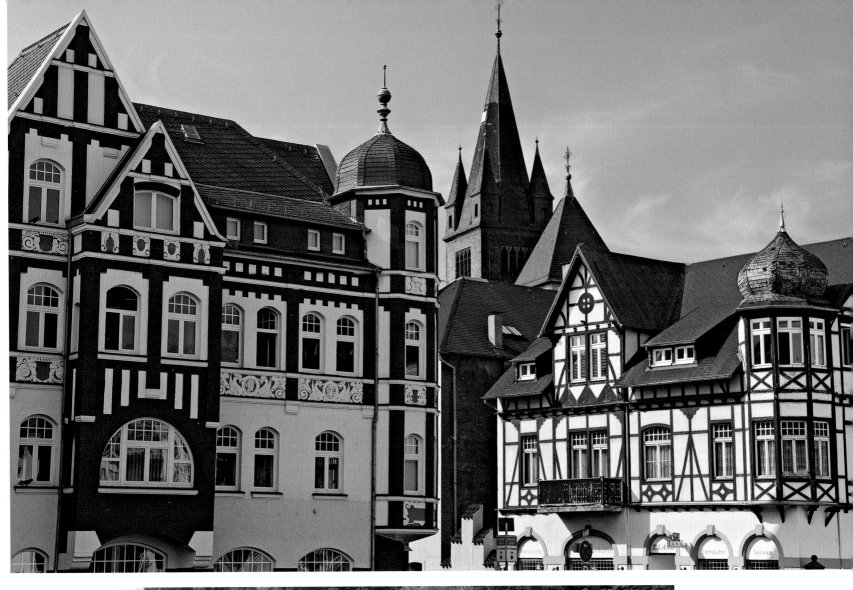

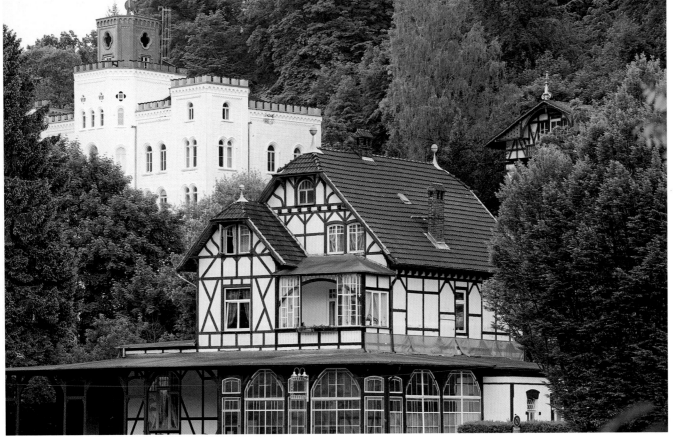

Above:
Historic Salhofplatz in Lahnstein on the Middle Rhine is enclosed by a 600-year-old town wall. The square in the centre of town was named after the Salhof zu Lahnstein, erected in c. 1150, which later came under the ownership of the barons of Stein from Nassau.

Left:
During Bad Ems' heyday as an upmarket spa huge hotels sprang up on the right bank of the Lahn, with private villas lining the shores to the left. One of the most elegant is Schloss Balmoral from 1868, now an art gallery, tucked in behind an equally impressive half-timbered dwelling.

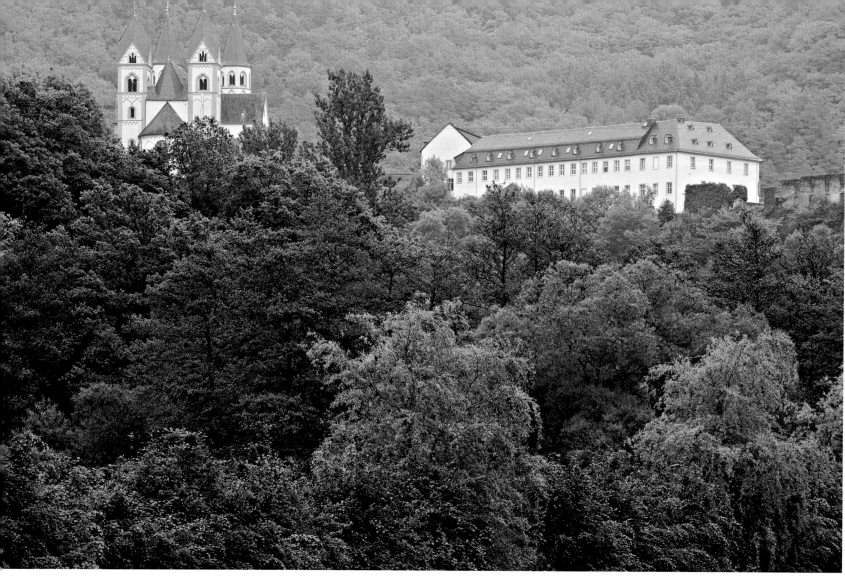

Above:
The ancient monastery of Arnstein pokes out from behind the trees on an exposed spot on the River Lahn. Ludwig III, the last count of Arnstein, and his wife Guda founded a Premonstratensian monastery here in 1139. The abbey has been run by the Congregation of the Sacred Hearts of Jesus and Mary since 1919.

Right:
Dausenau creeps right down to the very shores of the Lahn between the spas of Bad Ems and Nassau. Goethe was familiar with the pretty little town as he liked to frequent its historic inn, the Wirtshaus an der Lahn.

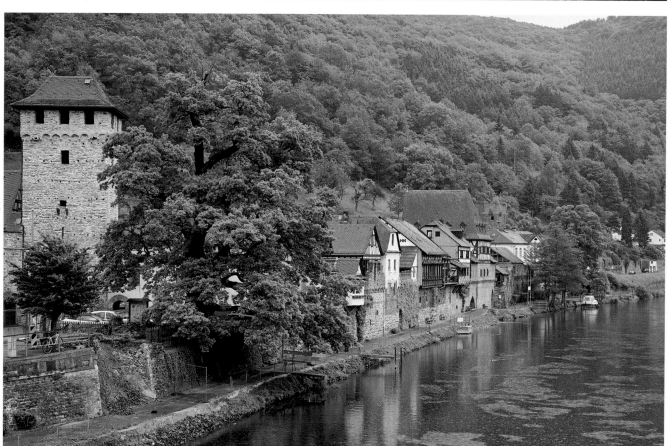

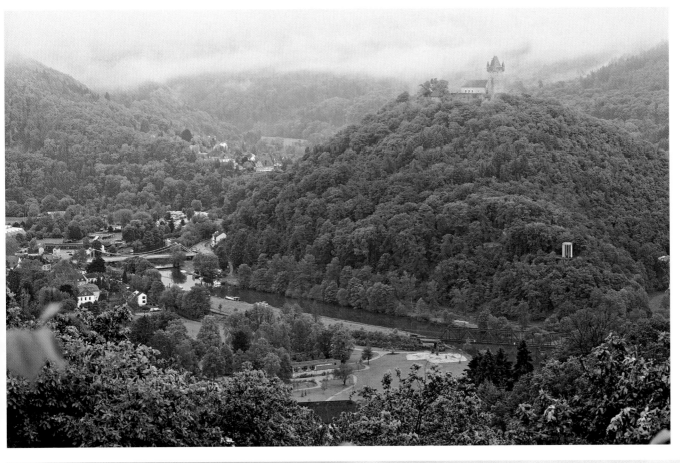

Left:
The ruins of the ancestral castle of Orange-Nassau are now part of the national park of Nassau. The stronghold dates back to c. 1100 and possibly once guarded an ancient trade route from Mainz to Koblenz that crossed the River Lahn where Nassau now stands.

Below:
Diez on the River Lahn is characterised by its narrow streets, proud half-timbered houses and its magnificent turreted castle. It also stages many festivals throughout the year, which in this charming setting are well worth a visit.

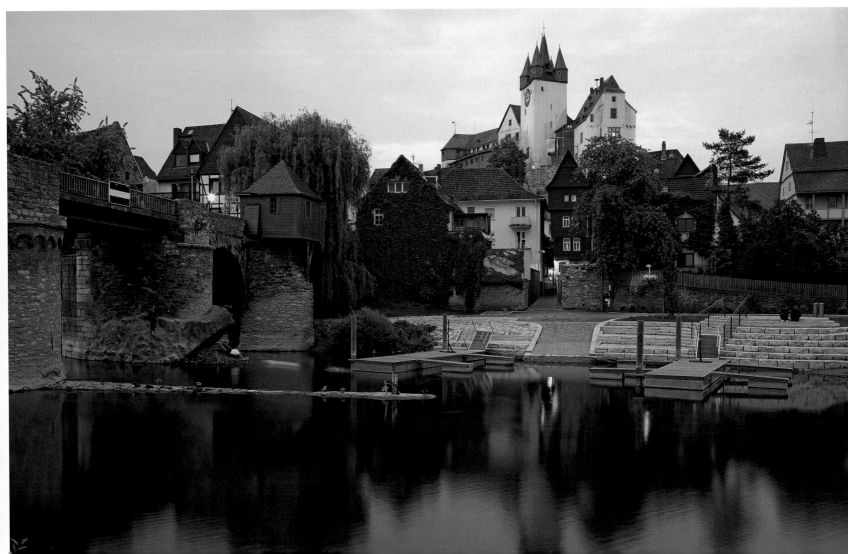

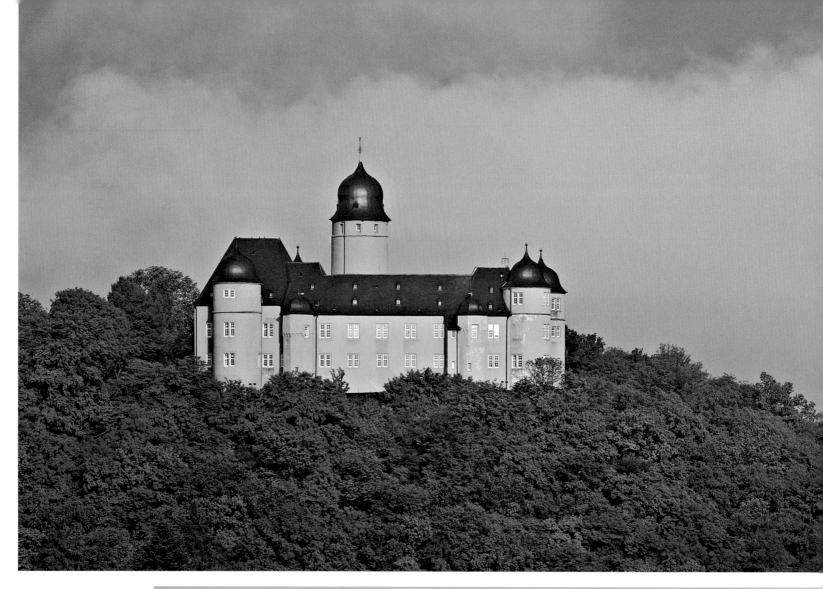

Right:
Hachenburg is heralded as the pearl of the Westerwald. Once a humming centre of medieval trade, it also claims to have the loveliest market square in the Westerwald area, embellished by its palace which until 1799 was home to the counts of Sayn.

Left:
Visible for miles around the baroque castle of Montabaur simply dominates the town of the same name below it. Dating back to the 10th century, the building's distinguishing features are without a doubt its tall, round towers with their flat helm roofs.

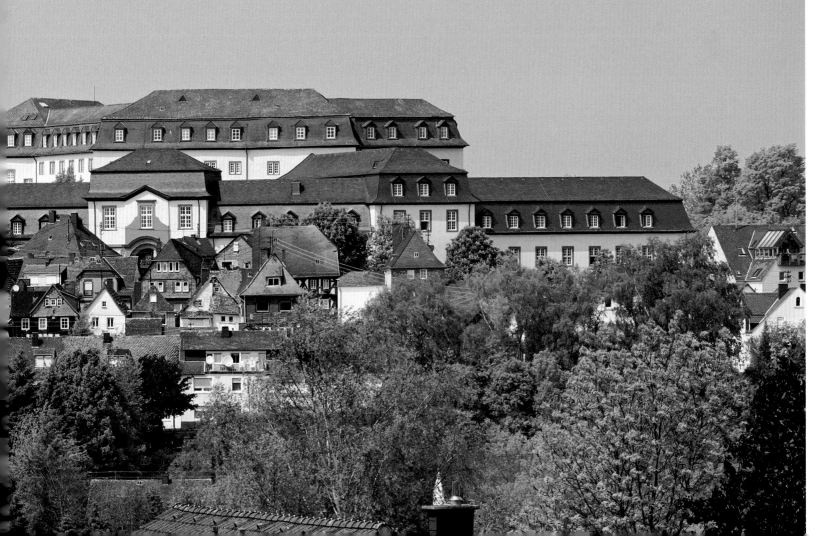

INDEX

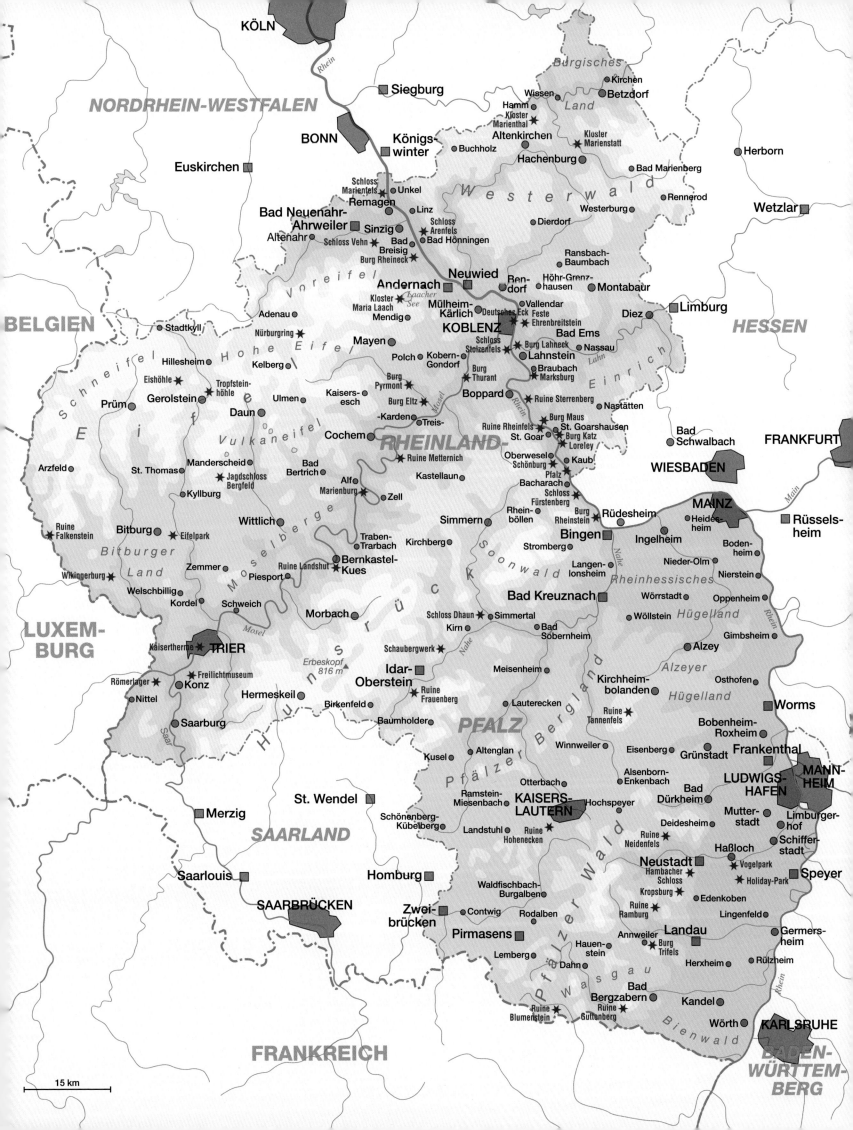

Rhine barge. Rivers have always been an important means of transportation, forging an essential link between different peoples and countries.

Design
www.hoyerdesign.de

Map
Fischer Kartografie, Aichach

Translation
Ruth Chitty, Stromberg, www.rapid-com.de

Printed in Germany
Repro by Artilitho snc, Lavis-Trento, Italy
www.artilitho.com
Printed and bound by Offizin Andersen Nexö, Leipzig
© 2011 Verlagshaus Würzburg GmbH & Co. KG
© Photos: Brigitte Merz and Erich Spiegelhalter
© Text: Maja Ueberle-Pfaff

ISBN 978-3-8003-4096-5

Photo credits
All photos by Brigitte Merz and Erich Spiegelhalter
with the exception of:
p. 34: Burg Eltz (administration)
Reproduction of the inside of the Sayner Hütte
(page 18/19) is with the kind permission of the local
administration of Bendorf.

Details of our programme can be found at
www.verlagshaus.com